Emotion

Emotion

Young British and American Art
from the Goetz Collection

Junge britische und amerikanische Kunst
aus der Sammlung Goetz

Edited by/Herausgegeben von
Zdenek Felix

Cantz

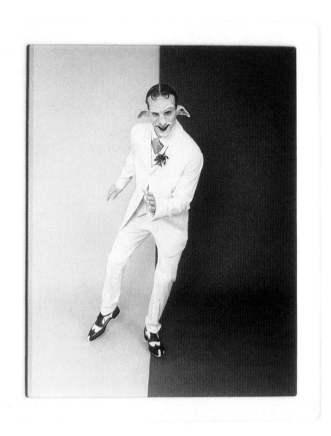

Matthew Barney, CREMASTER 4: The Isle of Man (Detail), 1994

INHALT

KUNST IM NETZWERK
VON BEDEUTUNGEN

Unter dem Titel »Emotion – Junge britische und amerikanische Kunst aus der Sammlung Goetz« stellen die Deichtorhallen charakteristische Werke von 18 Künstlerinnen und Künstlern aus der aktuellen Kunstszene Großbritanniens und der Vereinigten Staaten vor.

Die Münchner Privatsammlung Goetz zählt zu den profiliertesten Sammlungen der Gegenwartskunst in Europa. Ihr »Stammhaus«, das 1993 im Münchner Stadtteil Oberföhring von dem Schweizer Architektenduo Herzog & de Meuron als privates Museum mit Bibliothek erbaut wurde, steht inzwischen im Fokus internationaler Aufmerksamkeit. Das Gebäude, das in seiner äußeren Erscheinung aus drei präzisen Rechteckformen aus Glas und Holz aufeinandergeschichtet ist, bietet sich bei überschaubaren Abmessungen als nahezu idealer Ausstellungsort für die Kunst unserer Zeit an. Eine durchdachte Gliederung der Räume sowie optimale Lichtführung sorgen dafür, daß auch für diffizile Installationen ein angemessener Raum vorhanden ist. Die bisherigen Schwerpunkte der Sammlung – die italienische »Arte povera« und die »minimalistische Malerei« – wurden in der letzten Zeit durch eine überlegte Auswahl der jungen amerikanischen und britischen Kunst kontinuierlich ergänzt. Aus einer zunächst rein privaten Sammlung ist mit der Eröffnung des Hauses von Herzog & de Meuron eine »öffentliche« Institution geworden, die auf Voranmeldung besichtigt werden kann. Als Besonderheit bietet die »Sammlung Goetz« in unregelmäßigen Abständen thematische, von wissenschaftlichen Katalogen begleitete Wechselausstellungen aus eigenem Besitz an, ein »Service«, den viele große, öffentliche Museen vermissen lassen.

»Emotion« zeigt eine breite Auswahl von Werken jener Künstlerinnen und Künstler, die in den letzten Jahren Eingang in die Sammlung Goetz gefunden haben. Vertreten sind jeweils neun Positionen, die innerhalb der britischen und amerikanischen Kunst seit Ende der siebziger Jahre eine signifikante Rolle spielen. Die Auswahl nimmt auf die bisherigen Ausstellungen in den Deichtorhallen Rücksicht. So wurden Werke von Cindy Sherman und Jeff Wall, die in der Sammlung Goetz vorzüglich vertreten sind, im Hinblick auf die beiden großen Ausstellungen dieser Künstler in Hamburg in die jetzige Schau bewußt nicht einbezogen. Die tragende Idee war, anhand des reichen Materials der Münchner Sammlung einen Dialog zwischen den beiden angelsächsischen Kunstszenen herbeizuführen und somit auf die Korrespondenzen, aber auch die Unterschiede und Besonderheiten der jeweiligen Szene hinzuweisen. Entstanden ist eine umfangreiche Ausstellung, in der verschiedene Medien zum Einsatz kommen: Stark vertreten sind Film, Video- und Audioarbeiten, weiter fotografische und skulpturale Werke, oft aus unge-

wöhnlichen Materialien, Tapeten mit Körperabdrücken sowie Installationen mit Bild und Ton. Formal lehnen sich viele dieser Arbeiten an die Ästhetik von Mode-, Werbe- und MTV-Welt an, Pop und Underground scheinen hier zu verschmelzen, um neue, ungewöhnliche Formen zu entwickeln. Verwandtschaften bestehen zur Popmusik, zum zeitgenössischen Film, aber auch zu den Codes der Computer und des Internets. Diese »Inspirationsquellen« werden von den Künstlerinnen und Künstlern jedoch keineswegs nur »bejaht«. Vielmehr setzt sich die Mehrheit der Werke kritisch und ironisch mit dem sozialen Umfeld dieser Phänomene auseinander. Die eigene, private Wahrnehmungsebene, von einer nahezu schonungslosen Offenheit getragen, kommt als wichtiger Bestandteil der Arbeiten hinzu.

In der letzten Zeit hat eine Reihe von Ausstellungen wie »Brilliant! New Art from London« im Walker Art Center in Minneapolis (1995), »Life/Live« im Musée d'Art Moderne de la Ville de Paris (1996), »Full House« im Kunstmuseum Wolfsburg (1996) sowie »Sensation« in der Royal Academy in London (1997) die Aufmerksamkeit einer breiten Öffentlichkeit auf die junge Kunstszene in Großbritannien gelenkt. Wie Friedrich Meschede in seinem Beitrag für diese Publikation treffend schreibt, kam diese Entwicklung eher unerwartet, denn »was für die junge Kunst in den USA wie eine kontinuierliche Fortsetzung seit der amerikanischen Selbstbehauptung durch Pollock und Newman erscheint, ... (ist) für das Selbstverständnis der britischen Kunst neu.« Zwischen der Alten und Neuen Welt gab es allerdings seit der Nachkriegszeit mehrere ausgeprägte Konkurrenzsituationen, so die italienische »Arte povera« in den späten sechziger Jahren und die »Deutsche Malerei« in den späten siebziger und den frühen achtziger Jahren, beides »Tendenzen«, die in den Vereinigten Staaten aufmerksam verfolgt und als Herausforderung aufgenommen wurden. In Großbritannien hat es lediglich das kurze Zwischenspiel der britischen Pop Art um 1955 mit Richard Hamilton, R. B. Kitaj und David Hockney gegeben, doch kam dieser Impuls in Amerika über ein flüchtiges Interesse zunächst nicht hinaus.

Um so reizvoller schien es, aus dem umfangreichen Fundus der Sammlung Goetz zu schöpfen und eine Gegenüberstellung der beiden zur Zeit wohl lebendigsten »Szenen« der Gegenwartskunst zu arrangieren. Als Nebeneffekt dieser Konfrontation, die keine nationalen Kriterien hervorhebt, um so mehr aber die Leistungen der einzelnen würdigt, erscheint der Verzicht auf »nationalistische, stereotype Definitionen« (Carl Freedman), mit denen allzu oft operiert wird. Nicht zuletzt deshalb erweist sich das Gerede vom »Swinging London« als neues »Zentrum der Kunsterneuerung« als ein wenig hilfreiches Kriterium.

Im Hintergrund der britischen und amerikanischen Kunst, so wie sie von »Emotion« erfaßt wird, stehen die beiden »historischen« Impulse: die Pop Art und Concept Art. Zwischen den Polen der intellektuell-konzeptuellen Strategien einerseits und der sinnlich wahrnehmbaren Reflexion von realen und virtuellen Dingen des Alltags, der sozialen Wirklichkeiten und der medialen Scheinwelten andererseits, spannt sich der Bogen, der dieser Kunst als Ausgangs-

basis dient. Andy Warhol und Joseph Kosuth können hier als markante künstlerische Vorbilder genannt werden. Allerdings stellen die klassische Pop Art wie auch die konzeptuellen Strategien der sechziger Jahre nur eine Durchgangsstation dar. Im Hinblick darauf konstatiert Michael Craig-Martin, einer der Lehrer am legendären Goldsmiths College in London, daß die junge Generation zweifellos von bestimmten Vorstellungen der Concept Art ausgegangen sei. »Doch die Concept Art, die um 1970 entstand, war sehr nüchtern und puritanisch. Es gehört zu den Merkmalen der gegenwärtigen Kunst, daß sie alles andere ist als das. Sie ist aggressiv, und sie kann sehr vulgär sein und leidet weniger an Schuldgefühlen, was sie wiederum sehr unenglisch macht.« In dieser Hinsicht brechen die jungen Briten viel stärker mit ihrer gediegenen Tradition als die etwas älteren Amerikaner, die auf eine fast lückenlose Kontinuität der eigenen »Avantgarden« seit 1950 blicken können.

Beachtenswert bei »Emotion« ist der hohe Anteil von Frauen, besonders im britischen Teil der Ausstellung. Die verstärkte Rolle der Künstlerinnen bringt nicht nur die Erweiterung des thematischen Spektrums um weibliche, feministische Sichtweisen mit sich, sondern bedeutet zugleich auch die Erhöhung des emotionalen Potentials der gesamten Ausstellung. Falls der Titel »Emotion« eine Rechtfertigung benötigt, so könnte hierzu gerade dieser Aspekt dienen. Es ist für die Sammlung Goetz bezeichnend, daß sie sich vorrangig für jene künstlerischen Positionen einsetzt, die das Spektakuläre und Vordergründige als Mittel des künstlerischen Ausdrucks meiden. Die intellektuellen, den Kontext der Kunst betonenden und psychologisch begründeten Positionen werden um so stärker in den Fokus der Aufmerksamkeit gestellt. Darin läßt sich auch die Verantwortung der Sammlerin Ingvild Goetz erblicken, für die der Waren- und Mediencharakter der zeitgenössischen Kunst weniger, deren intellektueller und psychologischer Gehalt um so mehr bedeuten.

Daß diese umfangreiche Ausstellung mit circa 160 teilweise voluminösen Exponaten und Installationen der britischen und amerikanischen Kunst in Hamburg als deutsche Premiere zustandegekommen ist, erfüllt uns mit großer Freude. Zum Dank verpflichtet sind die Deichtorhallen in erster Linie der Sammlerin, die von Anfang an mit ihren Mitarbeitern das Vorhaben kräftig unterstützte. Die zahlreichen Gespräche und das unermüdliche Engagement von Ingvild Goetz haben die Vorbereitungen von »Emotion« wesentlich erleichtert. Die eingeladenen Autoren Daniel Birnbaum, Iwona Blazwick, Yilmaz Dziewior, Carl Freedman und Friedrich Meschede haben mit ihren Katalogbeiträgen von unterschiedlichen Standpunkten aus die Problematik der Ausstellung beleuchtet. Unser Dank gilt ebenfalls der Übersetzerin Belinda Grace Gardner für ihren intensiven Arbeitseinsatz sowie dem Team der Deichtorhallen für das tatkräftige Mitwirken beim Entstehen von »Emotion«.

Zdenek Felix, Direktor der Deichtorhallen

In the exhibition *Emotion – Young British and American Art from the Goetz Collection* the Deichtorhallen Hamburg are presenting works by 18 artists characteristic of today's art scene in Great Britain and the United States.

The Goetz Collection in Munich is one of the most distinguished private collections of contemporary art in Europe. The collection's 'headquarters', a private museum built in 1993 in the Munich district Oberföhring by the Swiss architects Herzog & de Meuron, has come into the focus of international attention. The building, whose construction consists of three precisely defined rectangles of glass and wood placed on top of each other, has compact and stringent dimensions, most ideal for exhibiting current art. A carefully devised layout and optimal lighting provide adequate space for even difficult installations. In recent years, the large store of Italian arte povera and minimalist painting, occupying central positions in the collection, has continuously been supplemented by a well-considered selection of young British and American art.

With the construction of the building, designed by Herzog & de Meuron, a collection, which initially began as a private enterprise, has become a 'public' institution open to view by arrangement. The Goetz Collection is also exceptional in that it stages alternating thematic exhibitions at irregular intervals, accompanied by publications, a 'service' that many large public museums do not render.

Emotion presents a wide range of works by those artists that have enriched the collection during the past five years. The exhibition features nine positions, respectively, that have held significance within British and American art since the 1970s. In selecting the works, previous exhibitions shown at the Deichtorhallen have been taken into account. Works by Cindy Sherman and Jeff Wall, for example, excellently represented in the Goetz Collection, were specifically not included in this show due to consideration for the two large exhibitions in Hamburg dedicated to these artists. Drawing upon the abundant material made available by the Munich collection, the basic idea was to generate a dialogue between both Anglo-Saxon art scenes, illuminating both the correspondences between the particular scenes as well as their differences and distinctive qualities. This attempt has resulted in an extensive exhibition that encompasses various media: film, video and audio works are one major aspect, as well as photography and sculpture, often composed of unusual materials, wallpaper with imprints of the body, as well as installations that combine image and sound. Formally, many of these works lean upon the aesthetics of fashion, advertisement and MTV; pop and underground seem to

merge here, generating new modes of art. One finds strong affinities towards pop music, contemporary cinema and the world of computers and Internet. However, these 'sources of inspiration' are under no considerations viewed solely in a positive manner. Moreover, the majority of the works address the social environment of these phenomena in a critical and ironical way. One other important component of the work is the aspect of the artists' own private perception – often expressed with almost brutal frankness.

Lately, a number of exhibitions such as *Brilliant! New Art from London* at the Walker Art Center in Minneapolis (1995), *Life/Live* at the Musée d'Art Moderne de la Ville de Paris (1996), *Full House* at the Wolfsburg Art Museum (1996) as well as *Sensation* at the Royal Academy in London (1997) have drawn much public attention to the young British art scene. As Friedrich Meschede aptly points out in his contribution to the catalogue, this course of events was rather unexpected, because "While in regard to young art in the U.S. there appears to have been a continuous development since the American self-assertion, given shape by Pollock and Newman and carried forth, with new protagonists, in every decade since the Second World War, this is a novel situation for the identity of British art." There had, however, been several pronounced occasions of rivalry between the Old World and the New since the postwar era, such as the Italian arte povera movement in the late 1960s and German painting in the late 70s and early 80s, both 'tendencies', which were observed attentively in the United States and accepted as a challenge. In Great Britain there was merely a short interval of British pop art around 1955 with Richard Hamilton, R. B. Kitaj and David Hockney, an interlude that at the outset in America did not arouse more than passing interest.

It thus seemed particularly tempting to draw from the extensive reserves of the Goetz Collection and to initiate a confrontation between what are possibly the two most lively 'scenes' of contemporary art today. One side effect of this confrontation, which does not stress any national criteria but emphasises each individual achievement, is the rejection of "nationalistic, stereotype definitions" (Carl Freedman) which one all too often encounters. Not least because of this, all the talk about 'Swinging London' as a new 'centre of artistic revitalisation' does not appear to be a very helpful criterion.

Underlying the British and American art presented in the exhibition *Emotion* are the two 'historical' impulses: pop art and conceptual art. Between the two poles of intellectual-conceptual strategies, on the one hand, and a tangibly perceivable reflection of the world of real and virtual commonplace objects, of social realities and the illusory worlds of the media, on the other, these art forms position themselves. Andy Warhol and Joseph Kosuth may be mentioned here as prominent artistic models. However, classical pop art as well as the conceptual strategies of the 1960s merely represent transitional stages. In this respect, Michael Craig-Martin, one of the instructors at the legendary Goldsmiths College in London, asserts that

doubtlessly the young generation took certain ideas of conceptual art as their starting point. "The conceptual art that emerged around 1970 was very austere and puritanical. It is one of the characteristics of current art that it is anything but that. It is aggressive and can be very vulgar and does not suffer much from a sense of guilt, which, in turn, makes it very un-British." In this respect, the young British artists break more thoroughly with their sound tradition than the American artists, who are slightly older and can look back upon an almost complete continuity of indigenous avant-garde movements since the 1950s.

The large number of female artists taking part in *Emotion* is noteworthy, especially in the British part of the exhibition. The strengthened role of female artists not only broadens the thematic spectrum in regard to female and feminist angles and views, but also enhances the emotional potential of the exhibition as a whole. Should the title need a justification, this aspect may well serve. It is a characteristic of the Goetz Collection that primarily positions are supported that do not employ superficial and spectacular artistic means. Instead, intellectual and psychologically based positions that emphasize the art context are given priority and brought into the focus of attention. Here one also becomes aware of the intentions of Ingvild Goetz, for whom the commodity or media character of current art means little, while its intellectual and psychological content means all the more.

It is a particular pleasure for us that this extensive exhibition of British and American art in Hamburg, encompassing approximately 160 works and installations, some of which are of a great magnitude, is taking place as a première in Germany. First and foremost, we should like to express our deep gratitude to the collector Ingvild Goetz, who together with her team strongly supported the project from the very beginning. Through the numerous conversations with Ingvild Goetz and her unflagging commitment, preparations for *Emotion* were made considerably smoother. Daniel Birnbaum, Iwona Blazwick, Yilmaz Dziewior, Carl Freedman and Friedrich Meschede, the authors who were requested to contribute to the exhibition catalogue, have illuminated the issues involved in this show from various angles. We would also like to thank the translator Belinda Grace Gardner as well as the team of the Deichtorhallen for their enormous effort and support in the realisation of *Emotion.*

Zdenek Felix, Director of the Deichtorhallen

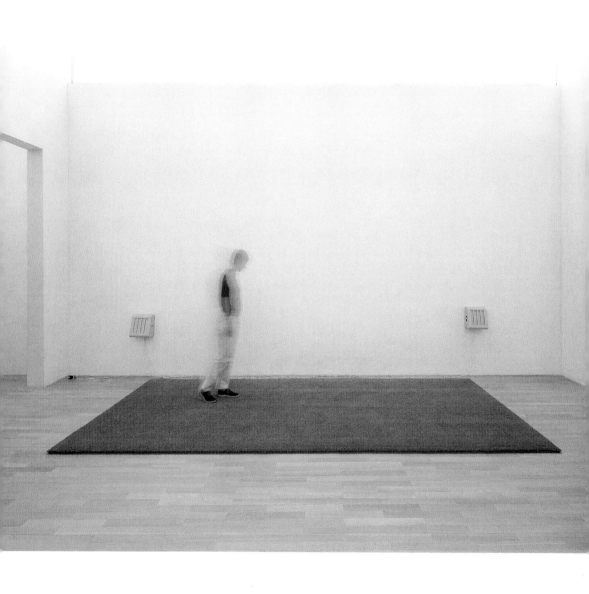

Angela Bulloch, Beach Synth, 1996

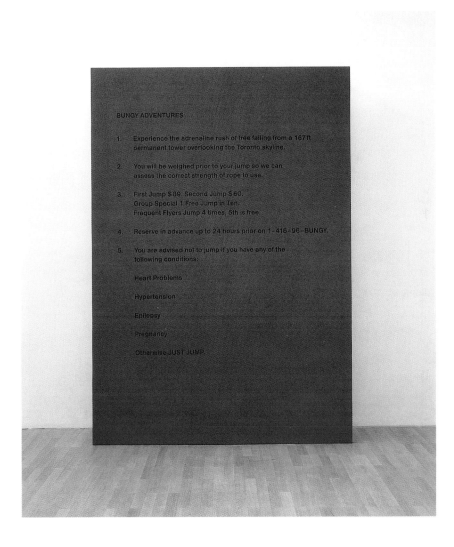

Angela Bulloch, Bungy Adventures (from "Rules Series"), 1993

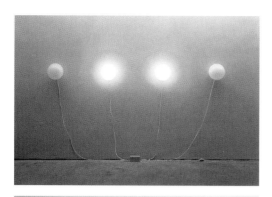

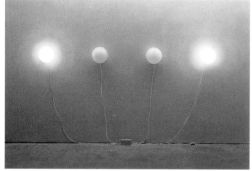

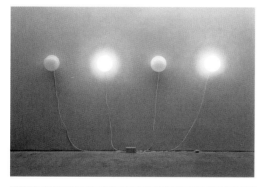

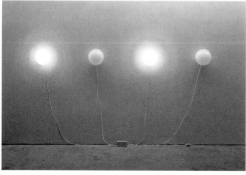

Angela Bulloch, Jade Four, 1990

FINE YOUNG CANNIBALS

Iwona Blazwick

Brilliant!!! Sensation!!! Mit diesen Attributen im Boulevard-Stil waren zwei Ausstellungen betitelt, die sich vom Konzept und von der Verpackung her als schlagkräftige Kombination aus Kunst, Marketing, Anthropologie, Glamour und Patronage erwiesen. Sie gehörten zu einer wachsenden Flut von Ausstellungen, die in den neunziger Jahren die Wiedergeburt von »Cool Britannia« verkündeten – die künstlerische Replik auf den Pop-Boom der sechziger Jahre, unsterblich geworden mit Richard Hamiltons »Swingeing London«. Die Ausstellung »Brilliant«, die 1995 im Walker Art Centre gezeigt wurde, holte die YBAs (»Young British Artists«) nach Amerika. Vielleicht zum ersten Mal befand sich die britische Kultur als angemessen exotisches Beobachtungsobjekt im Fokus des anthropologischen Feldstechers. Jake und Dinos Chapmans glänzendes Kunststoffbildnis von Stephen Hawking blickte vom Rollstuhl aus auf Museumsaufseher, die wie *Pearly Kings* und *Queens* (mit den perlenbestickten Kostümen jener Straßenverkäufer, die einst Londons verarmtes East-End bevölkerten und heute zur Touristenattraktion avanciert sind) oder wie Punks mit Irokesenschnitt ausstaffiert waren. Das gute alte England samt Monarchie und Gentlemen mit Bowler-Hüten war durch ein anderes, von Charles Dickens und Malcolm McLaren inspiriertes Stereotyp ersetzt worden. Wenn »Brilliant« zu den Ausstellungen gehörte, die an vorderster Front das neue Phänomen international publik machten, so komprimierte es die Schau »Sensation«, die 1997 in Londons Royal Academy zu sehen war, für den heimischen Verbrauch. Als wäre es nicht schon sensationell genug gewesen, die neue Avantgarde in Englands verstaubtester Institution zu präsentieren, wurde eine weitere Sensation! durch die Einbeziehung von Marcus Harveys Gemälde der Kindermörderin Myra Hindley ausgelöst. Angeblich eine umfassende Bestandsaufnahme britischer Kunst, stammte die Ausstellung ausschließlich aus einer Quelle – der Saatchi Collection. Patron der Ausstellung war ein Werbemagnat, ihre Rezeption seitens der Kritik machte sich entweder als empörter Aufschrei genau der Boulevard-Medien, auf die der Ausstellungstitel anspielte, bemerkbar oder als patriotische Lobeshymne seitens ihrer edleren Pendants. Was aber sagte dieses Pop-Phänomen über die britische Kunst aus? Denn ein Großteil der bei »Sensation« vertretenen Arbeiten evozierte auf drastische, sogar auf pathologische Weise die alltäglichen Auswüchse urbaner Angst und die Überlebensstrategien des kleinen Mannes.

Die augenscheinliche Komplizenschaft zwischen der britischen Kunstszene und den Mächten des Hype – Portraits einzelner Künstler sind sogar in Werbekampagnen für Parfüm

oder Mode erschienen – wird durch den Künstler Damien Hirst verkörpert. Sein Teufelspakt mit der Star-Kultur geht auf Vorläufer wie Salvador Dali, Yves Klein, Piero Manzoni, Andy Warhol oder Gilbert & George zurück. Ebenso wie Hirst waren diese Künstler Meister des Glamour – begeistert von seiner schillernden Affinität zu bestimmten Formen der Massenkommunikation. Kunst war nicht mehr auf den Wirkungskreis der kulturellen Eliten beschränkt, sondern fand da draußen statt – im Äther. Warum, so würde Hirst vielleicht argumentieren, der als Coverboy für das radikal-schicke Jugendmagazin »Dazed and Confused« und als Macher von Plakatwerbung und TV-Spots in Erscheinung trat, sollten Super-Models und Pop-Stars das Monopol über die Jugendkultur einnehmen? »Ich habe jede Menge Zeit damit verbracht, über Werbung zu reden, als ich in der Art-School war (…) damals war es mir noch nicht klar, aber genau da kam die wirkliche Kunst her (…)«.[1] In einem kannibalistischen Pas de deux stiehlt die Werbung von der Kunst (bei Entstehung dieses Texts läuft gerade ein Verfahren gegen eine Automobilfirma, die ganz offensichtlich Gillian Wearings fotografische Technik übernommen hat), und die Kunst wiederum blickt auf die super-kondensierten, surrealistischen und oft selbstironischen Verführungsstrategien der britischen Werbung. Eine bekannte Anzeige für Erfrischungsgetränke (»Blackcurrant Tango«) wurde 1997 sogar in Londons ICA-Ausstellung »Assuming Positions« gemeinsam mit Kunstwerken ausgestellt.

In vielfacher Hinsicht ist diese geheime Verabredung, die als eine Art virulente Strategie verstanden werden kann, Ursache für die Vitalität und Kraft der heutigen britischen Kunstszene. Zugleich jedoch überdeckt sie die Komplexität dessen, was es eigentlich bedeutet, im England der neunziger Jahre zu leben, beziehungsweise die Bedingungen, unter denen Kunst produziert wird. Ebensowenig gibt sie Auskunft über die ästhetischen, philosophischen und politischen Anliegen, die in einer von völlig divergenten Ansätzen geprägten künstlerischen Praxis (die irreführenderweise als ein singuläres Phänomen verkauft wird) implizit enthalten sind.

Anstatt aus einer linearen Ansammlung ihrer konstituierenden Teile geformt zu sein, funktioniert eine Kultur eher wie ein Möbiussches Band. Sie besteht aus fluktuierenden Ereignissen, Bezeichnungen und Phänomenen wie eine Art gasförmiger Äther, der einen nicht minder flüchtigen Kern umgibt.[2]

Der flüchtige Kern, aus dem die Kunst, Musik, Mode, Politik, Literatur und die Technologien der britischen Kultur in den neunziger Jahren erwachsen, ist ein Konglomerat aus unterschiedlichen Ethnien und sozialen Schichten, die sich in einer Abfolge von manchmal schwierigen, oft kreativen Wechselbewegungen zwischen Tradition und Aktualität gegenseitig unterdrücken, aber auch befruchten, indem sie ihre jeweiligen Kulturen miteinander verbinden.

Viele Einwandererfamilien aus Bangladesch, die in der ersten Generation in London, Bradford oder Huddersfield leben, ziehen sich im Kampf um die Erhaltung

1 Damien Hirst: Interview in *Dazed and Confused*, September 1997.

2 Vergl. Gilda Williams: »Pause … Rewind … Press Play: reviewing British Art in the 1990s« in: *Art from the UK*, Sammlung Goetz, München 1997

ihrer Würde und kulturellen Identität angesichts eines offenen und oft gewalttätigen Rassismus auf den Fundamentalismus zurück. Unterdessen kombinieren ihre Söhne und Töchter Bollywood (Bombay-Kino) Soundtracks (die von Videos kopiert wurden), »Eurotrash« Disco- und Techno-Musik, um »Bhangra« zu kreieren, eine Musikrichtung, die in Clubs im ganzen Land gespielt wird. In manchen, wie beispielsweise dem Club Khali im Norden Londons, drücken Jungs ihre schwule Identität, in die Saris ihrer Mütter gehüllt, als hinreißende Transvestiten aus und erweitern Disco-Dance um traditionelle indische Tanzformen.

Die Stadtverwaltungen von Manchester bis hin nach Hackney machen Anstalten, ihre kurze Begegnung mit der Moderne auszulöschen, indem sie die Hochhäuser des sozialen Wohnungsbaus aus den sechziger Jahren in die Luft sprengen – zugunsten einer Rückbesinnung auf Villen im Pseudo-König-Edward-Stil, die in Shoppingcenter-inspirierten Vorortsiedlungen entstehen. Gleichzeitig ist eine Generation von Musikern (Oasis), Filmemachern (John Maybury) und DJs (DJ Inky) aus dem müllübersäten Asphaltdschungel der Trabantenstädte emporgestiegen, genährt und angetrieben von den gefährlichen Freiheiten eines Lebens im Sperrgebiet jenseits von Behörden- und Polizeipräsenz.

Chris Ofili, in Manchester geborener Künstler nigerianischer Herkunft, integriert Fotografien schwarzer Gesichter, die er Zeitschriften für Haarmode, Lokalzeitungen, Fanzines und politischen Pamphleten entnommen hat, in seine Gemälde. Indem er sie in britischen und internationalen Museen westlicher (und weißer) moderner Kunst ausstellt, setzt er hier der schwarzen Kultur ein Denkmal. Indessen hat Künstlerkollege Hirst mit seiner Weltpokal-Hit-Platte »Vindaloo« einen triumphalen Einzug in zwei Bastionen populärer Kultur – Fußball und Popmusik – erlebt, die ursprünglich keinerlei Berührung zur bildenden Kunst hatten. Inspiriert wurde der Titel des Projekts durch jene Currygerichte zum Mitnehmen, die vom typischen (britischen) Fußballfan sehr geschätzt werden. Wenn auch nur auf einer Stil- und Repräsentationsebene, sind diese interkulturellen Kollisionen sowohl für die Anwesenheit der Trennlinien zwischen sozialen Klassen regionaler und ethnischer Zugehörigkeit als auch für deren Auflösung symptomatisch.

Das vielleicht bemerkenswerteste neue Phänomen in der aktuellen britischen Kulturszene ist die deutliche Präsenz von Künstlerinnen. 1997 waren alle Kandidaten für den Turner Prize Frauen. Das lag keineswegs an einer Quotenregelung, sondern allein an der großen Vielfalt kraftvoller ästhetischer Strategien und konzeptueller Programme, die von Künstlerinnen beigetragen wurden. Durch die politische und theoretische Pionierarbeit der vorangegangenen Generation von Feministinnen waren junge Frauen in den neunziger Jahren in gewisser Hinsicht doppelt befreit. Durch politische Veränderungen innerhalb des allgemeineren sozialen und kulturellen Klimas konnten sie selbstbestimmt arbeiten; theoretische Paradigmenwechsel hatten das universale weiße männliche Subjekt aus seiner Vormachtstellung vertrieben. Die achtziger

Jahre bereiteten den Boden für ein Jahrzehnt, in dem junge Frauen bis zu einem bestimmten Grad auch von der Last der Repräsentation befreit waren. Viele ließen sich von den formalen Experimenten ihrer Vorläuferinnen anregen: Sie zelebrierten sie und bauten auf sie – in einer gänzlich unödipalen Weise. Besonders deutlich ist dies in Arbeiten von Künstlerinnen wie Lucy Gunning, Mona Hatoum, Gillian Wearing, Jane und Louise Wilson oder Sam Taylor-Wood auf den Gebieten der Installation und des Videos zu sehen.

Zur gleichen Zeit überspringen die aufstrebenden Künstlerinnen spielerisch die Trennlinie zwischen high/low, weiblich/männlich. Sarah Lucas beispielsweise kombiniert eine mackerhafte Attitüde und einen Blick für das Vulgäre in ihren Fotografien einer Bierdose als ejakulierender Penis; die professionelle »Bad Girl«/Anti-Heldin Tracey Emin bestickt fein säuberlich ein Zelt mit den Namen all derer, mit denen sie jemals geschlafen hat oder tritt als weiblicher Rowdie betrunken und pöbelnd bei einer TV-Podiumsdiskussion auf (hier, endlich, war das lebensechte Korrektiv zur glatten Verpackung von »Cool Britannia« durch die Medien und Politiker). Steckt womöglich auch der Bodensatz eines weißen Protestantismus hinter diesen antiästhetischen Haltungen, dieser Bilderstürmerei? Lucas demontiert die Repräsentationen weiblicher Schönheit mittels atemberaubend derber Platzhalter, beispielsweise ein Bückling und ein Paar von Melonen, die in einem T-Shirt hängen. Richard Billingham fotografiert seinen betrunkenen, ramponierten Vater in einer verwahrlosten Küche. Genres des Stillebens und des Portraits werden als Schauplätze des Elends auf eindringliche Weise rekonstruiert.

Der Impuls, Kunst einfach zu zerstören, ist ebensosehr ein Merkmal des britischen Institutionswesens wie dessen Fähigkeit, sie zu fördern. Während einerseits ein Netzwerk von Art-Schools unterstützt wird – die fraglos die Quelle der meisten wichtigen neuen Entwicklungen auf den Gebieten von Kunst, Design, Mode und Musik sind –, hat kürzlich ein Beamter aus der Kommunalverwaltung ein Werk zerstört, das als eine der wichtigsten öffentlichen Skulpturen des zwanzigsten Jahrhunderts gefeiert wurde. Im Oktober 1993 enthüllte Rachel Whiteread *House*, ihr außergewöhnlicher, ganz konkreter Geist – der Abguß eines viktorianischen Hauses im Londoner East-End in natürlicher Größe. Im Januar 1994 ordnete der Beamte an, es niederreißen zu lassen.

In Großbritannien ist der Konservativismus der Thatcher-Ära, in der erklärt wurde: »there is no such thing as society«, von einem polierten, medien- und marktbewußten neuen Stil des Sozialismus in Gestalt von Tony Blairs Labour Party abgelöst worden. Unter beiden Regierungen hat sich die Unterstützung für die Künste vom öffentlichen zum privaten Sektor hin verschoben; sowohl die Rechte als auch die Linke haben als Prioritäten für die Künste Geschäftssinn, Marketing-Fähigkeiten und öffentliche Verantwortung gesetzt.

Die forschen, verführerischen, medien- und marktorientierten Qualitäten eines Großteils der visuellen Kultur in England sind zweifelsohne ein Vermächtnis des Thatcherismus und

des wirtschaftlichen Booms der achtziger Jahre. In der Industrie haben sich gesamte Beschäftigungsmuster von der Produktion zur Dienstleistung, von Ausbildungsberufen hin zur Managementberatung verschoben. Die Sicherheit des Arbeitsplatzes schwand in einer Kultur der Auflösung, der Schleudersitze, befristeten Arbeitsverträge und gemischten Geschäftsbereiche. Private Beteiligungen wurden zur Entlastung städtischer oder kommunaler Verantwortlichkeiten eingesetzt. Doch das Medium »Cool Britannia« beziehungsweise das Phänomen der YBAs, das weltweit so erfolgreich vermarktet wird, ist nicht die Botschaft. Unternehmertum steht nur am Anfang der Geschichte.

1988 war Damien Hirst Student am Londoner Goldsmiths College. Er entdeckte ein leerstehendes Lagerhaus in den Londoner Docklands und verwandelte es in einen Ort für die Präsentation von eigenen Arbeiten und denen von Freunden beziehungsweise Mitstudenten.[3] Die Ausstellung »Freeze« besaß alle Komponenten, die die britische Kunstszene weiterhin so vital machen. Ein entscheidender Faktor war die Lage der Räumlichkeiten. Das Lagerhaus gehörte zu den zahllosen verlassenen Gebäuden, die in allen großen britischen Städten zu finden sind. Durch den Niedergang der Fertigungsindustrien zum ersten Mal funktionslos geworden, waren sie dann durch fehlgeschlagene Erschließungsvorhaben wie das verheerende Canary-Wharf-Projekt ein weiteres Mal sich selbst überlassen worden. Grundstücksplaner begriffen jedoch schnell das Vermarktungspotential von Ausstellungen aufstrebender Künstler. Die Kunst verlieh ihren frisch sanierten Gebäudekomplexen die Aura modischer New Yorker Lofts. Die Ausstellungseröffnungen zogen Sammler an, die auch potentielle Pächter waren. Die Künstler entdeckten ihrerseits schnell, daß diese Räume aufregend proportioniert, architektonisch reizvoll, jenseits institutioneller Beschränkungen und – kostenlos – waren.

In »Freeze« manifestierten sich noch zwei weitere Phänomene, die für die aktuelle Kunstszene zentral waren. Erstens, der bemerkenswert fruchtbare Boden, den die britischen Art-Schools lieferten. Zweitens, eine kooperative Grundhaltung, die mit Thatchers Laissez-faire-Libertinismus keinerlei Ähnlichkeit hatte.

Im Unterschied zu Atelier-Ausbildungen im New Yorker Stil oder den Kunstakademien auf dem europäischen Kontinent bieten britische Art-Schools »den warmen, trockenen Ort« (wie ihn sich Joseph Beuys vorgestellt hatte), an dem junge Leute, die oft sonst nirgendwo hinpassen, Bedingungen finden, um sich frei entfalten zu können. Einerseits eine Möglichkeit zur Flucht von der Familie, Klassenzugehörigkeit, Lernschwäche oder sexueller Orientierungslosigkeit, andererseits eine Bildungsstätte, die Kreativ-Begabten den letzten Schliff gibt, bringen Art-Schools auch Musiker, Filmemacher, DJs, Mode- und Grafikdesigner hervor. Sie florieren widersinnigerweise gerade deshalb, weil es in England nur einen winzigen aktuellen Kunstmarkt gibt. Um zu überleben, müssen die meisten Künstler und Künstlerinnen an irgendeinem Punkt in ihrer Laufbahn unterrich-

3 Steven Adamson, Angela Bulloch, Mat Collishaw, Ian Davenport, Dominic Denis, Angus Fairhurst, Anya Gallaccio, Damien Hirst, Gary Hume, Michael Landy, Abigail Lane, Sarah Lucas, Lala Meredith-Vulja, Richard Patterson, Simon Patterson, Stephen Park und Fiona Rae

ten – viele arbeiten halbtags und jonglieren zwischen Unterricht und Praxis. Die Entmaterialisierung des künstlerischen Gegenstands in den späten sechziger und siebziger Jahren (und die daraus resultierende Problematik seiner Eignung als konkrete Handelsware) sowie die weitgehende Unsichtbarkeit von Frauen innerhalb des Kunstmarkts bis in die späten achtziger Jahre hinein führten zu einer Revolution in der Unterrichtspraxis an den Art-Schools. Frauen, die auf den Gebieten der Medien- und Konzept-Kunst tätig waren, vermittelten Studenten und Studentinnen einen internationalen Ausblick und machten sie mit dem kunsthistorischen und philosophischen Diskurs sowie mit Fragestellungen auf den Gebieten der Psychoanalyse, Kulturtheorie und *identity politics* vertraut.

Anstatt den Markt zu scheuen, werden Studenten heute unter anderem dazu ermuntert, die Anzeigen zu studieren, die 50% jedes Kunstmagazines ausmachen, sich bei Ausstellungseröffnungen blicken zu lassen, sich einzumischen. Was ihnen beigebracht wird, ist die Ökonomie des Überlebens. Studenten lernen aber auch gegenseitig viel voneinander, während sie zusehends zu einer poly-nationalen Gruppe zusammenwachsen. Paradoxerweise hat vielleicht die Vermarktung von »Cool Britannia« und der wachsende Druck auf den Bildungssektor, ihre Einkünfte durch Studenten aus Übersee zu steigern, dazu geführt, daß die sogenannte britische Kunstszene multikulturell und auf selbstregenerierende Weise heterogen geworden ist und junge Künstler aus aller Welt anzieht.

Kämpfe an den Rändern einer Gesellschaft verursachen oft ein rücksichtsloses, destruktives Konkurrenzverhalten innerhalb der Generationen (und auch zwischen ihnen) oder rufen eine bittere Apathie hervor. Die Künstler, die 1988 zusammenkamen, um »Freeze« zu realisieren, standen für eine strategische Verschiebung. Sie umgingen die öffentlichen und privaten Galerien und halfen sich selbst. Ohne sich um Legitimierung durch eine Institution oder einen Kurator zu kümmern, organisierten sie ihr eigenes Event, indem sie als Kapitalbeschaffer/Publizisten/Techniker/Aufsichtspersonen/Verleger in Personalunion handelten. Auch die geographischen Koordinaten verschoben sich. Es reichte nicht mehr aus, die Cork Street einmal hoch- und runterzuflanieren, dem einstigen Herzstück des Kunstmarkts, oder öffentliche Kunsträume wie das ICA, Serpentine oder Whitechapel zu frequentieren. Nunmehr mußte man den Londoner Stadtplan zur Hand nehmen und sich in obskure Ecken von Brixton, Bethnal Green oder Rotherhite begeben – oder sich in den Zug nach Glasgow setzen. In den neunziger Jahren begannen sich Künstler-Ausstellungen zu häufen, die vielleicht für einen Monat, einen Tag oder eine Nacht in halbverfallenen Häusern, in erschlossenen, aber unverkauften Liegenschaften oder in den Wohnzimmern und Küchen von Künstlern stattfanden. Diese Rekonfiguration der Kunstwelt-Karte umfaßte auch die Umgehung von London selbst oder sogar der traditionellen, hegemonischen Kunst-Zentren wie New York und Düsseldorf/Köln. Junge Künstler in Schottland begannen Kontakte mit Gleichgesinnten in Kopenhagen, Mailand, Stock-

holm, Los Angeles, Nizza, Toronto und Estland zu knüpfen. Die gängigen Muster lösten sich auf, alles geriet auf interessante Weise ins Wanken.

Bezeichnend ist auch die Tatsache, daß die Räume, die sie für ihre Projekte wählten, die Grenzen des traditionellen weißen Kubus sprengten. Es handelte sich dabei um die Überbleibsel von fehlgeschlagenen Wirtschaftssystemen und Verschiebungen innerhalb der Bevölkerung, vom Triumph der Dienstleistungs- über die Herstellungsindustrien, des Supermarkts über den kleinen Eckladen. Ebenso wie in New York die Kunst-Laboratorien der Nachkriegszeit in leeren Lagerhäusern, den Auslagen von Geschäften, sogar Sex-Shops zu finden waren (Claes Oldenburgs *Store*, 1961, Co-Labs *A More Store*, 1980, Group Materials *Times Square Show*, 1980) kann gegenwärtig die experimentierfreudigste junge Kunst in England regelmäßig in einem ehemaligen Wettbüro (City Racing), einer winzigen Sozialwohnung (Cabinet Gallery), einem Schulsaal (Beaconsfield) oder im Obergeschoß eines Pub (The Approach Tavern) besichtigt werden. Off-Projekte haben zum Beispiel in einem Psychiatrischen Krankenhaus (*Care and Control*, Rear Window, 1995), einem leerstehenden Planungsbüro aus den siebziger Jahren (*Cocaine Orgasm*, 1995) und einer öffentlichen Toilette (*Hackney Public Conveniences*, 1996) stattgefunden. Noch bevor wir sie als Betrachter zu Gesicht bekommen, ist die künstlerische Arbeit bereits in den Geschichten der Stadt gerahmt. Die Geister früherer Verwendungen schweben über unseren Begegnungen mit dem Neuen. Zugleich sind die Räume frei von institutionellen Vorgeschichten, Verfahren oder Hierarchien. Jede Ausstellung ist eine Art Kunstwerk, das – entwickelt und installiert von Künstlern – vom Austragungsort (selbst ein »Readymade«) bestimmt wird.

Gab es in den achtziger Jahren die Tendenz, eine Generation über ein einziges Medium zu definieren – zum Beispiel die britische Skulptur oder die deutsche Malerei – zeigt sich in den neunziger Jahren eine wahre Explosion unterschiedlicher Medien, wobei Künstler alle Möglichkeiten einbeziehen: von der Gestaltung konkreter Environments, bis hin zur Entwicklung unsichtbarer Netzwerke. Durch diese eklektische, polyphone Mixtur hindurch bleibt jedoch als konstantes und vielleicht überraschendes Phänomen die Malerei bestehen.

Die heutigen Maler sind talentierte moderne Historiker und schöpfen aus den formalistischen Programmen der Nachkriegszeit, in deren Folge die Malerei um Mittel wie Prozeßhaftigkeit, Materialität, zeitliches und räumliches Erleben erweitert wurde. In Nachahmung ihrer Pop-Art-Vorläufer schreiben sie diesen Strategien jedoch die Zeichen und Bilder des modernen Lebens ein. Heute sind aber aller Wahrscheinlichkeit nach die Produkte und Technologien, die sie zitieren, Gegenstände aus zweiter Hand. Betrachtet man die Gemälde von Keith Coventry, Peter Doig, Gary Hume, Jason Martin, Martin Maloney, Richard Patterson oder Fiona Rae, können wir in einer unheiligen, aber möglicherweise erlösenden Allianz zwischen moderner Malerei und Abbildern, Farben und Sujets schwelgen, die von den Supermodels, der vibrierenden

Idiotie eines Bildschirmschoners oder der Tapete in der Wohnung eines städtischen Hochhaus-komplexes inspiriert wurden. »(…) Bilder sind nicht länger Repräsentationen, sondern ein echtes Stück Leben.«[4] Dieses Treibgut der Massenkultur wird subjektiviert, im Netz gelebter Erfahrung eingefangen und für einen Augenblick zu einer vorläufigen Schönheit sublimiert, die anfällig ist für Unfälle. Seine Fragilität kontrastiert insofern mit Pop Art, als es nichts von dem grellen Optimismus, dem Liebesverhältnis zur Technologie, dem kämpferischen Angriff gegen die Solipsismen des Abstrakten Expressionismus zur Schau stellt. Die Gemälde dieser Genera-tion, die die Strategien der Vergangenheit nicht zurückweisen, sondern sich aneignen, bergen Zweifel und sind von Dunkelheit gesäumt. Verwackelte Linienführung, Pastelltöne, die rekon-valeszent wirken, halbherzige optische Täuschungen, inkongruente Erscheinungen vermitteln eine beklemmende Aura brüchiger Übereinkunft.

Andere machen sich einen »flaneurhaften« Optimismus zu eigen und schöpfen – da sie die Lektionen der Concept Art gelernt haben – aus der Sprache, der besonderen Situation und den unendlichen Möglichkeiten, die die virtuellen Netzwerke der Kommunikationstechnolo-gien bieten. Wir befinden uns vielleicht an der Schwelle zum 21. Jahrhundert, aber ihre Projekte haben mit High-tech wenig zu tun. Die Technologien, die sie wählen, sind weder das Internet noch die CD-Rom, sondern das Telefon, die Post, Kleinanzeigen, Toiletten-Graffiti, selbst die Buschtrommel, über die sich Klatsch und Gerüchte vermitteln. Diese Aktionsfelder sind preis-günstig, wenn nicht sogar kostenlos, lassen sich schnell in Besitz nehmen und sind wie geschaf-fen für virulente Interventionen. Die Strategien von Künstlern und Künstlerinnen wie Anna Best, Adam Chodzko, Jeremy Deller, Douglas Gordon, Liam Gillick, Simon Patterson und Giorgio Sadotti oder Matthew Higgs aktive Mail-Art-Plattform, *Imprint 93*, demonstrieren ein komple-xes Anliegen: etwas in Gang zu setzen, dies ohne Ressourcen zu tun und den Kunstgegenstand mittels eines emanzipatorischen Akts zu entmaterialisieren. Die Reichweite ihrer Aktivitäten ist eher mikrokosmisch als makrokosmisch. Sie operieren innerhalb einer bewußt einfach gehalte-nen Sphäre, die in den veränderlichen, vielwertigen Interaktionen eines alltäglichen gesell-schaftlichen Austausches verortet ist. Ihre Interventionen in die Organisationsprinzipien der Kartographie (Pattersons *Great Bear*), gesellschaftlicher Organisationen (Dellers Fan-Clubs) und Register (Paul Nobles *Imprint 93 – Arse-Tits bucz*) realisieren das gesamte komische Po-tential der Concept Art.

Es lassen sich auch Genealogien zurückverfolgen. Eine mag beispielsweise zwischen dem tautologischen Projekt eines Künstlers wie Joseph Kosuth (die in sich selbst kreisende Logik der Autonomie, die in einem Stuhl, der neben die Fotografie eines Stuhls plaziert ist, die wiederum neben eine Definition des Stuhls gehängt wurde, implizit ist) und Ceal Floyers Projektion eines Bildes von einem Lichtschalter in einem dunklen Raum be-stehen. Auf der anderen Seite kann Mary Kellys *Post Partum Document* (1976), in

4 Francesco Bonami, Gary Hume, Bonnefantenmuseum, Maastricht 1996

22

dem der Versuch unternommen wird, das Unbewußte durch tägliche, quasi-statistische Aufnahmen der Künstlerin und ihres Babys (inklusive schmutziger Windeln) zu visualisieren, vielleicht als Vorläufer einer Vielzahl von tagebuchartigen oder sogar forensischen Arbeiten betrachtet werden. Tracey Emin beispielsweise kombiniert Bild und Text in ihren bekenntnishaften Zeichnungen und Stickereien über ihre existentiellen Tage in der Hölle; Abigail Lane kompiliert Beweismaterial, Abdrucke, Spuren, Leichen, wahre und unwahre Geschichten.

Eine Subjektivität, die frei ist von expressionistischen Elementen, hat im Medium des Videos ein potentes Vehikel gefunden. In einer invertierten Erweiterung der phänomenologischen Beziehungen, die vom Minimalismus eingebracht und durch die Installationskunst auf dramatische Weise umgesetzt wurden, erzeugt das pechschwarze Umfeld der Video-Installation einen kurzfristigen Orientierungsverlust, ein Gefühl der Schutzlosigkeit, das noch gesteigert wird durch das Unbehagen, nicht zu wissen, wer sich sonst noch im Raum befindet. Ein visuelles und akustisches Environment hüllt den Betrachter in eine Narrative oder eine Abfolge von Bildern und Sinneswahrnehmungen ein. Von den piktoralen Konventionen des Fernsehbildschirms befreit, können Künstler die menschliche Figur in einem Maßstab von eins zu eins und in Echtzeit projizieren. Sie können sogar noch weiter gehen, indem sie die Oberfläche des Körpers durchdringen und uns in seine inneren Höhlen oder seine mentalen Räume führen. Mona Hatoums *Corps Etranger* (1994) holt die Linse, unser gieriges Auge, in ihren Körper hinein und navigiert sie durch jede Öffnung hindurch. Durch diesen Akt des Eindringens, der zugleich abstoßend und faszinierend ist, hebt sie im wahrsten Sinne den Körper als ein bindendes Konzept auf. Willie Doherty löst in seiner Arbeit *The Only Good One is a Dead One* aus dem Jahr 1993 Repräsentationen des Kriegs, der Geschichte, der Politik auf, indem er den Betrachter auf einer Art Roadmovie durch den Geist eines Menschen mitnimmt, der sowohl ein Terrorist als auch ein Opfer sein könnte.

Dem Raffinement der neuen reprografischen Technologien entspricht ihre Allgegenwart. Der Videorecorder ist ein Haushaltsgerät, das vor Braut und Bräutigam schwebt, Babys erste Schritte oder den Familienurlaub einfängt. Im gleichen Maße wie sich die aktuelle Fotografie gezielt amateurhaft gibt – etwa Schnappschüsse und Polaroids, die mit Reißzwecken angepinnt sind – wird in einem Großteil der jüngsten Video-Kunst auffällig oft der häusliche Rahmen in Szene gesetzt. Diese Innenansichten, aufgenommen im Wohnzimmer eines Freundes, einem Schlafzimmer oder Badezimmer (ob es sich dabei nun um ein luxuriöses Loft oder ein schäbiges Appartment handelt), lösen unbewußt eine Art Wiedererkennungseffekt aus und nivellieren den Glamour des projizierten Bildes.

In Lucy Gunnings Film über eine Frau, die Pferde verkörpert (*The Horse Impressionists*, 1996) bis hin zu Sam Taylor-Woods bemerkenswerter Serie enigmatischer Monologe oder inszenierter Begegnungen werden zwei Zonen erkennbar: eine private, imaginäre der verborge-

nen Sehnsüchte und Triebe (wie sie bewußt oder unbewußt ausagiert und artikuliert werden) sowie die Sphäre sozialer Beziehungen zwischen Liebhabern, Familien, Freunden und Fremden: zwischen der Künstlerin und ihrem Publikum.

Eine weitere quintessentiell-moderne Form ist die des Films. Im Zuge eines postmodernen Ethos des Eklektizismus und der Aneignung, haben einige Künstler und Künstlerinnen direkt aus dem Werk ihrer Vorbilder gestohlen. Sie laden uns beispielsweise ein, in äußerster Zeitlupe Hitchcocks *Psycho* (als 24-Stunden-Fassung) anzusehen (Douglas Gordon, 1993) oder sämtliche Clips aus allen Filmen über Kinder, die besessen sind, übernatürliche Kräfte oder seherische Fähigkeiten haben (Susan Hillers *Wild Talents*, 1997). Oder aber sie arrangieren vielleicht in chronologischer Abfolge alle cineastischen Momente, in denen die Kunstwelt thematisiert wird, und schneiden sie mit einem ganzen Archiv an Film-Einbrüchen zusammen (*Do you really want it that much?...More!*, Eichelman, Faiers, Rust, 1997). Szenarien, Gesten, Blicke werden zu elastischen, dekontextualisierten, faszinierenden Phantasmen, in denen wir uns verlieren können. Der Betrachter wird selbst zu einem Besessenen – freischwebend in einem Moment, der irgendwo zwischen »jouissance« und Batailles Vorstellung eines »kleinen Todes« liegt. Zugleich bleibt aber die Distanz bestehen, die es uns ermöglicht, das lumineszierende Fragment an unser inneres Auge emporzuhalten und es minutiös zu untersuchen.

Diese Wechselbeziehung zwischen Innen und Außen, an der man als Betrachter teilhat, wird von Künstlern erzeugt, die formal auf einem Gebiet arbeiten, das noch immer als »Skulptur« bezeichnet werden kann. Aber statt eines Gegenstandes handelt sich um eine *materielle Welt*, die Künstlerinnen wie Mona Hatoum oder Angela Bulloch schaffen. Ihre Environments sind künstliche Konstrukte, und doch sind sie spürbar real in ihrer Artikulation der Phänomenologie von Raum und Zeit. Doch neben sinnlichen Eindrücken von Schatten und Licht, Hitze, Textur und künstlerischem Aufbau, die deren Installationen vermitteln, spielt Hatoum zusätzlich auf Tabus und Phobien an und greift so über subjektive Erfahrung hinaus in die Politik der (Affekt-) Verlagerung. Bullochs nachgiebige, interaktive Räume wirken auf einer intuitiven Ebene spielerisch und befreiend, indem sie eine Art warmen, ungeformten Infantilismus hervorrufen. Und doch birgt ihre Arbeit auch eine dunkle Seite, die von unsichtbaren Regelwerken und Systemen oder offenen Verboten bestimmt wird.

Der Körper erscheint in der aktuellen Kunst entweder als abwesende Präsenz, die auf Schritt und Tritt impliziert wird oder in extrem figurierter bzw. disfigurierter Gestalt in unterschiedlichen Ausprägungen, die US-Künstler wie Robert Gober, Charles Ray oder Paul McCarthy in Erinnerung rufen. Die polymorphen Perversitäten der Schaufensterpuppen der Chapman-Brüder, aus denen Genitalien nur so herauswuchern, oder Abigail Lanes männliche Figur (*Misfit*, 1994), die – nackt von der Hüfte abwärts – nonchalant auf dem Galerieboden drapiert ist und scheinbar den Ausblick genießt, vermitteln ein überwältigendes Gefühl des

Unheimlichen. Ein anthropomorpher Wiedererkennungseffekt wird ausgelöst und sogleich durch surreale Verschiebungen gestört. Gelegentlich erscheint uns der Körper auch als Geist, angedeutet etwa bei Rachel Whitereads durchsichtiger, honigfarbener Matratze, die zusammengesunken an der Wand liegt, oder in Gestalt eines invertierten Hohlraums – Abguß eines Waschbeckens in strahlend weißem Gips. Whiteread wechselt das Register von Absurdität zu schmerzlicher Prägnanz.

Die Kunst, die in den neunziger Jahren in Großbritannien entsteht, kann weder als Bewegung oder als Produkt klar definiert werden. Vielleicht entspringt dieses heterogene Phänomen jedoch einer bestimmten Lebenshaltung. Statt Transzendenz oder Revolte: Pragmatismus, Vergnügen, ein kulturelles Erbe des Ikonoklasmus, gepaart mit einer Leidenschaft für Schönheit und konkrete Teilnahme, als Herangehensweisen an die Realität. Einem akuten Sinn für die sozialen und politischen Ungerechtigkeiten, die in England herrschen, gegen die jedoch nicht mit großen Entwürfen angegangen wird, sondern mit den Mitteln der Reflexion, des Engagements und der Gruppendynamik.

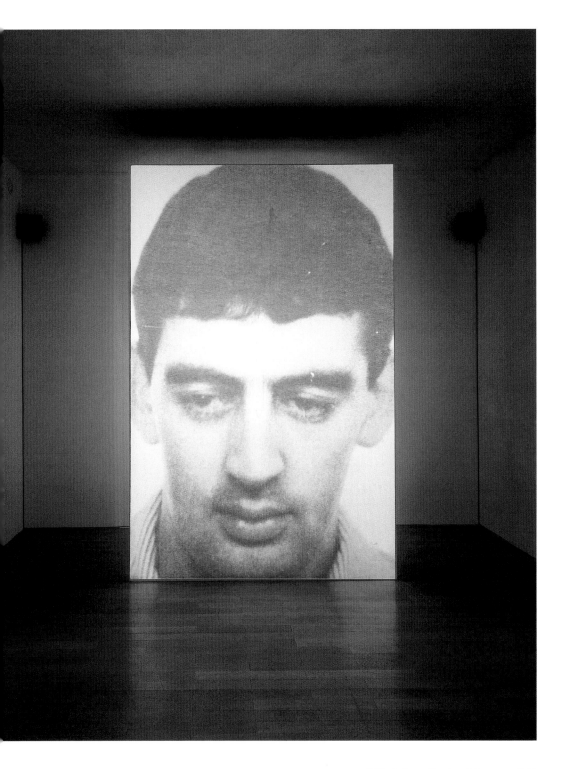

Willie Doherty, They're all the same, 1991

Willie Doherty, Fixed Parameter, 1989

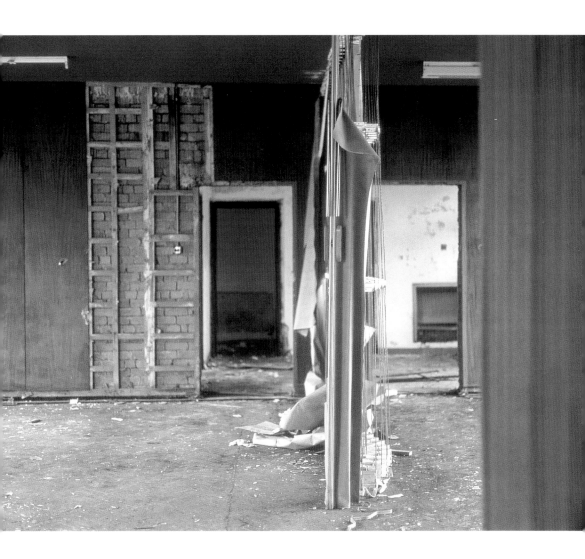

Willie Doherty, Disclosure II (Invisible Traces), 1996

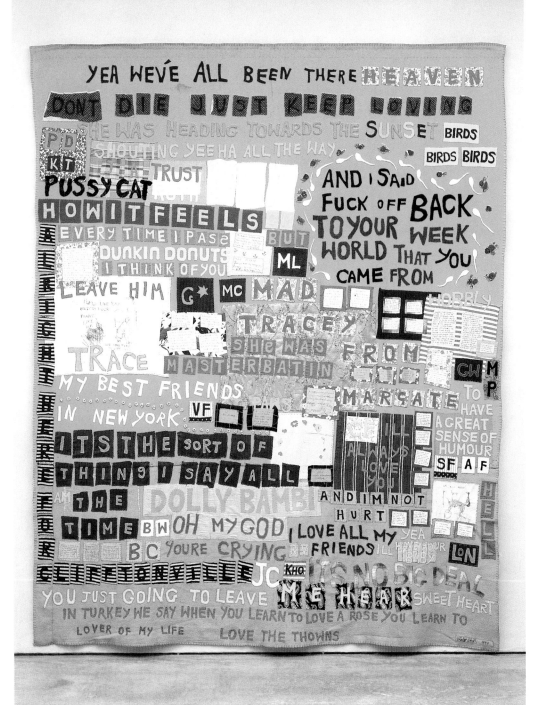

Tracey Emin, Mad Tracey from Margate, Everyone's there, 1997

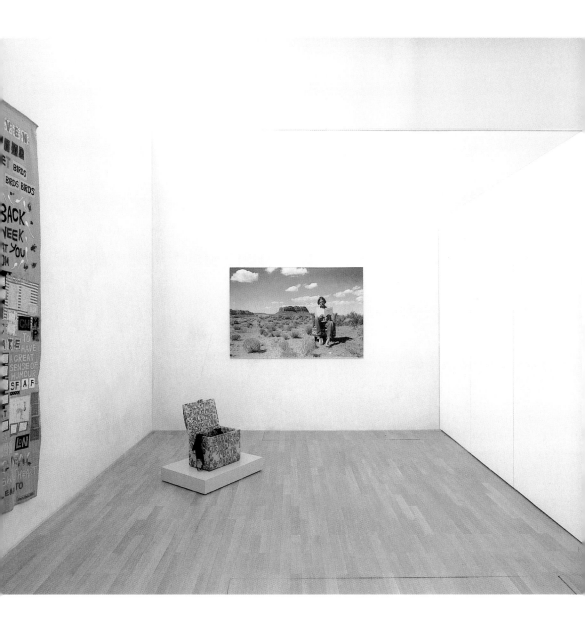

Tracey Emin
Mad Tracey from Margate, Everyone's there, 1997
All the Loving (Underwear Box), 1982–1997
Monument Valley (Grand Scale), 1995

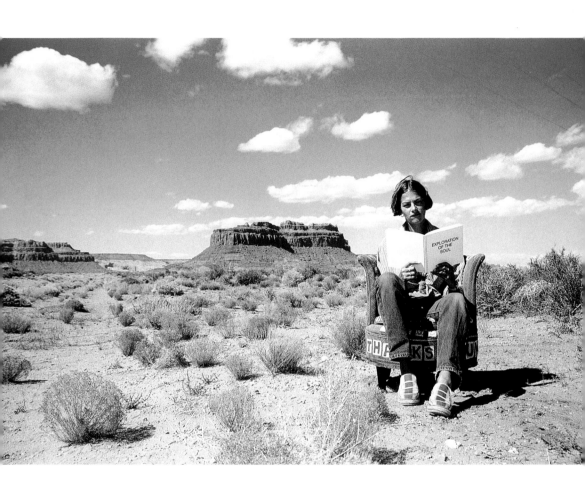

Tracey Emin, Monument Valley (Grand Scale), 1995

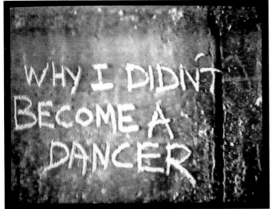

Tracey Emin, Why I Never Became a Dancer, 1995 33

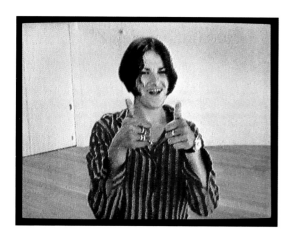

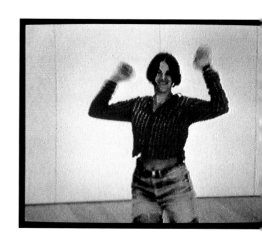

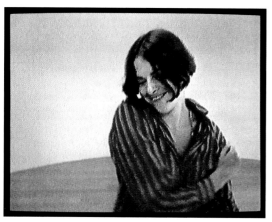

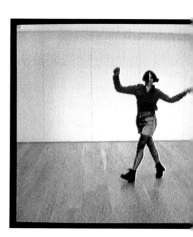

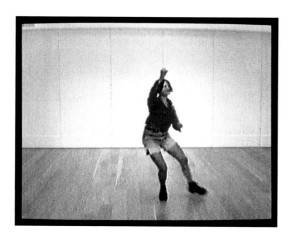

Tracey Emin, Why I Never Became a Dancer, 1995

Iwona Blazwick

Brilliant!!! Sensation!!! These tabloid style epithets are the titles of two exhibitions which in their conception and packaging delivered a potent fusion of art, marketing, anthropology, celebrity and patronage. They were among a swelling tide of exhibitions throughout the 1990s, that announced and confirmed the rebirth of 'Cool Britannia', the artistic reprise to the 1960s pop culture boom immortalised in Richard Hamilton's *Swingeing London. Brilliant* presented at the Walker Art Centre in 1995, brought the yBas (young British artists) to America. Perhaps for the first time contemporary British culture found itself at the end of the anthropologist's binoculars, suitably exoticised. Jake and Dinos Chapman's shiny plastic effigy of Stephen Hawking gazed down from his wheelchair onto museum guards dressed as Pearly Kings and Queens (characters once adopted by London's impoverished East Enders, now a tourist attraction) or Mohican style punks. Ye Olde England of monarchy and bowler hatted gents had been replaced with its stereotypical other, inspired by Charles Dickens and Malcolm McLaren. If *Brilliant* was among the front line of exhibitions promoting the new phenomena internationally, *Sensation*, shown in London's Royal Academy in 1997, consolidated it for home consumption. As if it wasn't sensational enough to present the new avant-garde within Britain's stuffiest institution, another Sensation! was triggered by the inclusion of Marcus Harvey's painting of child killer Myra Hindley. Ostensibly a comprehensive survey of British art the exhibition came entirely from one source – the Saatchi Collection. Its patron, an advertising magnate, its critical

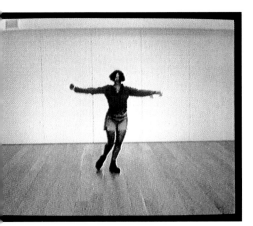

reception, either a chorus of outrage from the very tabloid newspapers its title mimicked or a swell of patriotic boosterism from their upmarket equivalents. What did this pop phenomena say about British Art? For much of the work included in *Sensation* is a poignant, even pathological evocation of an everyday dystopia of urban angst and grass roots survival strategies.

The British art scene's apparent complicity with the forces of hype – portraits of individual artists have even appeared in perfume and fashion ad campaigns – has been personified by the

artist Damien Hirst. His faustian pact with celebrity culture has a genealogy in figures such as Salvador Dali, Yves Klein, Piero Manzoni, Andy Warhol and Gilbert and George. Like Hirst these artists became masters of glamour, delighting in its dazzling propensities for a certain kind of mass communication. No longer the province of the cultural elites, art could be out there, in the ether. Why should super models and pop stars have the monopoly on contemporary youth culture Hirst might argue, appearing as coverboy for the radical chique youth magazine *Dazed and Confused* or making billboard and tv ads. "I spent a hell of a lot of time talking about commercials when I was at art school…I didn't realise it at the time, but that was where the real art was coming from…"[1] In a cannibalistic pas de deux advertising steals from art – there is at the time of writing a law suit against a car company that has quite openly stolen Gillian Wearing's photographic technique – and art looks to the super condensed, surrealist and often self-parodying seductions of British advertising. One renowned fizzy drinks ad (Black-currant Tango) was even exhibited alongside works of art at London's ICA's *Assuming Positions* in 1997.

In many ways this willful collusion, what might be understood as a kind of viral strategy, lies at the source of the energy and strength of the contemporary British art scene. Yet at the same time it obfuscates the complexities of what it is to live in Britain in the 1990s, the conditions in which art is being produced. Neither can it account for the aesthetic, philosophical and political ambition implicit in an entirely diverse range of practices, misleadingly promoted as a single phenomenon.

"A culture, rather than being formed by a linear accumulation of its constituent parts, is more like a Mobius strip of fluctuating events, names and phenomena, a sort of gaseous ether around an equally volatile core."[2] The volatile core that generates the art, music, style, politics, literature and technologies of British culture in the 1990s is a conglomerate of ethnicities and classes who may suppress, borrow from or synthesise each other's cultures in a series of sometimes painful, often creative moves between tradition and contemporaneity.

Many first generation Bangladeshi immigrant families living in London, Bradford or Huddersfield fight to retain their dignity and cultural identity in the face of overt and often violent racism, by retreating into fundamentalism. Meanwhile their sons and daughters fuse Bolly-wood (Bombay cinema) sound tracks (lifted from videos) "Eurotrash" disco and techno music to create Bhangra, played in clubs up and down the land. In some, such as Club Khali in north London, boys assert their gay identity by dressing up in their mother's saris, fabulous transvestites, disco dancing traditional Indian moves.

City councils from Manchester to Hackney are preparing to demolish their brief encounters with Modernism by detonating 60s built high rise public housing, in favour of a return to fake Edwardian villas in strip mall inspired suburban develop-

1 Damien Hirst, Interview, *Dazed and Confused*, September, 1997

2 Gilda Williams, *Pause… Rewind…Press Play. Reviewing British Art in the 1990s*, in: *Art from the UK*, Sammlung Goetz, Munich, 1997

ments. At the same time a generation of musicians (Oasis), film makers (John Maybury) and DJs (DJ Inki) have risen from the rubbish strewn, elevated concrete decks of the cities in the skies, nurtured and inspired by the perilous freedoms of living in what were no-go zones for council officials and the police force.

Manchester born of Nigerian parents Chris Ofili incorporates photographs of black faces taken from hair styling magazines, local papers, fanzines and political pamphlets into his paintings. By exhibiting them in British and international museums of western (and white) modern art he creates a black hall of fame. Meanwhile fellow dot painter Hirst made his triumphant entry into two bastions of popular culture also traditionally at far remove from fine art terrain – football and pop – with his World Cup hit record, *Vindaloo* – inspired by the take away curries much loved by the typical football fan. If only at the level of style and representation these cross cultural collisions are symptomatic, both of the presence of dividing lines of class, region and ethnicity, and their erosion.

Perhaps the most striking new presence in contemporary British culture is that of women artists. In 1997 all the Turner Prize candidates were women. No quotients here, just the undeniable fact of a powerful and diverse range of aesthetic strategies and conceptual agendas contributed by women artists. It was through the pioneering political and theoretical work of a previous generation of feminists that young women in the 1990s were to some extent doubly liberated. Political change within the broader social and cultural climate allowed them to work; theoretical shifts dislodged the single universal white male subject. The 1980s augured in a decade whereby young women were to some extent also liberated from the burdens of representation. Many found inspiration in the formal experiments of their forebears and in a thoroughly non-Oedipal way celebrated and built on them, most notably, as in the work of Lucy Gunning, Mona Hatoum, Gillian Wearing, Jane and Louise Wilson or Sam Taylor-Wood, in the areas of installation and video.

At the same time emerging women artists dance around the high/low, girl/boy divide – Sarah Lucas combines a laddish brio and an eye for the vulgar in her photographs of a can of lager as ejaculating penis; professional Bad Girl/anti-heroine, Tracey Emin, neatly embroiders a tent with the names of everyone she has ever slept with, or appears on a television panel discussion, drunk and abusive as a fully fledged lager-lout. (Here at last was a fiesty corrective to the media and the politicians' slick packaging of 'British Culture'). Is there also a residual White Anglo Saxon Protestantism that informs such anti-aesthetic stances, such iconoclasm? Lucas dismantles representations of female beauty with stunningly crude stand ins including a kipper and a pair of melons suspended in a T-shirt. Richard Billingham photographs his father, drunk and disheveled in a squalid kitchen. Genres of still life and portraiture are powerfully reconstituted as sites of abjection.

An impulse to simply destroy art is as much a feature of institutional Britain as its ability to nurture it. Whilst supporting a network of art schools which are without question the source of the most important new developments in art, design, fashion and music – one local government authority recently destroyed what had been celebrated as one of the most important public sculptures of the 20th century. In October 1993, Rachel Whiteread unveiled *House* – her extraordinary concrete ghost, a full scale cast of a Victorian house in London's East End. In January 1994, the local authority had it demolished.

Britain has made a transition from the Thatcherite brand of conservatism that announced "there is no such thing as society" to a polished media and market conscious new style of socialism with Tony Blair's Labour Party. Both governments have shifted support for the arts from the public to the private sectors; both left and right have emphasized business acumen, marketing skills and public accountability as priorities for the arts.

The brash, seductive, media conscious, market wise characteristics of much of British visual culture are no doubt a legacy of Thatcherism's roaring 80s. Entire patterns of employment shifted from manufacturing to services, from vocational professions to managerial consultancies. Job security vanished in a culture of dispersal, of hot desks, short term contracts and 'mixed portfolios'. Private interests mitigated against civic or communal responsibility. But the medium of Cool Britannia, of YBAs, so successfully promoted world wide, is not the message. Entrepreneurship is just the beginning of the story.

In 1988 Damien Hirst was a student at the Goldsmiths College in London. He found an empty warehouse in the Docklands of London and made it the site for an exhibition of his work and that of his friends, fellow students.[3] *Freeze* had all the basic components of what continues to make the British art scene so energetic. The first, crucial element was its site. The space was one of any number of abandoned buildings common to all large British cities, left empty the first time round by the death of the manufacturing industries; abandoned the second time round by failed development schemes like the disastrous Canary Wharf. Property developers were quick to realise the marketing potential of exhibitions of emerging artists. The art gave their newly converted properties the aura of fashionable New York lofts. The opening views attract collectors who are also potential tenants. Artists were quick to realise that these spaces were dramatically proportioned, architectonically compelling, outside institutional restrictions, and free. *Freeze* was also a manifestation of two other phenomena central to the contemporary art scene; first, the remarkably fertile ground provided by British art schools; secondly, an ethos of co-operation totally at odds with Thatcher's laissez-faire libertarianism.

Distinct from New York style atelier apprenticeships, or the Academies of Continental Europe, British art schools are 'the warm dry place' (as once envisioned

3 Steven Adamson, Angela Bulloch, Mat Collishaw, Ian Davenport, Dominic Denis, Angus Fairhurst, Anya Gallaccio, Damien Hirst, Gary Hume, Michael Landy, Abigail Lane, Sarah Lucas, Lala Meredith-Vulja, Richard Patterson, Simon Patterson, Stephen Park and Fiona Rae

by Joseph Beuys) that provide the conditions in which young people who often can't fit anywhere else, can come and thrive. As much an escape from family, class, dyslexia or sexual confusion as a finishing school for the creatively gifted, art schools also produce musicians, film makers, DJs, fashion and graphic designers. They thrive as a perverse result of Britain's tiny contemporary art market. In order to survive most artists must teach at some point in their careers and many choose to work part time, balancing teaching and practice. The dematerialisation of the object of art in the late 1960s and 70s and a concommitant lack of commodities for exchange in the marketplace; and the invisibility of women in the art market until the late 1980s, led to a revolution in art school teaching. Women working in a range of media, conceptual and time based practitioners gave students an international perspective and an awareness of discourse – not just art historical and philosophical – but in the areas of psychoanalysis, cultural theory and identity politics.

Instead of a coy resistance to the marketplace, students today are also encouraged to scan the ads that make up 50% of any art magazine, to hang out at private views, to get involved; what they are taught to understand are the economics of survival. Students get to learn a lot from each other as they become an increasingly poly-national group. Perhaps paradoxically it is the promotion of 'Cool Britannia' and the increasing pressure on the education sector to generate income from overseas students that has led to the so-called British art scene becoming self-renewingly heterogeneous, drawing young artists from different parts of the world.

Struggle at the margins can often breed either a sharp-elbowed, mutually undermining competition among or between generations, or a bitter apathy. The artists that came together to make *Freeze* in 1988 marked a significant strategical shift; they bypassed the public and the private galleries and helped themselves. Seeking no legitimation from institution or curator, they organised their own event acting as fund-raisers/publicists/technicians/invigilators/publishers. And the geographical co-ordinates changed too. It was no longer enough to cruise up and down Cork Street, the former heartland of the marketplace, or to check out public art spaces like the ICA, the Serpentine or the Whitechapel. No, you had to get your map of London out and navigate your way to obscure corners of Brixton, Bethnal Green or Rotherhithe. Or get on the train to Glasgow. The 1990s saw a proliferation of artist-organised shows which might appear for a month, a day, or a one-night stand, in semi-derelict buildings, developed but unsold properties, or artists' own sitting rooms and kitchens. This reconfiguration of the art world map also involved bypassing London itself, or indeed the traditional hegemonic centres of New York and Dusseldorf/ Cologne. Young artists in Scotland began to make contact with like-minded practitioners in Copenhagen, Milan, Stockholm, Los Angeles, Nice, Toronto and Estonia. Everything went interestingly out of register.

It is also significant that the spaces they have co-opted are anything but white cubes. They are the remnants of failed economies, population shifts, the triumph of services over manufacturing, of the superstore over the corner shop. Just as in New York the laboratories of post-war art were in empty warehouses, storefronts, even porn shops (Claes Oldenburg's *Store*, 1961, Co-Lab's *A More Store*, 1980, Group Material's *Times Square Show*, 1980) the most experimental work in Britain can now be seen in a defunct betting shop (City Racing), a tiny public housing apartment (Cabinet Gallery), a school hall (Beaconsfield) or the top room of a pub (The Approach Tavern). Off-projects have appeared in a mental hospital (*Care and Control*, Rear Window, 1995), an empty 70s open plan office (*Cocaine Orgasm*, 1995) and a toilet (*Hackney Public Conveniences*, 1996). The work is framed before we even see it, in the stories of the city. The ghosts of former usages hover around our encounters with the new. At the same time, the spaces have no institutional histories, procedures or hierarchies. Each exhibition is a kind of work of art, conceived and installed by artists, inflected by the venue, which is itself a 'ready-made'.

If there was a tendency in the 1980s to define a generation by a single medium – British sculpture, German painting – the 1990s has seen an explosion of media, with artists encompassing anything from the creation of concrete environments, to generating invisible networks. Through this eclectic, polyphonic mix, a constant and perhaps surprising presence does nonetheless remain – that of painting.

Contemporary painters are adept modern historians, drawing on the formalist agendas of the post-war period which expanded painting into the fields of process, materiality, temporal and spatial experience. However, echoing their pop art predecessors, they inscribe these strategies with the signs and images of modern life. This time around, the products and technologies they quote are likely to be used goods. Looking at the paintings of Keith Coventry, Peter Doig, Gary Hume, Jason Martin, Martin Maloney, Richard Patterson or Fiona Rae, we may revel in an unholy but perhaps redemptive alliance between modernist painting and images, colours and subjects inspired by supermodels, the vibrant idiocy of a computer screen saver, the wallpaper in a high rise council flat. "(...) images are no longer representations, but real chunks of life".[4] This flotsam and jetsam of mass culture is subjectivised, caught in the net of lived experience and momentarily sublimated into a tentative and accident prone beauty. Its fragility contrasts with pop art in that it displays none of the brash optimism, the love affair with technology, the combative slap in the face of Abstract Expressionism's solipsisms. The paintings of this generation, which do not reject but appropriate the strategies of the past, are full of doubt, edged with darkness. Wobbly slippages of line, pastel colours that have the look of being convalescent, half-hearted optical illusions, incongruous presences, add an air of anxious accomodation.

4 Francesco Bonami, Gary Hume, Bonnefantenmuseum, Maastricht, 1996

A flaneurish opportunism is adopted by others who, having learnt the lessons of conceptual art, draw on language, situation and the infinite possibilities offered by the virtual networks of communications technologies. This may be the dawn of the 21st century, but theirs is not a high-tech affair. The technologies of choice are not the internet or the CD-ROM but the telephone, the post, the small ads, toilet graffiti, even the bush telegraph of gossip and rumour. These sites are cheap if not free, fast to annex and ripe for viral intervention. The strategy of artists such as Anna Best, Adam Chodzko, Jeremy Deller, Douglas Gordon, Liam Gillick, Simon Patterson and Giorgio Sadotti; or Matthew Higgs' ongoing mail art platform, Imprint 93, demonstrate a combined desire: to make something happen; to make it with no resources; and to yet again dematerialise the art object as an emancipatory project. Their scope of activity is micro rather than macro; they operate within a low-key realm located in the shifting, multivalent interactions of everyday social exchange. Their interventions in the organising principles of mapping, (Patterson's *Great Bear*), social organisations (Deller's fan clubs), indexes (Paul Noble's *Imprint 93 – Arse-Tits bucz*) also realise the full comic potential of conceptual art.

There are genealogies to trace. One might lie between the tautological project of an artist such as Joseph Kosuth – the circular logic of autonomy implicit in a chair placed by a photograph of a chair hung alongside the definition of a chair – and Ceal Floyer's projection of an image of a light switch in a dark room. On the other hand, Mary Kelly's *Post Partum Document*, which attempts to visualise the unconscious through daily indexical recordings of the artist and her baby – including dirty nappies – might be seen as the precursor of numerous diaristic or indeed forensic works. Tracey Emin combines image and text in her confessional drawings and embroideries about her existential days from hell; Abigail Lane compiles evidence, prints, traces, corpses, stories true and false.

Subjectivity without expressionism has found a potent vehicle in video. In an inverted extension of the phenomenological relations proposed by minimalism and dramatically realised through installation art, the pitch black environment of the video installation creates a momentary loss of orientation, a sense of vulnerability heightened by the unease of not knowing who else is in the room. A visual and aural environment envelopes the viewer in a narrative or sequence of images and sensations. Liberated from the pictorial conventions of the TV monitor, artists can project the human figure on a one to one scale and in real time. They can go further – they can penetrate the surface of the body and lead us through its inner cavities, or its mental spaces. Mona Hatoum's *Corps Etranger,* 1994, has taken the lens/our greedy eye, into herself, through every orifice, literally dissolving the body as a binding concept in a penetration at once invasive, repellent and fascinating. Willie Doherty dissolves representations, of war, history, politics, by taking the viewer on a road movie through the mind of someone who could be both a terrorist and a victim in a work of 1993 *The Only Good One is a Dead One.*

The sophistication of new reprographic technologies is matched by their ubiquity. The camcorder is a domestic tool, hovering in front of the bride and groom, catching those first infant steps, or the family holiday. Just as much recent photography has become studiously amateur – snap shots and polaroids stuck up with bluetac – so there is an overwhelming domesticity about much recent video. Shot in a friend's sitting room, a bedroom or a bathroom – whether it be a gorgeous loft or scuzzy flat – these interior backdrops trigger a kind of subliminal recognition, normalising the glamour of the projected image.

From Lucy Gunning's film of women impersonating horses (*The Horse Impressionists*, 1996), to Sam Taylor-Wood's remarkable series of enigmatic monologues or dramatised encounters, two zones emerge: a private imaginary, of hidden desires and drives as they are consciously or unconsciously acted out or articulated; and a world of social relationships between lovers, families, friends and strangers – between the artist and her audience.

Another quintessentially modern form is also invoked – that of cinema. Part of a postmodern ethos of eclecticism and appropriation, some artists have simply stolen their heroes' work outright. They invite us to watch, in very slow motion, Hitchcock's (24 hour) *Psycho* (Douglas Gordon, 1993); or all the clips of all the films about children who are possessed, have supernatural powers or ecstatic visions (Susan Hiller's *Wild Talents*, 1997); or they might arrange in chronological order every cinematic moment featuring the art world, juxtaposed with an archive of movie burglaries (*Do you really want it that much?...More!*, Eichelmann, Faiers, Rust, 1997). Scenarios, gestures, glances become elastic, decontextualised, spellbinding phantasms in which we can loose ourselves. The viewer becomes possessed, boundless in a moment somewhere between 'jouissance' and Bataille's concept of 'a little death'. At the same time there is a detachment which allows us to hold the luminiscent fragment up to our mind's eye, and to examine it minutely.

This experience of being both inside and outside is generated by artists working in what might still be termed sculpture. But it is a material *world* rather than an object, which artists such as Mona Hatoum or Angela Bulloch have created. Their environments are artificial constructs, yet palpably real in their articulation of a phenomenology of space and time. But in addition to the sensations of shadow and light, heat, texture and architectonics generated by their installations, Hatoum plays on taboos and phobias, and goes on to reach beyond subjective experience into the politics of displacement. Bulloch's soft interactive spaces feel on an intuitive level, playful and liberating, generating a kind of warm, free-form infantilism. Yet her works also harbour a darkness, framed by invisible rules and systems or juxtaposed with overt prohibitions.

The body is either the absent presence implicated at every turn, or in the work of other contemporaries, overtly figured and disfigured in ways that resonate with US artists such as

Robert Gober, Charles Ray or Paul McCarthy. The polymorphous perversities of the Chapman brothers' mannequins, erupting with genitalia; or Abigail Lane's man, (*Misfit*, 1994) naked from the waist down, lying nonchalantly on the gallery floor admiring the view – generate an overwhelming sense of the uncanny. Anthropomorphic recognition is at once triggered and confounded by surreal displacements. We might also encounter the body as ghost, implied in Rachel Whiteread's translucent, honey coloured mattress slumped against a wall, or an inverted cavity cast from a sink in glowing white plaster. Whiteread shifts the register from absurdity to poignance.

The art being made in Britain in the 1990s cannot be neatly defined as a movement, or a product. Perhaps this heterogeneous phenomenon stems from an attitude. Pragmatism, pleasure, a cultural inheritance of iconoclasm coupled with a passion for beauty; involvement – rather than transcendence or revolt – as an approach to reality. An acute sense of social and political inequities that prevail in the British Isles, countered, not with master plans, but reflection, engagement and group dynamics.

30 seconds text.

In 1905 an experiment was performed in France where a doctor tried to communicate with a condemned man's severed head immediately after the guillotine execution.

"Immediately after the decapitation, the condemned man's eyelids and lips contracted for 5 or 6 seconds...I waited a few seconds and the contractions ceased, the face relaxed, the eyelids closed half-way over the eyeballs so that only the whites of the eyes were visible, exactly like dying or newly deceased people.

At that moment I shouted "Languille" in a loud voice, and I saw that his eyes opened slowly and without twitching, the movements were distinct and clear, the look was not dull and empty, the eyes which were fully alive were indisputably looking at me. After a few seconds, the eyelids closed again, slowly and steadily.

I addressed him again. Once more, the eyelids were raised slowly, without contractions, and two undoubtedly alive eyes looked at me attentively with an expression even more piercing than the first time. Then the eyes shut once again. I made a third attempt. No reaction. The whole episode lasted between twenty-five and thirty seconds."

...on average, it should take between twenty-five and thirty seconds to read the above text.

Notes on the experiment between Dr. Baurieux and the criminal Languille (Montpellier, 1905) taken from the Archives d'Anthropologie Criminelle.

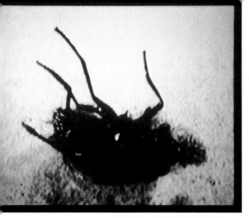

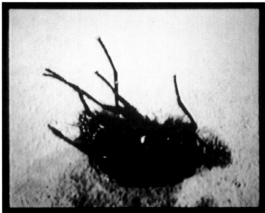

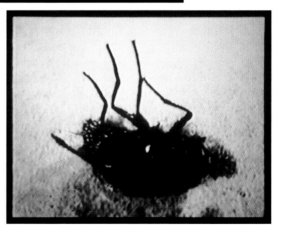

◁ Douglas Gordon, 30 Seconds Text, 1996
▷ Douglas Gordon, B-Movie, 1995

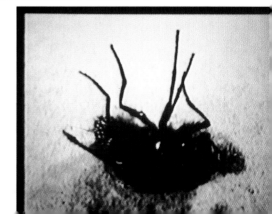

Douglas Gordon, Trigger Finger, 1994

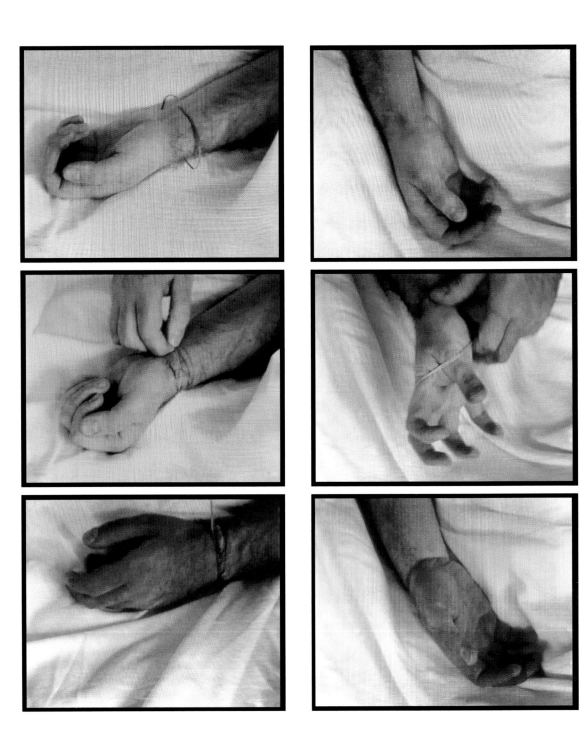

Douglas Gordon
◁ Left Dead, 1998 ▷ Dead Right, 1998

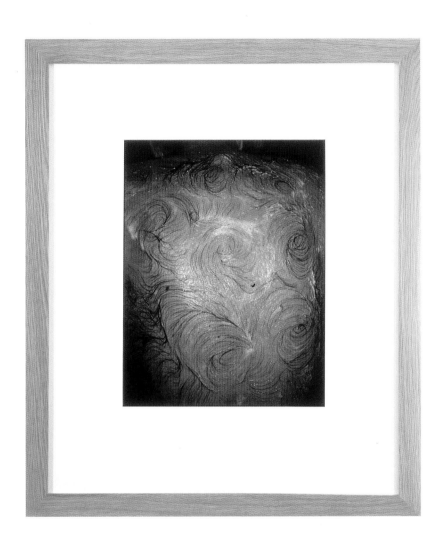

Mona Hatoum, Van Gogh's Back, 1995

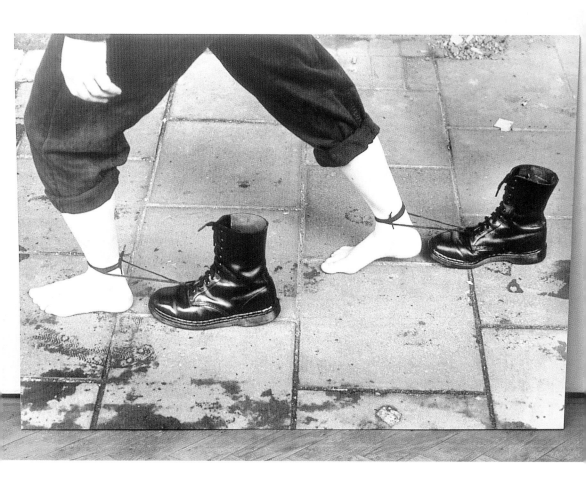

Mona Hatoum, Performance Still, 1985–95

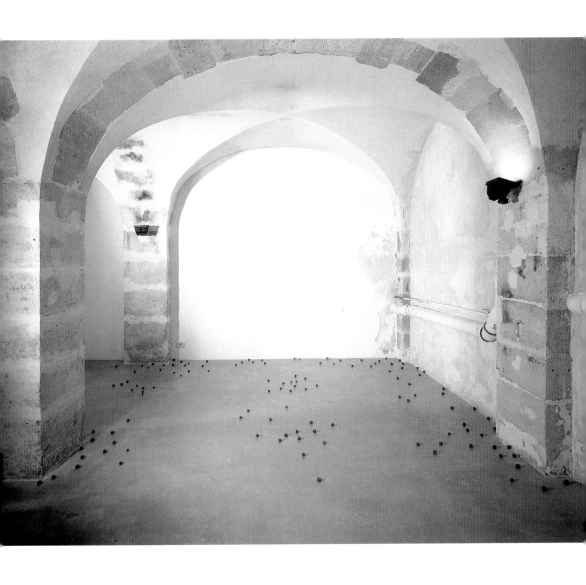

Mona Hatoum, Moutons, 1996

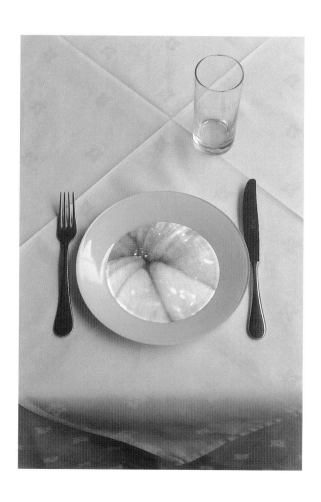

Mona Hatoum, Deep Throat, 1996, (Detail)

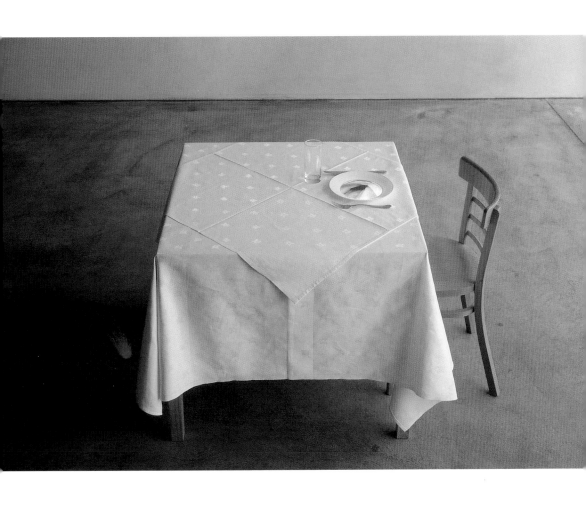

Mona Hatoum, Deep Throat, 1996

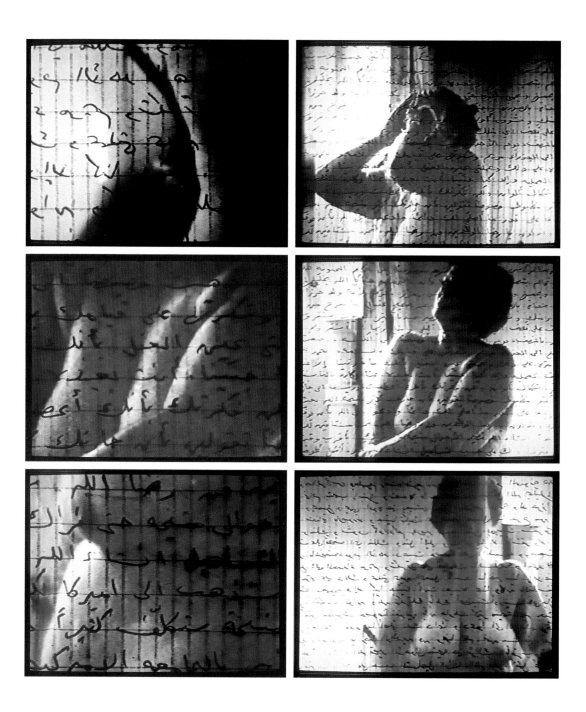

54 Mona Hatoum, Measures of Distance, 1988

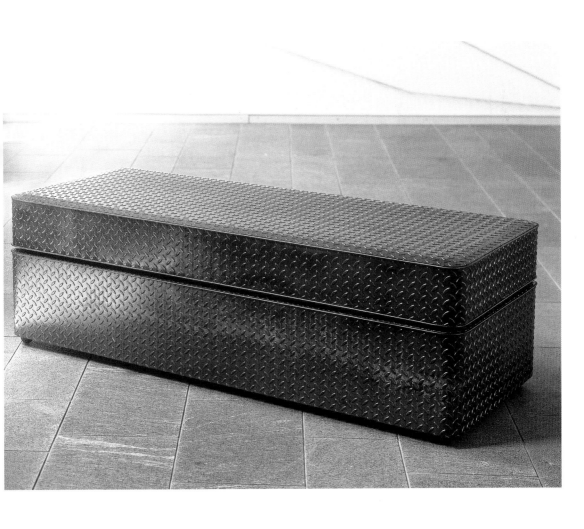

Mona Hatoum, Divan Bed, 1996

SPACE/RAUM

Carl Freedman

Die Dinge verändern sich. Kunst ist in Mode gekommen und gilt sogar als glamourös. Unlängst bei einer Eröffnung in London für die »New Contemporaries«, einer Übersichtsschau mit Arbeiten des künstlerischen Nachwuchses, füllten Massen von schönen jungen Leuten die Galerieräume. Draußen saßen noch viele weitere im Schutz der Bäume auf dem Rasen. Sie gehören zur neuen, stark expandierenden Generation von Künstlern, die den gleichen Erfolg und Ruhm anstreben, wie ihn ein Jahrzehnt vor ihnen die Goldsmiths-Generation erzielte. Für diese junge Generation von Künstlern muß die Chance auf Erfolg zum Greifen nah erscheinen. Es gibt zahlreiche neue kommerzielle Galerien. Saatchi erwirbt Arbeiten von Künstlern in einem zunehmend frühen Stadium ihrer Entwicklung (wenn das so weiter geht, kauft er demnächst Kunst aus Anfängermappen). Künstler haben den Status von Pop-Stars erlangt. Pop-Stars wollen ihrerseits Künstler sein. Es gibt eine nationale Diskussion über die Bedeutung aktueller Kunst, bei der die Medien als Schiedsrichter fungieren, und Kunstliebhaber und -hasser reihen sich gleichermaßen in die langen Wochenend-Schlangen vor der Tate Gallery ein.

Vor einer Dekade sah das alles noch ganz anders aus. Jahrelang befand sich London hinsichtlich der Kunst im Abseits. Es gab nur wenige Galerien, die Gegenwartskunst zeigten, und die versammelten sich um die Cork Street herum in Mayfair – einem Viertel, wo man Händler, die alte Meister verkauften, Jagdgeschäfte, den offiziellen Juwelier der Queen, eine Ausstellungsfläche von Rolls-Royce, Casinos und exklusive Animierclubs fand. Die Ausrichtung dieser Galerien läßt sich bestenfalls als provinziell und wenig ambitioniert beschreiben, und die Arbeiten, die sie präsentierten, waren großenteils zweitrangig und unoriginell. Die Ausstellungseröffnungen dort kamen meist als reichlich gesetzte und verklemmte Veranstaltungen daher, bei denen sich die Besucher den ganzen Abend über an einem Glas Wein festhielten und sich vom sanften Dröhnen höflichen Geplappers einlullen ließen.

Ich hatte von Kunst nur wenig Ahnung, aber ich begleitete meinen alten Freund aus Leeds, Damien Hirst, der gerade sein erstes Jahr am Goldsmiths College begonnen hatte, zu den Eröffnungen in der Cork Street. Damien begeisterte sich maßlos für die Kunst und das Leben, und er strahlte ein unwiderstehliches, geradezu sprühendes Selbstvertrauen aus. Das war um 1986, und es sollte noch einige Jahre dauern, bis sich Damiens charismatische Kraft vollends entfaltete. Zwar war sie damals schon vorhanden, aber noch nicht in Bahnen gelenkt – eine Fähigkeit, über die sich Damien wohl selbst nicht sonderlich bewußt war.

Bei diesen konventionellen Cork-Street-Eröffnungen gab es eine kleine Gruppe älterer Künstler, die wie Überbleibsel der Bohème-Kultur erschienen, wozu auch eine gewisse Trinkfreude gehörte. Sie freundeten sich mit uns an und nahmen uns nach den Eröffnungen mit in den Pub. Auf uns wirkten sie wie »echte« Leute aus der Kunstszene. Unter anderem gab es da Derek, der ein Kunstzentrum in Windsor leitete, Burt Irvin, eine Frau, die eine Galerie in ihrem Haus in Camberwell unterhielt und Denis Bowden, ein Künstler in seinen späten Sechzigern, dessen tief zerfurchtes Gesicht und sarkastisches Lächeln von einem konsequent gelebten Künstlerleben zeugten. Wir betranken uns und sprachen über weiß der Himmel was. Zu dem Zeitpunkt gab es noch keinen klar umrissenen Plan. Nur jede Menge Idealismus, jugendlichen Optimismus und den unbändigen Wunsch, die ganze Welt zu übernehmen. Gelegentlich treffe ich heute noch Denis bei einer Eröffnung, und er sagt dann immer mit einem Lächeln: »Ihr Typen. Ihr habt mit dem Ganzen angefangen.«

Naja, ein bißchen vielleicht. Aber eigentlich war es das Goldsmiths College, wo alles erst so richtig begann und wo sich eine eng verbundene Gruppe bildete. In dieser Gruppe hat es immer Reibungen, Konkurrenzkämpfe und widerstreitende Positionen gegeben – vor allem aber ein Gefühl des Zusammenhalts und der Gemeinschaft, das auf gemeinsamen Interessen und Zielen beruhte. Bei einer Gruppe derart willensstarker, ehrgeiziger und individualistischer Persönlichkeiten ist es bemerkenswert, daß dieses Bündnis über die Jahre hinweg sehr intakt geblieben ist.

Die zufällige Begegnung einer Anzahl hoffnungsvoller Studenten zu einem bestimmten Zeitpunkt hätte vielleicht nicht so große Auswirkungen gehabt, wenn nicht das produktive Umfeld des Goldsmiths College dazugekommen wäre. Das Goldsmiths College von damals existiert so heute nicht mehr.[1] Das College war in einem völlig separaten Gebäude untergebracht: ein angenehmes viktorianisches, vierstöckiges Bauwerk aus Backstein, das in einer ruhigen, isolierten und grünen Gegend von Camberwell lag. Die Ateliers waren hell und großzügig, es gab gutausgestattete Werkstätten mit freundlichen Technikern und eine tolle Bar, die von Studenten geführt wurde. Im Grunde war es fast ein utopischer Ort – eine perfekte, in sich geschlossene Welt, in der die Studenten alle Freiheiten hatten zu experimentieren und zu forschen. Kontrolle oder Einschränkungen gab es hier kaum.

Experimente wurden vom Lehrkörper positiv unterstützt. Bezüglich der künstlerischen Arbeit gab es keine Aufteilung in unterschiedliche Genres. Der Schlüssel zum Unterrichtskonzept lautete: Offenheit – die Vorstellung, daß in der Kunst alles möglich sei. Ex-Student Liam Gillick erinnert sich: »Es war zwar nicht so, daß ein Haufen Künstler in der Ecke mit Fleischpasteten auf den Köpfen herumstanden, aber es kam dem manchmal schon sehr nahe.«[2]

1 Es hat eine Reihe bedeutender Veränderungen gegeben: 1. Der Fachbereich für Kunst wurde 1989 in den Haupt-Universitätskomplex im tristen Südlondoner Viertel New Cross integriert. Das alte Art-College-Gebäude hingegen wurde zunächst als private Fachhochschule für Rechnungswesen genutzt und ist heute ein Luxus-Appartmenthaus im »Loft-Stil«. 2. Die große Anzahl ausländischer Studenten, vor allem aus Südostasien, die hohe Universitätsgebühren zahlen mußten und die aufgenommen wurden, um die Kurse zu subventionieren, hat zu einer deutlich spürbaren Spaltung geführt. 3. Der Abbau von Stipendien, die Einführung von Studentendarlehen und Kursgebühren bedeutet, daß Studenten ständig unter finanziellem Druck leiden, sich Schulden aufbürden und sich deshalb ständig Sorgen um ihre Zukunft machen. 4. Die Studenten leben im Schatten der vorhergehenden Generation von Studenten und werden mit falschen Erwartungen überhäuft.

2 Liam Gillick in: Ausstellungskatalog zu *Gambler*, London 1990.

Die zwei wichtigsten Lehrkräfte waren John Thompson, Leiter des Kursangebots, und Michael Craig-Martin, ein Gastdozent. Ihre unterschiedlichen Sichtweisen bildeten einen spannenden Gegensatz. Selbst von der äußeren Erscheinung her kontrastierte Craig-Martins adretter College-Look mit Thompsons zerknitterten Anzügen und zerzausten Haaren. Thompson war der romantische, intellektuelle Typ, und seine Interessen orientierten sich entlang einer Rimbaud-Zustand-des-Menschen-Beuys-Achse. Kunst war für ihn dreidimensionale Dichtung, etwas reines und unverfälschtes, jenseits von kommerziellen Interessen. Er war mit Paolini und Kounellis befreundet und fühlte sich der europäischen Kunst weitaus stärker verbunden als der amerikanischen.

1986 war Thompson Kurator der Ausstellung »Falls the Shadow« in der Hayward Gallery in London, die sich wie ein Resümee seiner Anliegen begreifen läßt (unter den ausgestellten Künstlern waren Baselitz, Fabro, Kounellis, Laib, Merz und Paolini). In seinem Katalogtext kritisierte er die Tendenz der aktuellen Kunst, eine Art internationales Spiel zu werden. Amerikanische Künstler wurden bewußt aus der Schau ausgeschlossen »als Gegenreaktion auf ihre unmäßige Hochstilisierung seitens eines überschwenglichen New Yorker Kunstmarkts«. Möglicherweise brachte er eher seine Wünsche zum Ausdruck als die tatsächliche Situation, als er behauptete, daß »nach drei Jahrzehnten amerikanischen Einflusses britische Künstler wieder begonnen haben, sich als ein Teil von Europa zu begreifen.«[3] Thompson, der sich oft in der Studentenbar herumtrieb, war ein sehr umgänglicher, liebenswürdiger Dozent und überaus demokratisch im Umgang mit seinen Studenten.

Während Thompson nach Europa schaute, wandte Craig-Martin seinen Blick in die entgegengesetzte Richtung: auf die andere Seite des Atlantiks zur amerikanischen Kunst und zu den Traditionen von Pop, Minimalismus und Concept Art. Craig-Martin interessierte sich nicht für den poetischen Symbolismus, sondern für den gewöhnlichen, alltäglichen Charakter von Gegenständen und die optische Qualität von Fabrikwaren. Sein eigener künstlerischer Ansatz basierte auf den Gesetzmäßigkeiten der Vernunft, auf Reduktion und Direktheit – eine Haltung, die er in seinem Unterricht mit weitreichenden Folgen weitergab. Und in unmittelbarem Gegensatz zu Thompson befürwortete Craig-Martin die kommerzielle Seite der Kunstwelt als beste pragmatische Möglichkeit, professionell Kunst zu betreiben.[4]

Die Lisson-Bildhauer, wie etwa Richard Deacon und Richard Wentworth (zeitweilig auch Dozent am Goldsmiths), waren die entscheidenden britischen Künstler der achtziger Jahre. Ihre Kunst der alltäglichen Gegenstände und Materialien wird gewöhnlich als direkter Einfluß auf die Goldsmiths-Generation gewertet. Doch auf den Seiten der internationalen Kunstmagazine begann sich eine andere Art von Kunst bemerkbar zu machen. Unter diesen Kunstmagazinen ragte die program-

3 John Thompson in: Ausstellungskatalog zu *Falls the Shadow*, London 1986.

4 Es ist erwähnenswert, zu welch unterschiedlichen Ergebnissen Thompsons und Craig-Martins Standpunkte führten. Thompson, der leicht bestürzt war über den schnellen Erfolg der jungen Künstler und hoffte, daß es sich nur um eine Seifenblase handele, die schnell platzen würde – was aber nicht geschah –, verließ 1992 das Goldsmiths und nahm eine Stelle als Lehrkraft im niederländischen Maastricht an. Craig-Martins Künstlerkarriere wurde durch seine enge Verbindung zur Goldsmiths-Generation neu angefacht, und er hörte eine Weile auf zu unterrichten. Kürzlich ist er wieder ans Goldsmiths zurückgekehrt, um eine eigens für ihn eingerichtete Professur anzunehmen.

58

matische Zeitschrift »Flash Art« als die aktuellste, kompromißloseste Publikation heraus. Das schwungvoll gestaltete Hochglanz-Magazin im Vierfarbdruck berichtete über alles, was sich gerade an Neuem in der Kunst tat.

Das Neue manifestierte sich zu der Zeit in einem Aufeinanderprallen von Richtungen, Ideen und Trends. Concept Art war wieder gefragt, was zur Wiederaufnahme der Untersuchung führte, auf welche Weise Kunst Bedeutung und ihre Wertigkeit erlangt. Barthes' Vorstellung vom »Tod des Autors« wurde viel diskutiert, und Sherrie Levine lieferte dazu mysteriöse visuelle Erläuterungen. Es gab Ausstellungen mit Titeln wie »Endgame: Reference and Simulation in Recent Painting and Sculpture« und »Forest of Signs: Art in the Crisis of Representation« sowie eine ganze Reihe von Artikeln, die apokalyptische Erklärungen über den »Tod der Kunst« gaben. Paradoxerweise jedoch expandierte zur gleichen Zeit der Kunstmarkt in geradezu atemberaubender Geschwindigkeit, und die Kunstmagazine strotzten nur so vor Anzeigen kommerzieller Galerien. Es schien fast, als hätte es niemals zuvor soviel Kunst gegeben. »Flash Art« folgte den Vorgaben des Markts und druckte im hinteren Teil des Hefts Auktionsberichte ab. Während Warenkunst den Tauschwert fetischisierte, wurde Jeff Koons, der zuvor Broker an der Wallstreet gewesen war, zu einem der führenden Künstler dieser Zeit.

All dies war ebenso berauschend wie verwirrend. Während das verführerische Vokabular der Postmoderne die Haftung übernahm, befand sich die Kunst im freien Flug und in einem Zustand extremer Relativität. Es schien so, als könnte eigentlich alles Kunst sein, wenn nur der Kontext und die Bedingungen stimmten: beispielsweise ein Spaziergang auf dem Lande, die fotografische Reproduktion einer Fotografie, die ein anderer aufgenommen hatte, Nike-Turnschuhe, die in einem Regal ausgestellt waren, oder ein invertiertes Urinal, das von dem fiktiven Künstler R. Mutt signiert war. Und selbst wenn diese neue Kunst nicht immer verstanden wurde, so setzte sie doch Zeichen. Denn das, was sie vermittelte, war eine Erweiterung der Möglichkeiten innerhalb der Kunst – Strategien, die zeitgleich auch durch das Lehrangebot am Goldsmiths eingeimpft wurden.

Wenn es eine Öffnung des geistigen Raums gab, in dem man kreativ denken und Ideen entwickeln konnte, bot sich London selbst als idealer Ort für die physische Manifestation dieser Ideen durch die Kunst an. Diese Stadt war ein leerer Raum, der darauf wartete, mit Inhalt gefüllt zu werden. Es gab keine aktuelle Kunstszene in dem Sinne, also gab es auch nichts zu ersetzen. Tatsächlich hatte sich London nie als Zentrum der Kunst auf die Weise etabliert, wie es Paris und New York getan hatten – was wiederum bedeutete, daß es auch kein historisches Vorbild gab, gegen das angetreten werden mußte. London verfügte auch im wörtlichen Sinn über leere Räume, die leicht als Ausstellungsflächen instrumentalisiert werden konnten, und zwar in Form postindustrieller, ausgedienter Fabrik- und Lagergebäude, die sich hauptsächlich in der Gegend im Osten Londons und um die Docklands herum konzentrierten.

Die Ausstellung »Freeze«, die im Sommer 1988 stattfand, machte sich diese offene, unangefochtene Raumsituation zunutze. »Freeze« hatte kein spezifisches Programm, und die Auswahl an Künstlern in der Schau basierte bis zu einem gewissen Grad auf einer *de facto*-Gruppe, die sich aus Freundschaften, die in Künstlerateliers und – bezeichnenderweise – in der Studentenbar geschlossen wurden, entwickelte. Die Prämisse war ganz simpel: eine Ausstellung zu machen und sie so professionell wie möglich über die Bühne zu bringen.

Der weitverbreitete Mythos in bezug auf »Freeze« lautet, daß die ganze Unternehmung ein Produkt von Thatchers Initiativ-Kultur war, und die Künstler wurden häufig als »Thatchers Kinder« bezeichnet, als seien sie Porsche fahrende Yuppies gewesen. Fraglos war der Katalog zur Ausstellung eine aufwendige, hochwertige Publikation. Doch die Tatsache, daß er direkt von Olympia und York gesponsert wurde, Erschließer von Canary Wharf, war eher ein Resultat glücklicher Umstände als besonderer Geschäftstüchtigkeit. Wenn man vom Katalog einmal absieht, wurde »Freeze« auf einer sehr bescheidenen Grundlage von £ 3000 finanziert. Hirst war die treibende Kraft hinter »Freeze«: Er hatte das Gebäude gefunden, seine partielle Renovierung organisiert und für Publicity gesorgt, als die Ausstellung dann lief. Sein ansteckender Enthusiasmus, sein Ehrgeiz und seine respektlose Clownerie machten einen wesentlichen Teil der kollektiven Anstrengung aus. Aber es wäre unzutreffend, Hirsts Rolle bei »Freeze« als die eines gewieften Entrepreneurs zu beschreiben, selbst wenn er mittlerweile zu einem geworden ist.

Es gibt ein Schwarzweißfoto, das kurz vor der Eröffnung von »Freeze« aufgenommen wurde. Darauf sind die Künstler abgebildet, die sich hinter einem weißgedeckten Tisch versammelt haben. An beiden Enden des Tischs stehen Zinkkübel, die mit weißen Rosen gefüllt sind. Eine strahlende Nachmittagssonne erhellt den Raum, und das Lächeln auf den Gesichtern drückt unbekümmerte Freundschaft aus. Es ist ein Bild, in dem sich der selbstsichere Stil mitteilt, der »Freeze« ausmachte, eine Schau, die von Studenten organisiert war, aber mit bescheidenem Chic und natürlicher Professionalität realisiert wurde.

»Freeze« wurde in drei Teilen veranstaltet. Gegen Anfang des dritten Teils kehrte ich von einem einjährigen Aufenthalt in den USA zurück. Meine Kenntnisse der aktuellen Kunst waren fast gleich null, und ich arbeitete hart daran, die Arbeiten, die im Kontext von »Freeze« gezeigt wurden, zu verstehen. Sarah Lucas war im Begriff, eine Wand aus grauen Betonziegeln zu errichten, deren Fugen nicht aus Zement, sondern aus grauen Schaumgummistreifen bestanden. Die Ziegel waren an die Wand des Bauwerks mittels eines Systems von Stütznägeln befestigt, das von dem Schaumgummi verdeckt wurde. Sie schien mit dem Material zu ringen, um die richtige optische Wirkung hinzukriegen. Eine Arbeit, die einen unmittelbaren, wenn auch unergründlichen Reiz hatte, war Angela Bullochs sanft leuchtendes *Light Piece*. Violettes Licht floß in unterschiedlichen Abstufungen zwischen zwei großen weißen Leuchtkugeln hin und her,

die an der Wand angebracht waren, während die Drähte und der Schaltmechanismus beiläufig auf den Boden herabbaumelten.

Mat Collishaws *Bullet Hole*, ein riesiger Leuchtkasten, der eine offene Kopfwunde abbildete, verstand ich auf Anhieb. Mein Bruder hatte eine Sammlung von pathologischen und anderen medizinischen Fachbüchern. Das war so eine typische Leeds-Marotte. Eine sehr schwarze Art von Humor und Respektlosigkeit gegenüber morbiden und grausigen Dingen. Diese Haltung wurde von einem Freund meines Bruders, Marcus Harvey, geteilt, der später wegen seines Myra-Hindley-Gemäldes berühmt-berüchtigt wurde. Und natürlich auch von Damien, der dieses Morbiditätsphänomen bald zu seiner ganz eigenen Sache machen sollte. Marcus und Damien verschafften sich bei einer Gelegenheit unerlaubt Zutritt zu der Leichenhalle eines Krankenhauses in Leeds und fotografierten sich gegenseitig beim Halten von Leichenteilen zur medizinischen Auswertung. Auf den Fotografien lachen sie beide in einer Art hysterischer Ausgelassenheit. Bevor sie den Ort verließen, stahlen sie noch ein Ohr, das mein Bruder später in der Post erhielt. Jedenfalls wurde das Abbild von der Kopfwunde aus einem dieser Pathologie-Bücher entnommen und auf irgendeine Weise über Damien an Mat weitergereicht. In Collishaws *Bullet Hole* erhält das plastische Abbild von Gewalt einen zusätzlichen Dreh, da die Wunde eine unerwartete Sinnlichkeit durch ihre potentielle Ähnlichkeit mit einer Vagina birgt – eine optische Anspielung, die eine sehr perverse Art von Humor zum Ausdruck bringt.

Nachdem »Freeze« zu Ende war, wurde der Versuch unternommen, den Raum auf Dauer in Gang zu halten, aber es hat nicht funktioniert. Also gründeten Damien, ich selbst und meine damalige Freundin Billee Sellman eine Firma mit der Vorstellung, auf den Erfolgen von »Freeze« aufzubauen. Für die Firma waren mehrere Namen im Gespräch, darunter »Fox«, »Big London« und »Talent«, aber wir einigten uns schließlich auf »Sellman, Hirst and Freedman«, wobei uns besonders gefiel, daß der Name so ähnlich klang wie der einer jüdischen Steuerberatungsfirma. Wir hatten das Ziel, »eine neue Generation junger britischer Künstler in profilierten Ausstellungen zu zeigen«, wie man in einer unserer Publicity-Broschüren aus der Zeit nachlesen konnte.

Die Firma wurde zu einem kurzlebigen, öffentlichen und finanziellen Erfolg – gefolgt von einem schnellen, völlig unkontrollierten Absturz in den unwiderruflichen Ruin. Das Ganze war wie ein Höhenflug: eine riesige Lagerhalle als Galerie, aufwendige Deckenbeleuchtung, grandiose Eröffnungen und Sammler, die auftauchten, noch ehe die Ausstellungen fertig aufgebaut waren, und untereinander um den Kauf von Arbeiten konkurrierten. Eine Menge Geld war ständig bei uns in Umlauf, und meine Taschen schienen ewig mit dicken Bündeln vollgestopft zu sein, wobei ein Großteil der Einkünfte aus dem Verkauf der Arbeiten stammte. Etwas Geld erhielten wir auch durch Sponsoren, wobei der einzige große Sponsor, Rank Xerox, wieder absprang. Wir hatten einige Kunstwerke für ein Firmen-Event zur Verfügung gestellt, das von

Rank Xerox im Commonwealth Institute veranstaltet wurde. Als wir anschließend alles zusammenpackten, haben wir wohl ein paar Kisten Alkohol zuviel mitgehen lassen sowie einen Teil der Catering-Ausrüstung und ein Surfbrett von der Australien-Schaufläche, das leider später vermißt wurde.

Die »Sellman, Hirst and Freedman«-Galerie war ursprünglich in einer Keksfabrik in Bermondsey untergebracht, und wir nannten sie »Building One« nach der tatsächlichen Fabrikbezeichnung. Drei Ausstellungen fanden zwischen März und November 1990 statt: »Modern Medicine«, »Gambler« und »Market«, und bei jeder wurden Goldsmiths-Absolventen präsentiert. Damien verließ die Firma nach der ersten Schau, »Modern Medicine«, um sich wieder auf seine eigene Kunst zu konzentrieren, da das Geschäft eine zeitaufwendige Angelegenheit geworden war, die einen sieben Tage in der Woche beanspruchte. Seine Rückkehr zur Kunstproduktion zeigte sich in seinen ersten wichtigen skulpturalen Arbeiten, den mit elektronischen Fliegen-Vernichtern ausgestatteten Vitrinen *A Thousand Years* und *A Hundred Years*, und sie wurden als zentrale Stücke in der Gruppenausstellung »Gambler« gezeigt. »Market« war eine Einzelausstellung des Künstlers Mike Landy, bei der 93 Brotkisten- und Marktstand-Skulpturen zu sehen waren – eine exzessive, extravagante Schau der Alltagsästhetik, die letztlich ein finanzielles Desaster war und zur Schließung von »Building One« führte.

In den frühen neunziger Jahren stieg die Zahl von Ausstellungen, die von Künstlern organisiert waren. Auch ließen sich jetzt immer mehr Goldsmiths-Studenten bei Galerien unter Vertrag nehmen, manchmal direkt vom College aus (oft vermittelt durch Craig-Martin). Die Aufmerksamkeit der Medien wuchs, hinzu kam das einflußreiche Interesse von Charles Saatchi, und allmählich bildete sich eine Art Kunstbewegung heraus.

Dieser Erfolg, vor allem auf kommerzieller Seite, brachte eine vorhersehbare Kritik mit sich. In Großbritannien hatte die Linke traditionell die Künste für sich beansprucht, was bedeutete, daß die Kunst im Dienst des Volkes stehen sollte und Künstler eindeutig gegen das Establishment zu sein hatten. Angesichts eines derart abgehalfterten und programmatischen Standpunktes, war es jedoch im Grunde radikaler, das Establishment zu akzeptieren und an dessen Seite zu arbeiten.

In jedem Fall hat die Geschichte gezeigt, daß selbst die radikalste künstlerische Arbeit vom Kunst-Establishment absorbiert wird und im Museum landet. Eine enttäuschte Lucy Lippard kam in ihrem wegweisenden Buch über Concept Art »Six Years: The Dematerialization of the Art Object« zu dieser Schlußfolgerung: »Hoffnungen, daß Concept Art die allgemeine Kommerzialisierung der Kunst vermeiden würde, waren weitgehend unbegründet. 1969 schien es, als würde niemand, nicht einmal eine Öffentlichkeit, die gierig nach Neuem war, tatsächlich Geld – und sogar viel – für eine Fotokopie zahlen, die sich auf ein bereits vergangenes oder nie direkt wahrgenommenes Ereignis bezog, oder für eine Gruppe von Fotografien,

die eine flüchtige Situation oder einen solchen Zustand dokumentierten, den Entwurf für ein nie realisiertes Werk, Worte, die gesprochen, aber nie aufgezeichnet wurden; es schien so, als würden diese Künstler zwangsläufig von der Tyrannei eines Warenstatus und einer Marktorientierung befreit werden. Drei Jahre später verkaufen die prominentesten Konzeptkünstler Arbeiten für substantielle Summen hier und in Europa; sie werden von den prestigeträchtigsten Galerien der Welt repräsentiert (und noch überraschender – stellen dort auch aus). Es ist offensichtlich, daß unabhängig davon, welche kleinen Revolutionen auch immer durch die Entmaterialisierung des Objekts in der Verständigung stattgefunden haben, Kunst und Künstler in einer kapitalistischen Gesellschaft Luxusgüter bleiben.«[5]

Die Akzeptanz »eines Warenstatus und einer Marktorientierung« durch die Goldsmith-Generation wurde vereinfacht durch die Tatsache, daß die Art von Kunst, die produziert wurde, sich als Ware bestens eignete. Es handelte sich um Kunst mit einer stark gegenstandsbezogenen Ästhetik, die formal in sich geschlossen war und die sich schnell und auf direkte Weise mitteilte. Zudem war es die Sorte Kunst, die man mitnehmen und verschicken konnte, die äußerst fotogen war und entsprechend gut in Zeitungen und Magazinen wirkte.

Unterdessen blieben die Künstler als erkennbare Gruppierung bestehen, die weiterhin auf der Basis gegenseitiger Unterstützung und einer recht regen Vetternwirtschaft funktionierte. Diese Vorstellung einer kohärenten Künstlergruppe wurde durch die Flut internationaler Gruppenausstellungen noch unterstützt. Natürlich sorgten gerade die eindringlichsten und aggressivsten Arbeiten von Künstlern aus dieser Gruppe für Schlagzeilen (und bekommen umgekehrt jetzt auch die volle Wucht der Gegenreaktion auf die britische Kunst zu spüren). Doch die grobe kulturelle Stereotypisierung dieser Kunst haben die Künstler nicht selbst verursacht. Die Vorstellung, daß aktuelle britische Kunst beispielsweise ein Synonym ist für Hooliganismus, die Werte der Arbeiterklasse, Biertrinken, Punk-Musik und eine allgemein aggressive Anti-Establishment-Haltung, ist eine Erfindung der Medien und der um Publikumswirksamkeit bedachten Museumskuratoren. Für diese oberflächliche journalistische Kategorisierung steht die weitverbreitete, aber wenig hilfreiche Verwendung des Begriffs yBa. Niedergeschrieben wirkt er unbeholfen, und er klingt idiotisch, wenn man ihn ausspricht. Seine restriktive Betonung nationaler Zugehörigkeit führt inhärent zur Produktion nationalistischer, stereotyper Definitionen.

Auch Charles Saatchis Neigung für schnelle Kunst mit unmittelbarer Wirkung hat zu dieser schiefen Auffassung über die aktuelle britische Kunst beigetragen. Diese Neigung wird durch Saatchis Strategie motiviert, Kunst zu instrumentalisieren, um seinen Namen öffentlichkeitswirksam zu lancieren und sich selbst als ein künstlerähnliches Phänomen zu verkaufen. Er sammelt nicht nur Kunst, sondern eignet sie sich auch an. Befindet sich eine Arbeit erst einmal in seinem Besitz, ist es beinahe so, als würde dessen Autorschaft auf ihn übergehen. Ein Indiz für dieses Verlangen, die Beziehung zwischen Werk und

5 Lucy Lippard: *Six Years: The Dematerialization of the Art Object.* New York/London 1973, S. 21.

ursprünglichem Autor aufzuheben, läßt sich an Saatchis Weigerung ablesen, mit den Künstlern, dessen Arbeiten er sammelt, Umgang zu pflegen oder von ihnen aufgesucht zu werden.

Solange sich die öffentliche Wirkung von Saatchis Aktivitäten noch auf den Pseudo-Museumsraum der Saatchi-Collection beschränkte, war die selbstherrliche Erschaffung eines eigenen Imperiums noch deutlich als Privatvergnügen erkennbar. Als seine Sammlung jedoch innerhalb der »Sensation«-Ausstellung an der Royal Academy gezeigt wurde, war diese Einschränkung nicht mehr so offensichtlich. In der Öffentlichkeit wurde Saatchis äußerst subjektiver Geschmack heruntergespielt und seine Sammlung so dargestellt, als würde sie eine mehrheitliche, objektive Meinung repräsentieren. Zugleich hat jedoch die Tatsache, daß Saatchi als Citizen Kane der Kunstwelt auftritt (ich frage mich, worin Saatchis »Rosebud« besteht), jüngeren Künstlern unschätzbar viel Geld eingebracht. Im Gegensatz zur staatlichen Förderung von Künstlern in Ländern wie Holland und Deutschland, vergibt Großbritanniens Arts Council staatliche Fördermittel ausschließlich an Institutionen – insbesondere an Opernhäuser und Theater – und nicht an individuelle Künstler. Ironischerweise hat diese Politik des Arts Council – nominell eine linke Körperschaft – sehr viel mehr als jede Thatcher-Ideologie dazu beigetragen, daß Künstler Selbständigkeit und Geschäftstüchtigkeit entwickeln mußten.

Obwohl die exklusive Saatchi-Medien-Kunst-Star-Kontroverse-Knüller-Allianz möglicherweise die Rezeption von Gegenwartskunst in der breiteren Öffentlichkeit dominierte, erschienen am anderen Ende der Skala in den neunziger Jahren eine große Vielfalt unabhängiger Ausstellungen und Raumprojekte in London, die von Künstlern häufig auf Low- oder sogar No-Budjet-Niveau organisiert waren. Bürokomplexe, Schlafzimmer, Wettbüros und Pubs wurden temporär in Ausstellungsflächen umgewandelt, wobei der Ausstellungsraum selbst zu einer eigenständigen Kunstform avancierte. Ein besonders ausgeprägtes und komplexes Projekt dieser Art war »The Shop«. »The Shop« war im wörtlichen Sinn ein Laden in Londons East End, der von Tracey Emin und Sarah Lucas geführt wurde. Man konnte dort kleine, handgefertigte Kunstwerke kaufen, aber der Shop war auch eine Art durchgängig geöffnete Kneipe. Die Kunst wurde direkt im Laden von Emin und Lucas produziert und umfaßte T-Shirts mit Logos wie »Have you wanked over me yet« und »Yes, the world does turn around me«, leere Zigarettenschachteln, die in einfache Hasenskulpturen verwandelt worden waren, sowie Aschenbecher, auf deren Unterseite ein fotokopiertes Bild von Damien Hirsts Gesicht befestigt war. Der Laden existierte zwischen Januar und Juni 1993 und wurde am Gipfel seines Erfolgs in wahrer Underground-Manier dichtgemacht.

Die Dynamik der Zusammenarbeit, die bei »The Shop« eine wichtige Rolle spielte, war eine der Hauptantriebskräfte in der Londoner Kunstszene. Die Solidarität und Freundschaft unter den Künstlern hat für einen ungewöhnlichen Gemeinschaftssinn und für unschätzbar viel gegenseitige Unterstützung gesorgt. Dies wird vermutlich in der nächsten, viel umfangreiche-

64

ren Generation junger Künstler so nicht mehr der Fall sein. Der Raum, der sich vor zehn Jahren öffnete, ist mittlerweile gefüllt worden, und London hat sich als international anerkanntes Zentrum für aktuelle Kunst etabliert. Viele Möglichkeiten existieren bereits und müssen nicht erst geschaffen werden. Ein wenig hat man schon das Gefühl, als sei etwas vorüber. Nicht die Kunst. Auch ist es kein Gefühl der Nostalgie oder des Verlusts – nur das Wissen darum, daß die Zukunft niemals so sein kann wie die Vergangenheit, und daß sich die Dinge ändern.

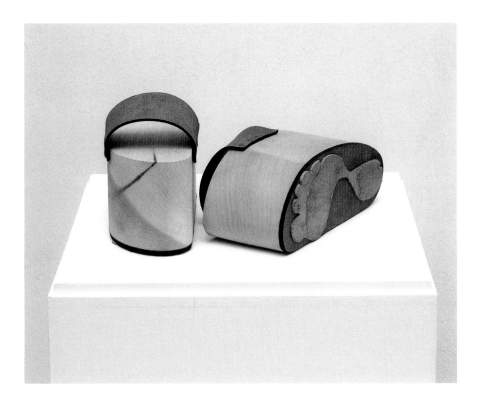

Abigail Lane, Untitled (Ingvild Goetz), 1997

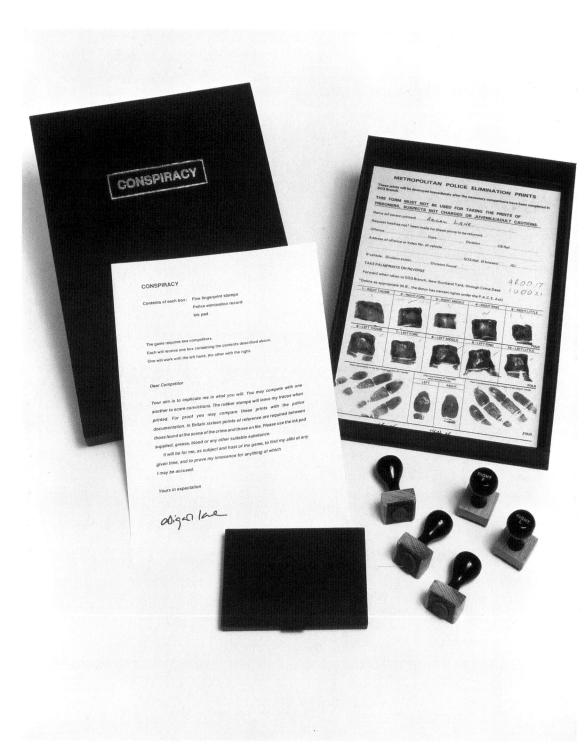

Abigail Lane, Conspiracy, 1992

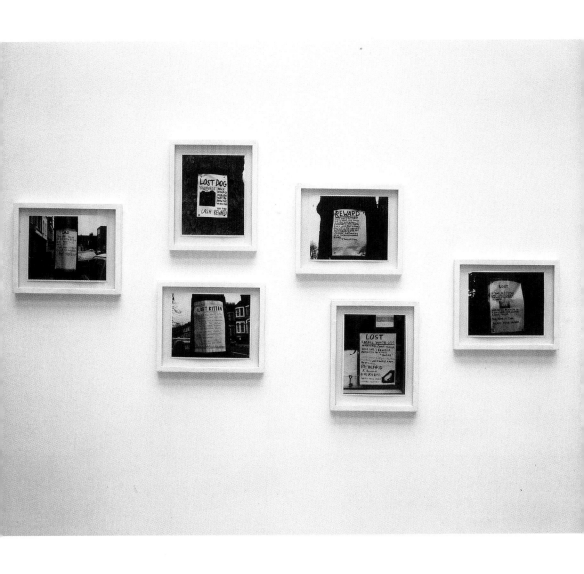

Abigail Lane, Absent Friends, 1994–95

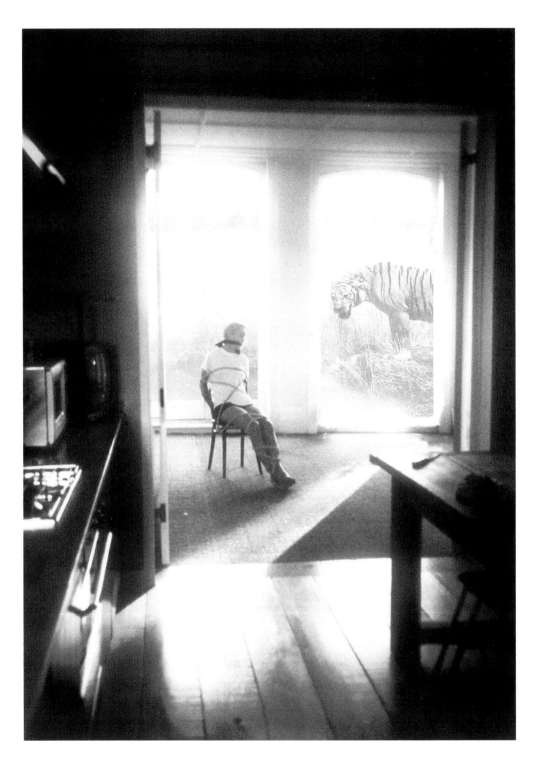

Abigail Lane, She Imagined She Knew the Future, 1997

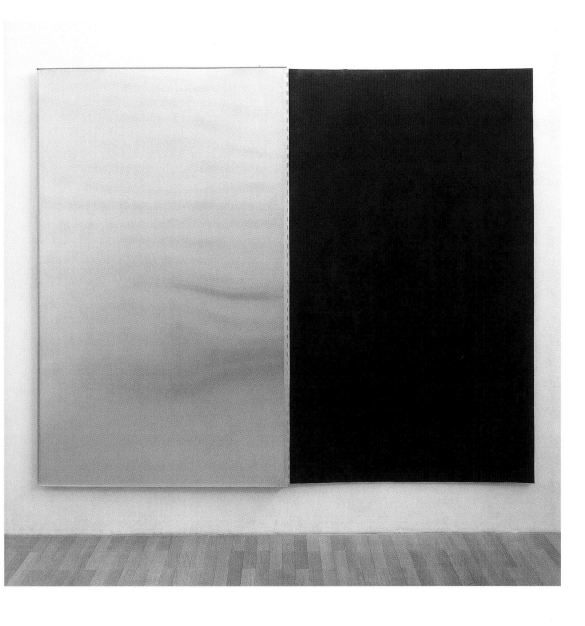

Abigail Lane, Ink Pad (Blue), 1994

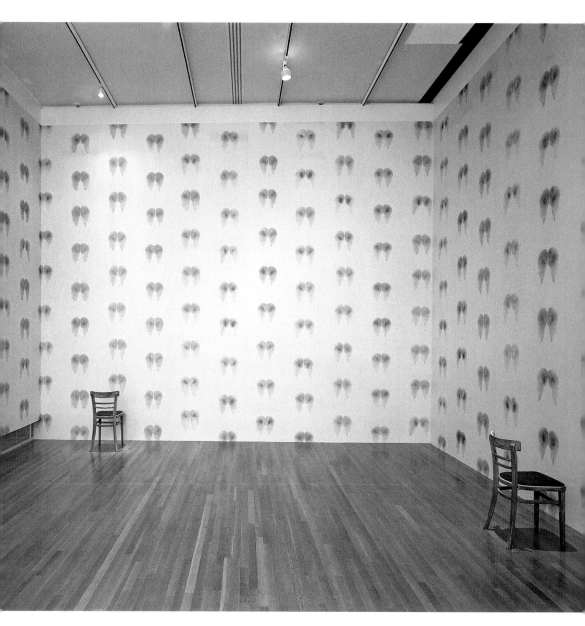

Abigail Lane, Bottom Wallpaper, 1994
Blue Inked Chair, 1996

Carl Freedman

Things change. Art has become fashionable, glamorous even. At a recent opening in London for the New Contemporaries, a survey show of recent graduate talent, there were crowds of young beautiful people filling the galleries. Outside, many more sat on the tree canopied lawns. They are the new, greatly expanded generation of artists, looking to find the same success and fame achieved by the Goldsmiths' generation a decade before them. For this new generation, the possibility of success must seem very close at hand. There are numerous new commercial galleries. Saatchi is acquiring from artists at an ever earlier stage (He'll be buying artists' O'level portfolios before too long). Artists have taken on pop star status. Pop stars want to be artists. There's a national discussion, refereed by the media, about the meaning of contemporary art, and art lovers line up with art haters in the busy weekend queues for the Tate.

Ten years ago things were very different. For many years London was seen as a backwater for art. Galleries which showed contemporary art were very few in number and clustered around Cork Street in Mayfair – a neighbourhood of Old Masters dealers, hunting outfitters, the queen's jewellers, a Rolls Royce showroom, casinos and upmarket hostess clubs. The attitude of these galleries could best be described as provincial and unambitious, and the work they showed was largely second-rate and derivative. A private view would be a staid, self-conscious affair, the odd glass of wine accompanying a light drone of polite chatter.

I knew nothing about art at that time, but I'd go along to these Cork Street openings with my old friend from Leeds, Damien Hirst, who had just started his first year at Goldsmiths College. Damien had a crazy passion for both art and life, and he radiated an irresistible, brightly charged confidence. It was around 1986, and it would still be some years before Damien's charismatic power fully surfaced. Then it was present but unfocused, and something Damien himself wasn't particularly aware of.

There was one small group of older artists at these staid Cork Street openings, representing a vestige of the Bohemian spirit including enjoying having a drink. They befriended us and would take us to the pub after openings. They seemed like the real thing. Among others, there was Derek who ran an arts centre in Windsor, Burt Irvin, a woman who ran a gallery in her house in Camberwell, and Denis Bowden, an artist in his late 60's whose deeply wrinkled face and wry smile spoke of a properly lived artist's life. We'd get drunk and I've no idea what we all talked about. There was no specific plan at that time. Just lots of idealism, youthful optimism

and a desire to take over the world. I still occasionally run into Denis at an opening, and it's his custom to say with a grin; "You guys. You started the whole thing".

Well, sort of. But it was at Goldsmiths College where things properly begin and where the forming of a strongly connected group occurred. Within this group there have always been frictions and rivalries and contesting positions. But overwhelmingly, there has been a sense of cohesion and commonality based on shared interests and aims. Remarkably for a group of strong-willed, ambitious, individually minded people, that bond over the years has remained very much intact.

The chance coming together of a number of promising students at one time might never have added up to that much if it were not matched by the productive environment of Goldsmiths College. The Goldsmiths College of that period is unrecognisable today.[1] The college was located in its own completely separate building, a pleasant Victorian four storey brick structure set in a quiet isolated location in a leafy part of Camberwell. The studios were spacious and well lit, there were well equipped workshops with friendly technicians, and a great bar which the students ran themselves. It was pretty well utopian really – this perfect self-contained bubble in which the students were free to experiment and explore with very few checks or constraints.

And experimentation was positively encouraged by the teaching staff. There was no separation of work by media. The key to the teaching was openness – a sense that in art anything was possible. Ex-student Liam Gillick recalled: "It wasn't like a load of artists standing around in the corner with Cornish pasties on their heads, but it could get close sometimes".[2]

The two principle teaching forces were John Thompson, head of the course, and Michael Craig-Martin, a visiting tutor. Their different perspectives formed an intriguing opposition. Even from outward appearance Craig-Martin's tidy preppy look contrasted with Thompson's dishevelled suits and unkempt hair. Thompson was the romantic intellectual type and the orientation of his interests was along the Rimbaud-human-condition-Beuys axis. Art was three-dimensional poetry, something pure and unadulterated by commercial concerns. He was friends with Paolini and Kounellis and felt much closer to European art than American.

In 1986 Thompson curated an exhibition *Falls the Shadow* at the Hayward Gallery in London which can be read as a résumé of his interests (artists included Baselitz, Fabro, Kounellis, Laib, Merz and Paolini). In his catalogue essay he questioned the way art was becoming some kind of international game. American artists were excluded from the show "as a counter-response to their over promotion by a zealous New York art market." Echoing his own desires perhaps more than the real

1 There are a number of significant changes. a) The art department was integrated into the main campus in the grim South London recess of New Cross in 1989, the old art college building becoming first a private accountancy college, and now luxury 'loft style' apartment-complex. b) The great influx of high fee paying foreign students, particularly those from South East Asia, brought in to subsidise courses, creates a distinct bipartite atmosphere. c) Reduction of student grants, introduction of student loans and course fees, means students are constantly under financial pressures, in debt, and consequently constantly worry about their future prospects. e) The students live in the shadow of the previous generation of students and are burdened with false expectations.

2 Liam Gillick in *Gambler,* exhibition catalogue. London, 1990

situation, Thompson proposed that "British artists after three decades of American influence have started once again to feel themselves part of Europe".[3] Often to be found in the student bar, Thompson was a very approachable, likeable tutor, and properly democratic in his relationship with the students.

If Thompson looked towards Europe, then Craig-Martin's perspective faced the opposite way, across the Atlantic to American art and to the traditions of pop, minimalism, and conceptual art. Craig-Martin's concern was not with poetic symbolism but with the ordinary everyday quality of things and with the look of manufactured objects. His approach to his own art making was one of common sense and pared down directness, something he passed on in his teaching with lasting effect. And in direct contrast to Thompson, Craig-Martin embraced the commercial side of the art world as the best pragmatic option for being a professional artist.[4]

The Lisson sculptors, such as Richard Deacon and Richard Wentworth (also a tutor at Goldsmiths' for a while) were the dominant British artists in the 1980's. Their art of commonplace objects and everyday materials is customarily put forward as directly influencing the Goldsmiths' generation. But another kind of art was beginning to make itself known through the pages of international art magazines. And among those magazines it was the eponymous *Flash Art* which stood out as being the most uncompromisingly contemporary. With its snappy design and slick full-colour print, it brought news of everything that was new in art.

And the new at that time was an intense collision of tendencies and ideas and trends. Conceptual art was back in demand and style, and it brought with it a renewed examination of how art acquires meaning and its value. Barthes' notion of the *Death of the Author* was given much airing, with Sherrie Levine providing mystifying visual illustrations. There were exhibitions with titles like *Endgame: Reference and Simulation in Recent Painting and Sculpture*, and *Forest of Signs: Art in the Crisis of Representation*, and a procession of articles making apocalyptic pronouncements about the 'Death of Art'. Yet paradoxically, at the same time, the art market was expanding at a frenetic rate and art magazines bulged with commercial gallery adverts. It seemed like there had never been so much art. *Flash Art* followed art market patterns, carrying auction reports in its back pages. Whilst commodity art fetishised exchange-value, and Jeff Koons, previously a commodities broker on Wall Street, assumed a leading position among artists at that time.

It was all as equally intoxicating as it was perplexing. Underwritten by the seductive vocabulary of postmodernism, art was freewheeling and in a state of extreme relativity. It seemed, given the right context and conditions, anything could be art – a walk in the country perhaps, a photographic reproduction of somebody else's photograph, some Nike sneakers displayed on a shelf, or an inverted urinal signed by the fictional artist R. Mutt. And even if this new art was not always under-

3 John Thompson, *Falls the Shadow*, exhibition catalogue, London 1986

4 The different outcomes of Thompson's and Craig-Martin's positions are worth mentioning. Thompson, somewhat dismayed by the rapid success of young artists, a bubble he hoped would burst but didn't, left Goldsmiths in 1992 and accepted a teaching post in Maastricht, Netherlands. Craig-Martin's art career was reignited through his association with the Goldsmiths generation and he stopped teaching for a while. Recently he returned to Goldsmiths to accept a specially created position of professor.

stood, it did make a significant impression, for what it conveyed was an opening up of the possibilities in art – something which was also being instilled simultaneously by the teaching at Goldsmiths.

If there was an opening of mental space in which to creatively think and develop ideas, London offered itself as an ideal place for those ideas to physically manifest themselves as art. It was empty space waiting to be filled. There was no contemporary art scene as such so there was nothing to displace. In fact London had never established itself as a centre for art in a way places like Paris or New York had, meaning there was no historical example to compete with either. London also literally had empty spaces that could readily be appropriated as exhibition spaces, in the form of post-industrial disused factory and warehouse buildings, concentrated mainly in an area around the east of London and the Docklands.

The *Freeze* exhibition, which took place in the summer of 1988, took advantage of this open and uncontested space. There was no specific agenda to *Freeze*, and the selection of artists in the exhibition was to some extent based on a *de facto* group arising out of friendships formed in the artists' studios and, foretellingly, in the student bar. The premise was simply to hold an exhibition and do it as professionally as possible.

The prevailing myth of *Freeze* is that it was a product of Thatcher's enterprise culture and the artists are frequently described as "Thatcher's children", as if they were Porsche-driving yuppies. Unarguably, the catalogue for the exhibition was an expensive high quality publication. Yet its sponsorship directly by Olympia and York, developers of Canary Wharf, was more a result of fortuitous circumstance than consummate entrepreneurial skills. Excluding the catalogue, Freeze was funded on a very modest £3,000. Hirst was the vital force behind *Freeze*, originally finding the building, organising its partial renovation, and promoting the exhibition once it was running. His infectious enthusiasm and ambitious energy, as well as his irreverent buffoonery, were a big part of the collective effort. But it would be inaccurate to describe Hirst's role in *Freeze* as that of a business minded entrepreneur, even if that is what he has now become.

There is a black and white photograph taken just before the opening of *Freeze*. It's of the artists gathered together behind a white linen covered drinks table. There are zinc buckets filled with white roses on each end of the table. The light is bright late afternoon sunshine, and the smiles are ones of easy going friendship. It's a picture which sums up the assured style of *Freeze*, a show organised by students but done so with an attitude of modest chic and unaffected professionalism.

Freeze was held in three parts, and it was around the beginning of the third part when I arrived back from a year living in America. My knowledge of contemporary art was virtually nil, and I worked hard to find a way to understand the work in *Freeze*. Sarah Lucas was making

a wall of grey concrete bricks, which had strips of grey foam in place of cement. The bricks were fixed to the wall of the building by a system of nail supports, hidden by the foam. It looked like she was struggling hard to get it to look right. One work which had an immediate if unfathomable appeal was Angela Bulloch's softly glowing *Light Piece*. Lilac light passed with a gradual ebb and flow between two large white wall-mounted orbs, the wires and switching mechanism trailing casually on the floor.

I understood Mat Collishaw's *Bullet Hole*, a huge light box of an open head wound. My brother had a collection of pathology books and other medical books. It was a Leeds thing. A very black kind of humour and irreverence towards morbid and gruesome things. It was something shared by my brother's friend Marcus Harvey, who later gained notoriety for his Myra Hindley painting, and of course shared also by Damien who would make this morbidity phenomenon very much his own. Marcus and Damien on one occasion illicitly gained entrance to a hospital mortuary in Leeds, and took photographs of each other holding medical specimen cadavers. In the photographs they're both laughing with a kind of hysterical joy. Before leaving they stole an ear which my brother later received in the post. Anyway, this image was taken from one of those pathology books, somehow passed down to Mat through Damien. In Collishaw's Bullet Hole this graphic image of violence has an extra twist, with the wound having an unexpected sensuality in its potential resemblance to a vagina – a visual pun expressing a very perverse kind of humour.

After *Freeze* finished there was an attempt to keep the space going on a more permanent basis, but that didn't work out. So Damien, myself and my then girlfriend, Billee Sellman formed a company with the idea of building on the achievements of *Freeze*. The company had various names, including *Fox*, *Big London* and *Talent*, but we eventually settled on *Sellman, Hirst and Freedman*, liking the way it sounded similar to a Jewish accountancy firm. The aim was to present "A new generation of young British artists in high profile exhibitions", as one of our publicity pamphlets of the time read.

The company was a short lived, critical and financial success. Followed by a rapid, out of control dive into irreversible bankruptcy. It was heady stuff, with a large warehouse gallery, vast overheads, grand openings and collectors arriving before shows had been barely installed and competing amongst each other to buy works. There was a lot of cash sloshing around, and my pockets seemed to always be crammed with a big bundle of notes with most of the income coming from the sale of work. Some money was raised through sponsorship, though the only major sponsor, Rank Xerox, pulled out. We had supplied some art works for a corporate event organised by Rank Xerox at the Commonwealth Institute. While packing up afterwards we slipped off with a few too many crates of alcohol, some catering equipment and a surf board from the Australia display, which unfortunately were later noticed missing.

The *Sellman, Hirst and Freedman* gallery was originally part of a biscuit factory in Bermondsey, and we called it Building One after its existing factory designation. Three exhibitions were held between March and November 1990, *Modern Medicine, Gambler* and *Market*, each featuring Goldsmiths graduates. Damien left the company after the first exhibition *Modern Medicine* to focus on making his art as the business had grown to be a consuming seven days a week occupation. His return to art making produced his first major sculptural pieces, the fly killer cabinets *A Thousand years* and *A Hundred Years*, and they were included as the central feature of the group show *Gambler. Market* was a Mike Landy solo show of 93 bread crate and market stall sculptures, an excessive extravaganza of everyday aesthetics, which was ultimately a financial disaster, and it closed Building One down.

The early 1990's saw a growing number of artist-organised exhibitions, plus the signing up of Goldsmiths students to galleries, sometimes directly from college, (often brokered by Craig-Martin), and increasing media attention, as well as the influential interest of Charles Saatchi, and an art movement of sorts began to evolve.

This success, especially the commercial side, brought a predictable sort of criticism. In Britain the Left has traditionally claimed art as its own, meaning art should be in the service of the people, and artists unequivocally anti-establishment. However, faced with such a tired and programmatic attitude, it was actually more radical to accept the establishment and to work alongside it.

Anyway, history has shown even the most radical artist's work gets absorbed by the art establishment and ends up in museums. A disappointed Lucy Lippard made the following conclusion in her seminal book on conceptual art *Six Years: The Dematerialization of the Art Object:* "Hopes that conceptual art would avoid the general commercialisation of art were for the most part unfounded. It seemed in 1969 that no one, not even a public greedy for novelty, would actually pay money, or much of it, for a Xerox sheet referring to an event past or never directly perceived, a group of photographs documenting an ephemeral situation or condition, a project for work never to be completed, words spoken but not recorded; it seemed that these artists would be forcibly freed from the tyranny of a commodity status and market-orientation. Three years later, the major conceptualists are selling work for substantial sums here and in Europe; they are represented by (and still more unexpected – showing in) the world's most prestigious galleries. Clearly, whatever minor revolutions in communication have been achieved by the process of dematerializing the object, art and artist in a capitalist society remain luxuries".[5]

The acceptance of "a commodity status and market-orientation" by the Goldsmiths generation was made less difficult as the kind of art being made was already suited to commodification. It was art with a strong object based aesthetics

5 Lucy Lippard, *Six Years: The Dematerialization of the Art Object*, New York and London, 1973, p. 21.

and formally self-contained, and communicated with speed and directness. It was the sort of art that could be picked up and shipped around, that photographed well and looked good in newspapers and magazines.

Meanwhile, the artists maintained a discernible grouping, based on a combination of continuing mutual support and a fair degree of incestuousness. The sense of a coherent group was compounded by a procession of reinforcing international group shows. Naturally, the most forceful and abrasive type of work by artists from this group has been the kind to take the headlines. (And equally now, the brunt of the anti-British art backlash). But crude cultural stereotyping of this art has not been generated by the artists themselves. The idea that British contemporary art is synonymous, for example, with: hooliganism, working class values, lager drinking, punk music, and a general aggressive anti-establishment attitude, is something that's been conjured up by the media and crowd pleasing museum curators. Indicative of this lazy journalistic labelling is the widespread, unhelpful use of the term yBa. It looks awkward written down and sounds stupid when its spoken. Its restrictive emphasis on nationality has the effect of inherently producing nationalistic stereotype definitions.

Charles Saatchi's taste for fast, immediate impact art has also contributed to this skewed perception of British contemporary art. It's a taste which derives from Saatchi's strategy of using art to advertise his name and promote himself as an artist-like phenomenon in his own right. He doesn't just collect art, he appropriates it. Once a work is in his possession, it is as if its authorship is reassigned to himself. Evidence of this wish to sever the relationship between art work and original author is found in Saatchi's refusal to be approached or to engage with the artists whose work he collects.

While public visibility of Saatchi's activities were restricted to the pseudo-museum space of the Saatchi Collection, his self-aggrandising empire building was still recognisably a private enterprise. When his collection was displayed at the Royal Academy in the *Sensation* show last year, that delineation was no longer apparent. In the public realm, Saatchi's highly subjective taste was played down and his collection was presented as if it represented consensual, objective opinion. At the same time, Saatchi playing Citizen Kane of the art world, (I wonder what Saatchi's Rosebud is?), has meant an invaluable flow of money into the pockets of younger artists. Unlike the state funding of artists in countries like Holland and Germany, Britain's Arts Council grants state funding to institutions, particularly the opera and theatre, and not to individual artists. Ironically, this policy of the Arts Council, notionally a left wing body, contributed far more to the need for artists to be economically enterprising and self-reliant, than Thatcherite ideology ever did.

Though the high end-Saatchi-media-art-star-controversy-blockbuster-alliance may have dominated the general public's awareness of contemporary art, at the other end of scale,

often operating on low or non-existent budgets, the 1990's in London have seen a great diversity of artist-organised independent exhibitions and artist-run spaces. Office blocks, bedrooms, betting shops, and pubs have all found themselves temporarily transformed into exhibition spaces, with the independent exhibition space becoming an art form in itself. 'The Shop' was one of the most complex and fully developed examples of this. 'The Shop' was quite literally a shop in London's East End that was run by Tracey Emin and Sarah Lucas. It sold small hand made art works, though it was also something of a late night all day drinking club. The art was made on the premises by Emin and Lucas and included T-shirts with logos such as "Have you wanked over me yet" and "Yes, the world does turn around me", empty packets of cigarettes turned into simple rabbit sculptures, and ash trays with a photocopied picture of Damien Hirst's face stuck on the bottom. Open between January and June 1993, it closed down at the height of its success in true underground fashion.

The collaborative dynamic of 'The Shop' is something which has been a key force in the London scene. The solidarity and friendship amongst artists has provided a rare sense of community and invaluable support. This will most likely be absent from the next much larger generation of young artists. The space which opened up ten years ago has now been filled, and London is a well established and internationally recognised centre for contemporary art. Opportunities exist already and do not have to be made. It does feel like something is over. Not the art. Nor is it a feeling of nostalgia or loss – just the way the future is never the same as the past, that things change.

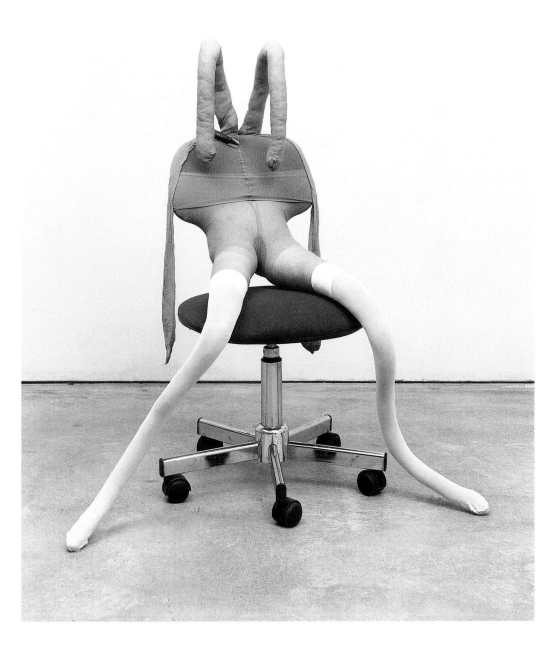

Sarah Lucas, Bunny Gets Snookered # 2, 1997

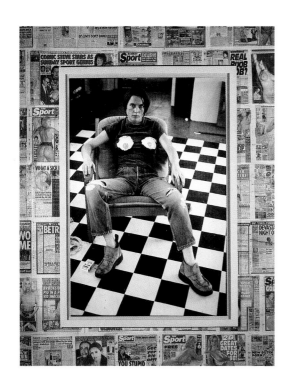

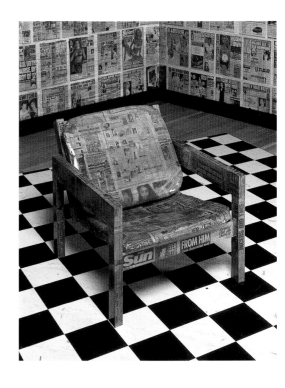

Sarah Lucas
◁ Self-Portrait with Fried Eggs, 1996
△ Untitled (Chair), 1996

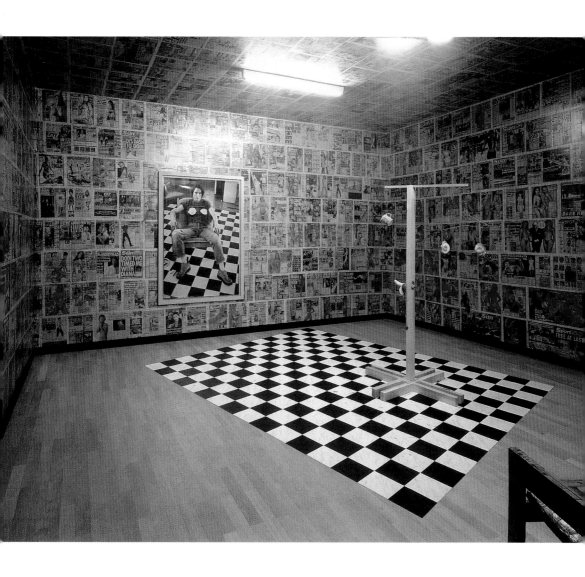

Sarah Lucas, The Smoking Room, 1997

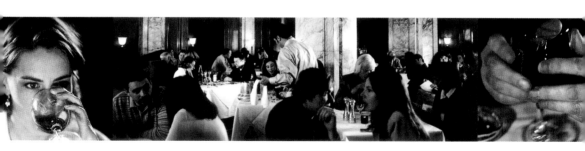

△ △ Sam Taylor-Wood, Five Revolutionary Seconds V, 1996

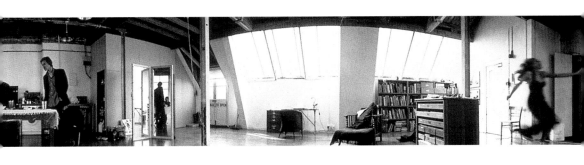

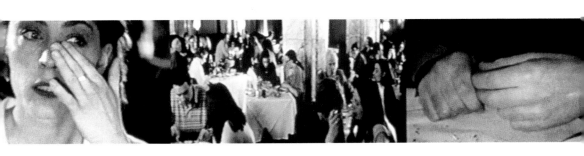

◁ △ Sam Taylor-Wood, Atlantic (Stills), 1997

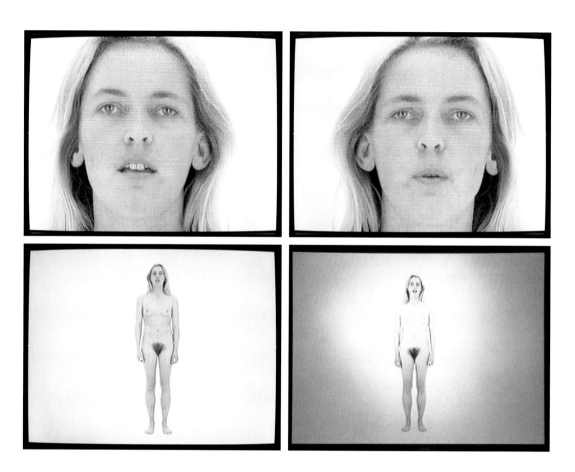

84 Sam Taylor-Wood, Knackered, 1996

Rachel Whiteread, Demolished, 1996

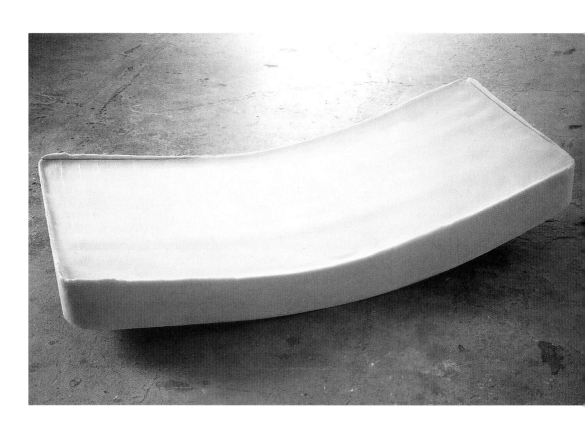

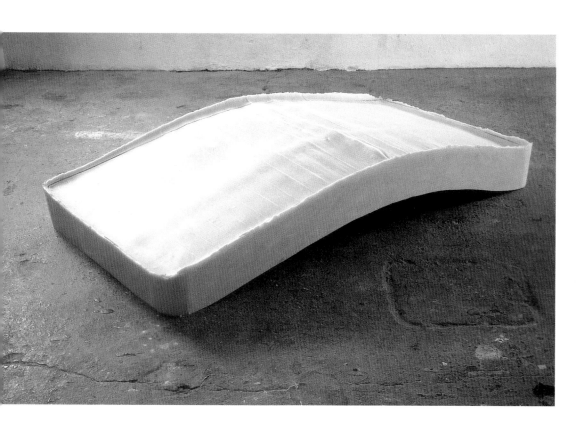

Rachel Whiteread, Untitled (Concave and Convex Beds), 1992

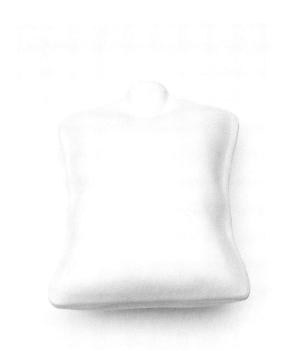

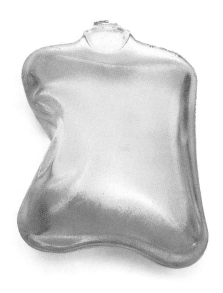

Rachel Whiteread
◁ Untitled (Torso), 1994/1995
△ Untitled (Torso), 1994/1995

Rachel Whiteread
Untitled (Kitchen Floor), 1993
Untitled (Kitchen Floor), 1993

POST POP
LONDON SWINGS AGAIN

Yilmaz Dziewior

Pop art is: popular (designed for a mass
audience), transient (short term solution),
expendable (easily forgotten), low cost, mass
produced, young (aimed at youth), witty,
sexy, gimmicky, glamorous, big business.
Richard Hamilton, 1957

I. Der Komplex Pop

Jon Savage, einer der führenden englischen Musik- und Kulturtheoretiker, postulierte bereits im Frühjahr des letzten Jahres: »Pop is again at the center of British life«.[1] Während die Wiederbelebung von Pop seiner Meinung nach anfangs lediglich als Reaktion auf Grunge und Techno wahrgenommen wurde, kristallisiert sich zunehmend die soziale und politische Dimension dieses Phänomens heraus, das sich übergreifend auf alle Bereiche des kulturellen Lebens Großbritanniens erstreckt. Für Savage birgt allerdings die Politisierung von Pop nicht allein die Potenzierung eines kritischen Umgangs mit den Phänomenen der Popkultur. Er konstatiert vielmehr die Gefahr der Vereinnahmung von Pop durch eine wiedererstarkte Nationalidentität und belegt dies unter anderem mit der zunehmenden Häufigkeit, mit der die englische Fahne, der Union Jack, sowohl von Musikern wie auch von Modedesignern Großbritanniens als Accessoire verwendet wird. Der internationale Durchbruch von Künstlern und Künstlerinnen wie Damien Hirst, Sarah Lucas und Rachel Whiteread und der durch ein breites Publikum getragene Erfolg von Musikgruppen wie Oasis, Blur, Pulp und Spice Girls untermauern ein wiedergewonnenes kulturelles Selbstbewußtsein, wie es Großbritannien zuletzt Mitte der sechziger Jahre erlebte, als auf der Titelseite des amerikanischen Wochenmagazins »Time« zu lesen war »London: The Swinging City.« Der aktuelle, in der Rezeption unterschiedlicher kreativer Aktivitäten zum Ausdruck kommende Brithype ist der Versuch, an die Erfolge der »Swinging Sixties« anzuknüpfen. Dabei handelt es sich nicht ausschließlich um eine (hypertrophe) Selbsteinschätzung, vielmehr sind es vor allem auch amerikanische und kontinentaleuropäische Medien, die London als »the world's coolest city« bezeichnen.[2]

Bereits die wenigen oben aufgezählten Musikgruppen geben einen Eindruck von der großen Diversität des aktuellen musikalischen Popspektrums Großbritanniens und belegen, daß nicht unbedingt die Zugehörigkeit zu einer bestimmten stilistischen Fraktion innerhalb des Musikkontextes oder die Relevanz für ein spezifi-

1 Jon Savage: Letter from London. State of the Union, in: Artforum, Mai 1997, S. 37.

2 Vgl. beispielsweise die Titelseite von Newsweek, 4. November 1996: »London Rules. Inside the World's Coolest City.«

90

sches Zielpublikum entscheidend für den internationalen Erfolg ist. Allein das Label Britpop, also die Partizipation an der britischen Musikszene einerseits und die Integration von Elementen aus der Popmusik andererseits, sind die vereinenden (erfolgversprechenden) Komponenten dieser Gruppen. In ähnlicher Weise läßt sich auch das Phänomen yBa (young British art) charakterisieren.[3] Diese auf eine sehr heterogene, sich aus vielen Einzelpositionen zusammensetzende Gruppierung angewendete Klassifizierung ist ebenso unspezifizierend wie das Label Britpop, das nicht nur als Bezeichnung für ein Segment der aktuellen englischen Musik, sondern von einigen Kritikern ebenfalls für die Arbeiten von jungen Künstlern und Künstlerinnen Großbritanniens verwendet wird. Auch die diesem Artikel vorangestellte Bezeichnung »Post Pop« ist als Charakterisierung nur eingeschränkt adäquat, umschreibt aber prägnant das wiedererwachte Interesse von britischen Künstlern und Künstlerinnen an dem Material und den Strategien der Populärkultur. Für die jungen Kunstschaffenden Großbritanniens ließen sich darüber hinaus durchaus auch andere Kriterien wie die politische und soziale Dimension oder die subjektive Codierung ihrer Werke und der Einfluß (auto)biografischer Aspekte als konstituierende Voraussetzungen ihrer Arbeiten anführen. Gerade weil aber das Soziale stets auch Teil der Populärkultur ist und jede Kunstproduktion, auch die, die als Auseinandersetzung mit Populärkultur entsteht, eine subjektive Setzung darstellt, gehen die hier nur angedeuteten Tendenzen häufig eine komplexe Symbiose ein.

Wenn Rachel Whiteread beispielsweise Hohl- und Zwischenräume von Alltagsgegenständen, wie Badewannen, Betten[4] oder Stühlen abgießt, transformiert sie, vergleichbar mit der Vorgehensweise von Claes Oldenburg, triviale Gebrauchsgüter in eine von ihrem ursprünglichen Erscheinungsbild abweichende Materialität.[5] Während Oldenburg aber die Objekte durch Größen- und Materialmodifizierungen oft mit absurden Konnotationen versieht, sind vor allem bei Whitereads frühen Skulpturen autobiografische Bezüge relevant.[6] In noch deutlicherem Maße läßt sich die hier beschriebene Verschmelzung von Pop- beziehungsweise Trivialkultur und autobiografischen Verweisen in dem durch seine Low-fi-Ästhetik bestimmten Werk von Tracey Emin ausmachen. Die eigene Biografie ist das Material und der Fundus, aus dem die Künstlerin ihre Arbeiten generiert. Mit schonungsloser Offenheit berichtet Emin über ihre Vergewaltigung in früher Jugend, eine Abtreibung und über ihre Teenage-Erfahrungen in der englischen Kleinstadt Margate. Ihre Arbeit *Mad Tracey from Margate, Everyone's there* (1997) ist Tagebuch und Storyboard zugleich. Die mit ausgeschnittenen Stoffbuchstaben auf eine blaue Decke aufgenähten Wörter, Sentenzen und Sätze können als Konzentrat von Geschichten gelesen werden, die eine Vorstellung vom Leben der Künstlerin geben, dessen banale und außergewöhnliche Ereignisse Emin gleichermaßen involvierend erzählt.

3 Vgl. hierzu Simon Ford: Der Mythos vom »young British artist«, in: Texte zur Kunst, Mai 1996, S. 127–134.

4 Vgl. ihre zweiteilige Arbeit *Untitled* (Concave and Convex Beds), 1992 in der Sammlung Götz.

5 Sowohl Oldenburg, der die Stoffvarianten seiner Arbeiten mit dem Untertitel *Ghost Version* versah, wie auch Whiteread, die den Betonabguß eines vollständigen Zimmers 1990 mit *Ghost* betitelte, rekurrieren mit ihren Bezeichnungen bewußt auf das Geistige bzw. Gespenstische ihrer Arbeit.

6 Vgl. »Rachel Whiteread in conversation with Iwona Blazwick«, in: Ausst.-Kat. Rachel Whiteread, Stedelijk Van Abbemuseum Eindhoven 1993, S. 8: »Your moulds are urban and domestic – what led you to using furniture? This was at first an autobiographical impulse, using something familiar.«

»Ein Hauptverdienst, den man der Arbeit der yBas zuspricht, ist ihre Parodie auf die Vorstellung von plakativer Britishness. Denn auch wenn sie in ihren Arbeiten auf die popular culture verweisen und auch einen Großteil ihrer Bekanntheit von dort beziehen, ist das Zielpublikum für ihre Arbeiten genau umrissen. Der Populär- und Trivialstil wird zwar zitiert, aber nur, um nach Umwandlung via Pastiche eine moribunde Hochkultur zu verjüngen…«[7] Mit diesen Sätzen charakterisiert Simon Ford treffend das Verhältnis der jungen Briten zur Populärkultur und ihren Anspruch, ungeachtet der Massenwirksamkeit ihrer Arbeiten einen genuinen Beitrag zum aktuellen Kunstdiskurs zu leisten. Die bewußte Hinwendung zum Populären ändert dabei nichts an der Tatsache, daß dieser Diskurs sich in erster Linie im engen (elitären) Kreis des Kunstkontexts vollzieht. »Image und Mythos von Pop, bis dahin als lästige, kommerzielle, böse, der eigentlichen Musik äußerliche Phänomene, waren plötzlich Bestandteil des Pop-Kunstwerkes, bewußt eingesetzt und Bestandteil des zu Kritisierenden.«[8] Diese von Diedrich Diederichsen in bezug auf die Popmusik der siebziger Jahre beschriebene Entwicklung ist vergleichbar mit der heute wiedereinsetzenden Reflexion in der aktuellen britischen Kunst über die Wirkung populärer Tendenzen und über die soziale Relevanz des Phänomens Pop. Wenn Sarah Lucas die Decke und die Wände ihrer Installation *The Smoking Room* (1997) mit Boulevardzeitungen wie »The Sun« oder »Daily Mirror« tapeziert, bedient sie sich populärer Massenmedien mit hohen Auflagen und einem großen Bekanntheitsgrad. Mit der Verwendung dieser für ihre provozierenden Schlagzeilen und sexistischen Aufnahmen von Frauen bekannten Medien konstatiert Lucas ein allgemein gesellschaftlich sedimentiertes Frauenbild, wobei sie bewußt auf eine direkte (feministische) Kritik verzichtet. Sie zeigt die populären Printmedien lediglich wie sie sind, ohne sie moralisierend zu kommentieren. »Anfangs wollte ich es ohne die Zeitungen machen, die sind erst später dazugekommen. Ich verwende sowieso oft Zeitungen. Sie sind mehr eine Art Hintergrund, der darauf hinweist, wie die Zeiten sind, sie zeigen auf sehr allgemeine Weise, was die Leute so interessiert – vielleicht ist es sehr obszön, aber jedenfalls weit verbreitet.«[9]

7 Simon Ford: Der Mythos vom »young British artist«, in: Texte zur Kunst, Mai 1996, S. 129.

8 Diedrich Diederichsen: Peinlich. Über das Peinliche des Unpeinlichen in der Kunst, in: Spex, April 1985, zit. nach Diedrich Diederichsen: Elektra. Schriften zur Kunst, Hamburg 1986, S. 25f.

9 Ingvild Goetz: Meine Arbeit ist meine Beschreibung der Welt. Interview mit Sarah Lucas, in: *Art from the UK*, Sammlung Goetz, München 1997, S. 123.

II. Let the music swing

Analog zu den sechziger Jahren konstituiert sich erneut ein aktualisierter Pop-Mythos, dessen Effizienz sich aus den zeitlich parallel erzielten Erfolgen in den unterschiedlichen kulturellen Bereichen speist. Auch Ende der neunziger Jahre wird die Verflechtung von Musik, Mode, Design und Kunst als Garant für Distinktionsgewinne angesehen, nicht ohne die Warnung vor Populismus und Qualitätsverlust. Dabei vollzieht sich die Erweiterung der Referenzfelder auf mehreren Ebenen. In diesem Zusammenhang ist die gegenseitige Beeinflussung von Kunst und Pop sowohl aus

historischer Sicht wie auch in bezug auf ihre gegenwärtige Wechselbeziehung aufschlußreich. Wie in den sechziger Jahren stellen die Artschools Englands nach wie vor wichtige Institutionen für den Nachwuchs der Musikszene dar.[10] Umgekehrt hat wiederum auch die Musikszene Einfluß auf die Arbeit junger Künstler und Künstlerinnen. Dabei ist die Interaktion von Kunst- und Musikbereich vielfältig und schlägt sich nicht nur im Entwurf von Plattencovern und Musikvideos von Künstlern nieder (Richard Hamilton zum Beispiel gestaltet das White Album der Beatles, oder Damien Hirst dreht ein Musikvideo für Blur). Einige Musiker, wie Bryan Ferry von Roxy Music oder Peter Townsend von The Who, haben vor ihrer Musikkarriere an englischen Kunstakademien studiert. Die Artschools bieten auch heute noch für viele den nötigen Freiraum, mitunter Proberäume und die Möglichkeit, Auftritte als Ereignis zwischen Konzert und Performance aufzuführen. Die erstmals 1996 und in der Folge mehrmals in abgeänderten Variationen von Angus Fairhurst aufgeführte Performance *Lowest Expectations* thematisiert genau diesen Zwischenbereich von bildender Kunst und Musik. Sein Auftritt trägt die Merkmale eines Pop-Konzertes. Es gibt den Frontmann (Fairhurst), die Bandmitglieder (befreundete Künstler), Instrumente und eine komplexe Lightshow. Allerdings wird die durch das Setting erzeugte Erwartung der Besucher nicht erfüllt. Zwar stimmt die »Band« den Beginn von eingängigen Songs an, spielt aber nur die ersten Takte und wiederholt diese dann in Form von Loops über mehrere Minuten. Das Verhalten der Künstler auf der Bühne, ihre Aktionen, Posen und Interaktionen sind Referenz an Pop-Konzerte. Die als Teil der Lightshow projizierten Videos nehmen wiederum direkt Bezug zum bildnerischen Werk von Fairhurst.

III. Pop denken

Die theoretische Grundlage für die historische Pop Art der sechziger Jahre legten die Mitglieder der Londoner »Independent Group«, die sich mit soziologischen, politischen und ökonomischen Aspekten im kulturellen Leben Großbritanniens auseinandersetzten. Diese Gruppe aus Malern und Bildhauern (Eduardo Paolozzi, Richard Hamilton), Architekten (Alison und Peter Smithson), Kritikern und Historikern (Reyner Banham, Toni del Renzio sowie Lawrence Alloway) formierte sich schon zu Beginn der fünfziger Jahre. Alloway war es auch, der in seinem Artikel »The Arts and the Mass Media« für Architectural Design im Februar 1958 erstmals den Begriff Pop im theoretischen Kontext verwendete, jedoch ohne explizite Bezugnahme auf die zeitgenössische Kunst. Zwei Jahre zuvor hatte Richard Hamilton das Wort Pop bereits in seiner heute legendären Collage »Just what is it that makes today's homes so different, so appealing« integriert.

 Aus heutiger Sicht gewinnen die von der »Independent Group« zwischen 1952 und 1955 organisierten Veranstaltungen zum Auto- und Hubschrauber-

10 Vgl. hierzu den Artikel von Jörg Heiser: Worlds in Collisions. *Pop und Kunst*, in: Spex, Dezember 1997, S. 38–41.

Design, zur Werbung und italienischen Warengestaltung, Mode, Science-fiction und Maschinenästhetik eine für die Kunst der sechziger Jahre programmatische Bedeutung. Als Pendant zu diesen theoretischen interdisziplinären Auseinandersetzungen fungiert im Kontext des aktuellen Pop-Diskurses die 1991 gegründete englische Kunstzeitschrift »Frieze«, die zusätzlich zu Künstlerporträts, kunstinternen Themen und Ausstellungsbesprechungen auch regelmäßig ausführliche Artikel über Design, Film und Musik publiziert.

Die Pop Art der sechziger Jahre war intensiv verbunden mit den Sensationen der Konsumkultur. In diesem Sinne stellt Guy Debords 1967 erschienenes Buch »Die Gesellschaft des Spektakels« ihr philosophisches Manifest dar. Dabei lassen sich die von Debord entworfenen Szenarien vor allem auf den Sensationsaspekt von Pop anwenden.[11] Debords kritische Grundhaltung wurde von vielen Künstlern der sechziger Jahre geteilt, die sich mit der Faszination der Warenwelt auseinandersetzten. Angezogen und skeptisch zugleich, vertraten sie eine dezidiert provozierende Haltung, indem sie selbst die trivialsten Erscheinungen für bildwürdig erachteten und auf ihren Nutzen für den Kunstkontext überprüften. Mit der scheinbaren Negation einer individuellen künstlerischen Handschrift agierten die Pop-Art-Künstler bewußt gegen den metaphysischen Anspruch des Abstrakten Expressionismus. Nicht weniger bedeutsam wie Debords Schrift war für die Künstler der Pop Art das ein Jahr später, 1968, erschienene Buch »Das System der Dinge« von Jean Baudrillard, in dem dieser in Form einer Theorie (und Kritik) der Konsumgesellschaft den Versuch einer Klassifizierung von Alltagsgegenständen unternimmt. Baudrillard untersucht in seinem Buch deren Symbolcharakter und ihr Verhältnis zum Unterbewußtsein ihrer Besitzer und Konsumenten. In Hinblick auf die Erscheinungszeit der beiden Publikationen muß man feststellen, daß zu diesem Zeitpunkt der Höhepunkt der Pop Art bereits überschritten war. Nicht zuletzt auch aufgrund ihrer vehementen Kritik an der Konsumkultur können die genannten Schriften gleichsam als Nachruf auf die Pop Art gelesen werden.

Im Gegensatz zur Pop Art der sechziger Jahre verwenden die jungen britischen Künstler und Künstlerinnen heute die Objekte der Warenwelt weniger mit dem Blick auf das System ihrer Präsentation im Sinne der Mythen und Phantasien, in denen sie in der Werbung stilisiert werden. Vielmehr greifen sie auf Motive, Ereignisse und Darstellungsformen aus dem Pop-Kontext zurück, die für ihre eigene Jugend prägend waren. Im Unterschied zu den Künstlern der sechziger Jahre ist diese Generation mit der Omnipräsenz des Fernsehens (MTV, etc.) und sich stetig differenzierenden Werbestrategien in einer zwar freien, aber wesentlich durch das Kapital geprägten Gesellschaft aufgewachsen. Wie vielfältig die Künstler mit diesen veränderten Voraussetzungen umgehen, zeigt die aktuelle britische Kunstszene, deren Virulenz in vielen Bereichen in signifikanter Weise durch die Integration von Elementen der Populärkultur geprägt ist.

11 Es ist in diesem Zusammenhang bezeichnend, daß die große Ausstellung zur aktuellen britischen Kunst, die 1997 in der Londoner Royal Academy und 1998 im Hamburger Bahnhof in Berlin präsentiert wurde, den Titel »Sensation« trägt.

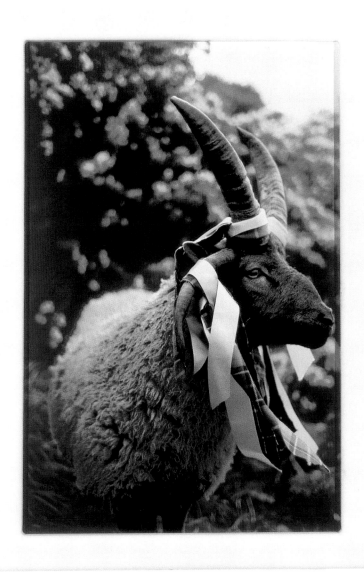

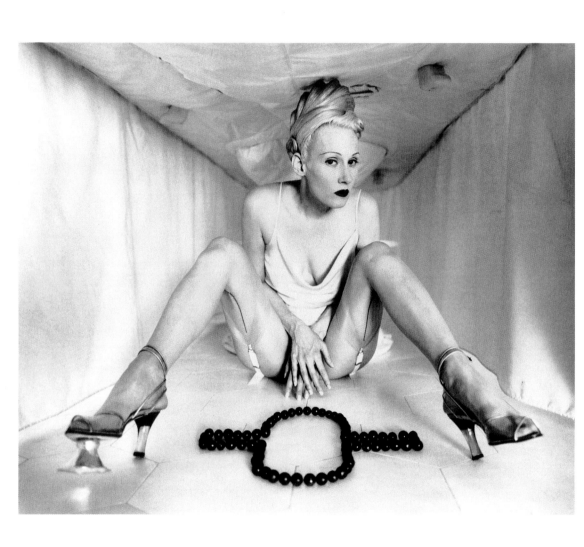

Matthew Barney, GOODYEAR: CREMASTER 1, 1995

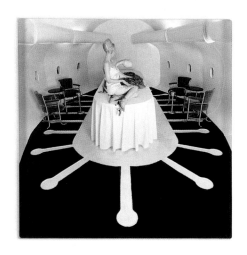

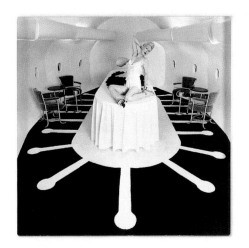

Matthew Barney, CR 1: Goodyear Lounge, 1995

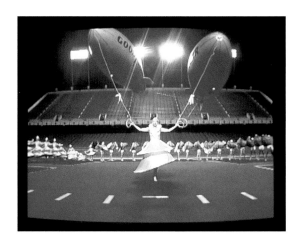

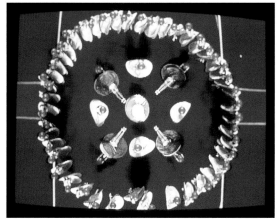

Matthew Barney, CREMASTER 1, 1995/96

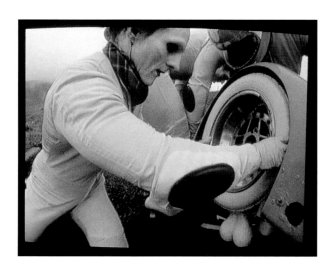

Matthew Barney, CREMASTER 4, 1994/95

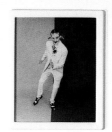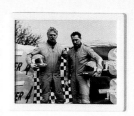

Matthew Barney, CREMASTER 4: The Isle of Man, 1994

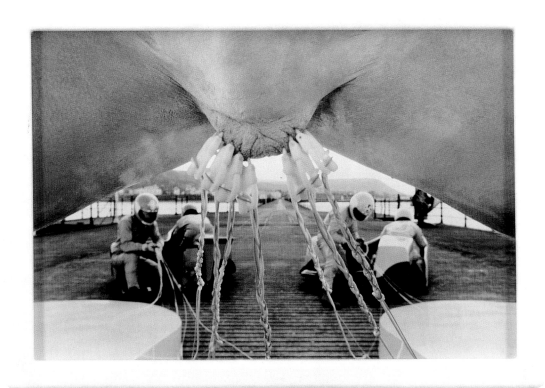

Matthew Barney, CREMASTER 4: Three Legs of Man, 1994

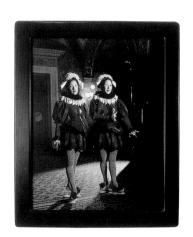 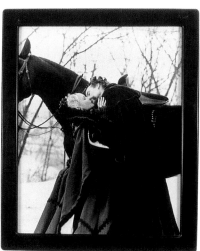 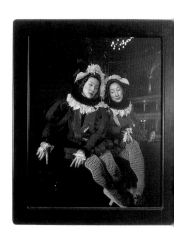

Matthew Barney, CREMASTER 5: Elválás, 1997

POST POP
LONDON SWINGS AGAIN

Yilmaz Dziewior

Pop art is: popular (designed for a mass audience), transient (short term solution), expendable (easily forgotten), low cost, mass produced, young (aimed at youth), witty, sexy, gimmicky, glamorous, big business.
Richard Hamilton, 1957

I. The Complex 'Pop'

Already in the spring of last year Jon Savage, one of the leading British music and cultural theorists, put forth the following claim: "Pop is again at the center of British life."[1] While in his opinion the resurrection of pop was viewed merely as a reaction to grunge and techno at the beginning, the social and political dimension of this phenomenon, that encompasses all aspects of cultural life in Great Britain, have increasingly become apparent. Savage believes, however, that the politicization of pop does not solely involve an enhancement of critical approaches to the phenomena of pop art. Moreover, he notes the danger of pop becoming monopolized by a revived national identity and sees evidence of this in the increasing frequency with which, for example, the British flag, the Union Jack, is put to use by musicians and fashion designers throughout England as an 'accessoire'. The international breakthrough of artists such as Damien Hirst, Sarah Lucas and Rachel Whiteread and the success of music bands like Oasis, Blur, Pulp and the Spice Girls, supported by a large public, have revived a cultural self-esteem that Great Britain had last experienced in the mid sixties, when the title page of the American *Time* magazine carried the headline: "London. The Swinging City". The current 'Brit-hype', expressed in the eager reception of various creative activities, is an attempt to link up with the successes of the "Swinging Sixties". This is not only a result of (hypertrophic) self-assessment; in fact, it is predominantly the American and continental-European media that are referring to London as "the world's coolest city".[2]

The handful of music groups listed above already give an impression of the large diversity within the current spectrum of pop regarding the field of music in Great Britain and indicate that belonging to a certain stylistic faction within the music context, or being relevant to a specific target audience, is not necessarily the most prominent factor for international success. The label 'Brit-pop' alone, as well as being associated with the British music scene, on the one hand, and the integration of elements derived from pop music, on the other, are the unifying (success-promising) compo-

1 John Savage, "Letter from London. State of the Union." In: *Artforum*, May, 1997, p. 37

2 See, for example, the title page of *Newsweek*, November 4, 1996: "London Rules. Inside the World's Coolest City".

103

nents of these groups. The phenomenon yBa (young British art) can also be seen in this light.[3] This classification, which encompasses a large group and thus many individual artistic approaches, is as unspecific as the label 'Brit-pop' that is not only used to describe a segment of current British music but is also employed in regard to the works of young British artists. Even the term "Post Pop" in the heading of this article is only partially adequate as a characterization, although it does poignantly express the renewed interest of British artists in the material and strategies of popular culture. Concerning the young artists in Great Britain one might additionally point out other criteria, such as the political and social dimension or the subjective coding contained in their art and the influence of (auto)biographical aspects as prerequisite constituents for their works. However, precisely because the social sphere is always a part of popular culture and all types of art production – including those that emerge out of a confrontation with popular culture – are subjective assumptions, the tendencies only hinted at here often enter into a complex symbiosis.

When, for example, Rachel Whiteread uses the hollow spaces of everyday objects such as bathtubs, beds[4] or chairs as a mold, she is transforming trivial consumer goods, in a way similar to Claes Oldenburg, into material forms[5] deviating from their original mode of appearance. Whereas Oldenburg often supplies the objects with absurd connotations by means of modifications in material and size, in the case especially of Whiteread's early sculptures autobiographical references are most relevant.[6] Even more distinctly, the merging of pop or trivial culture and autobiographical references can be seen in the work of Tracey Emin, defined by its particular 'low-fi' aesthetics. In fact, her own biography is the store of material out of which the artist generates her works. With blunt openness Emin gives an account of how she was raped in early youth, reports on an abortion and her experiences as a teenager in the small English town of Margate. Her work *Mad Tracey from Margate, Everyone's there* (1997) functions both as a diary and a storyboard. The words, aphorisms and sentences, cut out and sewn onto a blue blanket, can be read as condensed versions of stories that give insight into the artist's life from which Emin relates the banal and extraordinary events with the same degree of involvement.

"One major achievement ascribed to the yBas is their parody of the notion of 'Britishness'. Since even if they do refer to the 'popular culture' in their works and derive the greater amount of their popularity from there, the target audience for their works is clearly outlined. The popular and trivial style is quoted but only to rejuvenate a moribund high culture after transforming it via pastiche (…)"[7] Here Simon Ford precisely characterizes the relationship of young British artists with popular culture and their claim to make a genuine contribution to the current art discourse,

3 Cf. Simon Ford, "Der Mythos vom 'young British artist'", in: *Texte zur Kunst*, May, 1990, p. 127–134.

4 Compare her two-piece work *Untitled (Concave and Convex Beds)*, 1992, in the Goetz Collection.

5 Both Oldenburg, who supplies the versions of his works in fabric with the subtitle *Ghost Version*, and Whiteread, who gave the concrete cast of a complete room in 1990 the title *Ghost*, consciously allude to the 'spiritual' as well as the 'gostly' quality of their works with these suggestive names.

6 Compare Rachel Whiteread in conversation with Iwona Blazwick, in: Ex. Cat. *Rachel Whiteread*, Stedelijk Van Abbemuseum Eindhoven, 1993, p. 8: "Your moulds are urban and domestic – what led you to using furniture? – This was at first an autobiographical impulse, using something familiar."

7 Cf. Simon Ford, "Der Mythos vom 'young British artist'", in: *Texte zur Kunst*, May, 1996, p. 128 (transl. from the original quote).

regardless of the mass appeal of their works. At the same time, however, the conscious orientation towards the popular does not diminish the fact that this discourse takes place foremost within the tight (elitist) circle of the art context. "The image and myth of pop, up to then viewed as bothersome, commercial, evil phenomena external to the actual music, all of a sudden, were a feature of the pop art work, consciously employed and a component of the object of criticism."[8] The development Diedrich Diederichsen sketches here in regard to the pop music of the seventies is comparable to the reflection on the effect of popular tendencies and the socio-political relevance of the phenomenon of pop that current British art focuses on once again today. When Sarah Lucas covers the ceiling and walls of her installation *The Smoking Room* (1997) with tabloids such as *The Sun or Daily Mirror* she is using popular mass media with a large circulation and a high degree of familiarity. By employing these media that are known for their provocative headlines and sexist pictures of women, Lucas restates a generally accepted image of women in society, while consciously abstaining from direct (feminist) criticism. She merely shows popular print media as they are, without commenting on them in a moral sense. "Initially, I was thinking about making it without the newspapers, the newspapers came later. I've used newspapers a lot, anyway. They just are a kind of background of what times are like and a sort of common level of what's interesting in a very general way – maybe, it's quite a salacious way, but anyway, quite common."[9]

II. Let the Music Swing

In analogy to the sixties, an updated version of the pop-myth is once more establishing itself, the effectiveness of which is based on the successes achieved simultaneously within the different cultural fields. At the end of the nineties the intertwining of music, fashion, design and art are equally viewed as a guarantee for an increase in distinction, not without an inherent warning, however, against populism and a decrease in quality. At the same time, the fields of reference are expanding on various levels. In connection to this, the mutual influencing of art and pop is interesting from a historical view, as well as in regard to their current interrelation. Much like in the sixties the art schools in England are still important institutes for upcoming generations in the music-scene.[10] Vice versa, the music-scene also influences the work of young artists. Yet the interaction taking place within the areas of art and music is very complex and manifests itself not only in the fact that artists design record jackets and music videos (e.g., Richard Hamilton designed the Beatles' *White Album* and Damien Hirst produced a music video for Blur). A number of musicians, such as Bryan Ferry from the group Roxy Music or Peter Townsend from The Who, studied at English art academies before launching

8 Diedrich Diederichsen, "Peinlich. Über das Peinliche des Unpeinlichen in der Kunst", in: *Spex*, April, 1985, cf. Diedrich Diederichsen, *Elektra. Schriften zur Kunst*, Hamburg 1985, p. 25f. (transl. from the original quote).

9 Quoted from Ingvild Goetz, "Meine Arbeit ist meine Beschreibung der Welt. Interview with Sarah Lucas", in: *Art from the UK*. Sammlung Goetz, Munich, 1997, p. 131.

10 Cf. the following article by Jörg Heiser, "Worlds in Collisions. Pop und Kunst", in: *Spex*, December, 1997, p. 38–41

their musical career. For many, even today, the art schools still offer vital opportunities for experimenting, for instance, practice rooms and possibilities for staging events ranging between concerts and performances. Angus Fairhurst's performance *Lowest Expectations*, first shown in 1996 and subsequently with certain variations, demonstrates exactly this zone where the fine arts and music merge. His performance has the characteristics of a pop-concert: a front man (Fairhurst), band members (some artist-friends), instruments and a complex light show. However, the audience's expectations aroused by the setting are not fulfilled. The 'band' does strike up the beginnings of some catchy songs but only plays the first few bars and repeats them then in a sort of endless loop for a number of minutes. The way the artists perform on stage, their gestures, poses and interactions – all these allude to pop-concerts. The videos, on the other hand, projected as part of the light show, refer directly to Fairhurst's artistic work.

III. Thinking Pop

The members of the London Independent Group that dealt with the sociological, political and economic aspects of cultural life in Great Britain created the theoretical basis for the historical pop art of the sixties. This group of painters and sculptors (Eduardo Paolozzi, Richard Hamilton), architects (Alison and Peter Smithson), critics and historians (Reyner Benham, Toni del Renzio and Lawrence Alloway) was formed already in the early fifties. In fact, it was Alloway who first used the term 'pop' in a theoretical context in his article "The Arts and the Mass Media" for the publication *Architectural Design* in February, 1958, without though explicitly referring to contemporary art. Two years before, Richard Hamilton had integrated the word 'pop' in his meanwhile legendary collage *Just what is it that makes today's homes so different, so appealing.*

From a present point of view the events organized by the Independent Group between the years 1952 and 1955 concerning automobile and helicopter design, advertisement and Italian product design, fashion, science fiction and machine aesthetics had a programmatic impact on the art of the sixties. Within the context of the current discourse on pop the art magazine *Frieze*, established in 1991, functions in a complementary fashion, featuring – apart from portrayals of artists, specific art topics and exhibition reviews – extensive articles on design, cinema and music as well.

11 It is interesting to note in this context that the large exhibition of current British art that was presented in 1997 at the London Royal Academy and in 1998 at the Hamburger Bahnhof in Berlin had the title *Sensation*.

Pop art of the sixties was strongly interwoven with the sensations of consumer society. In this sense, Guy Debord's book *The Society of the Spectacle*, published in the year 1967, can be viewed as the philosophical manifest of that time. In this respect the scenarios Debord develops apply especially to the sensational aspect of pop art.[11] Debord's discriminating outlook was shared by many critics during

the sixties that were involved in examining the fascination of the product world. Being both drawn to this world and sceptical, they took a decidedly provocative approach by considering even the most trivial phenomena as worthy of transforming them into pictures, and by scrutinizing them in regards to their practical value for the art context. By seemingly negating an individual artistic hand, the pop artists consciously opposed the metaphysical claims of Abstract Expressionism. Debord's writings held the same importance for the pop artists as Jean Baudrillard's book *Le système des objets*, published a year later in 1968, in which the author attempts to classify everyday objects by means of a theory (and critique) of consumer society. In his book Baudrillard examines the symbolical character of these objects and their relationship to the subconscious of the consumers putting them to use. It must be noted, however, that at the particular point in time when both books were published, the climax of pop had already been exceeded. Not least because of their vehement criticism of consumer culture, these treatises can almost be seen as an obituary for pop art.

In contrast to pop art in the sixties young British artists today employ objects from the product world not so much with a view towards the system of their presentation in regard to the myths and fantasies they are stylized into within the field of advertisement. But, moreover, they are reviving motifs, events and forms of presentation from the pop context that had a formative influence on them in their youth. Unlike the artists of the sixties, this generation grew up surrounded by the omnipresence of television (MTV, etc.) and of constantly more differentiated advertisement strategies, in a society free, but essentially dominated by capital. The manifold ways in which these artists deal with the changed conditions is demonstrated by the current British art scene whose explosiveness in many areas is significantly triggered by the integration of elements derived from popular culture.

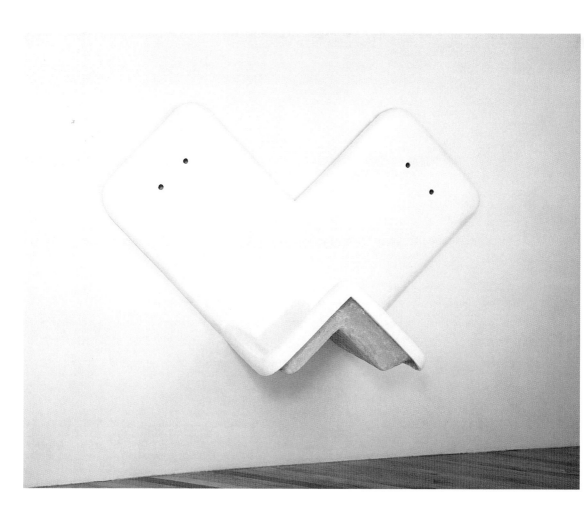

Robert Gober, The Sink Inside of Me, 1985

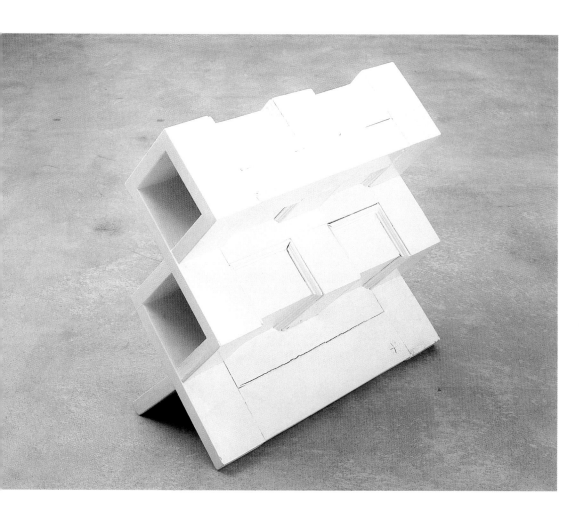

Robert Gober, Untitled, 1988

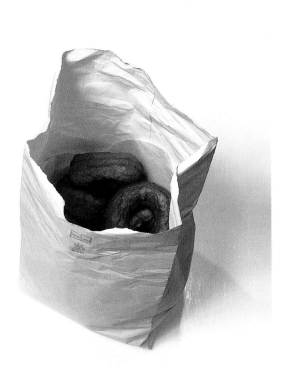

Robert Gober, Bag of Donuts, 1989

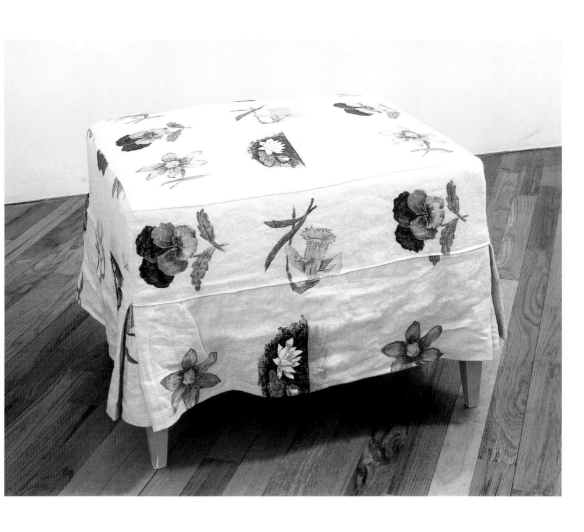

Robert Gober, Untitled, 1988

Robert Gober, Untitled, 1994

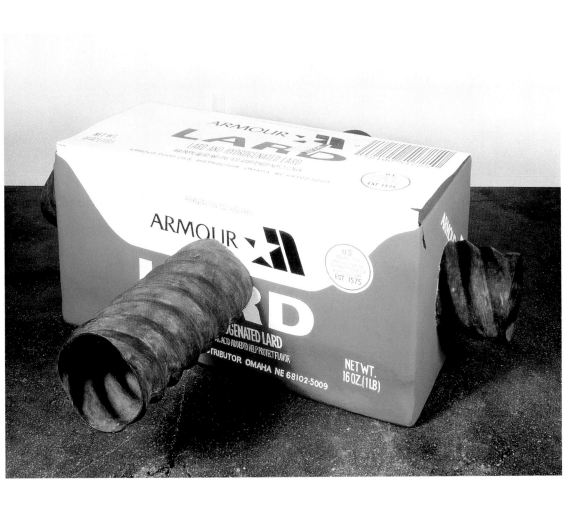

Robert Gober, Lard Box, 1994–95

Robert Gober, Untitled (Red Shoe), 1992

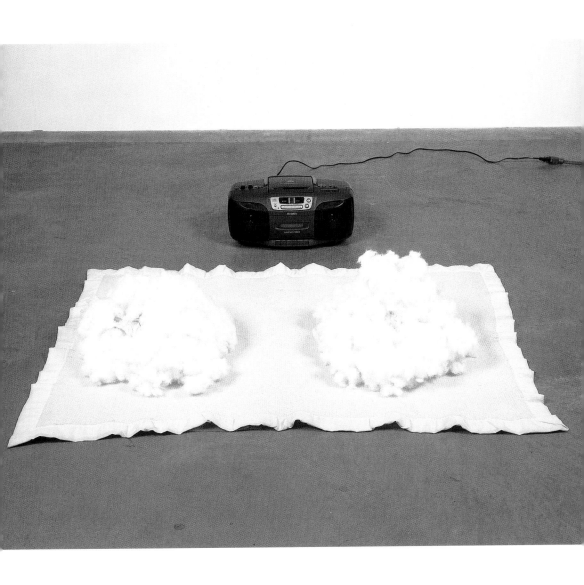

Mike Kelley, Dialogue # 1 (An excerpt from "Theory, Garbage, Stuffed Animals, Christ"),
German Version, 1991–96

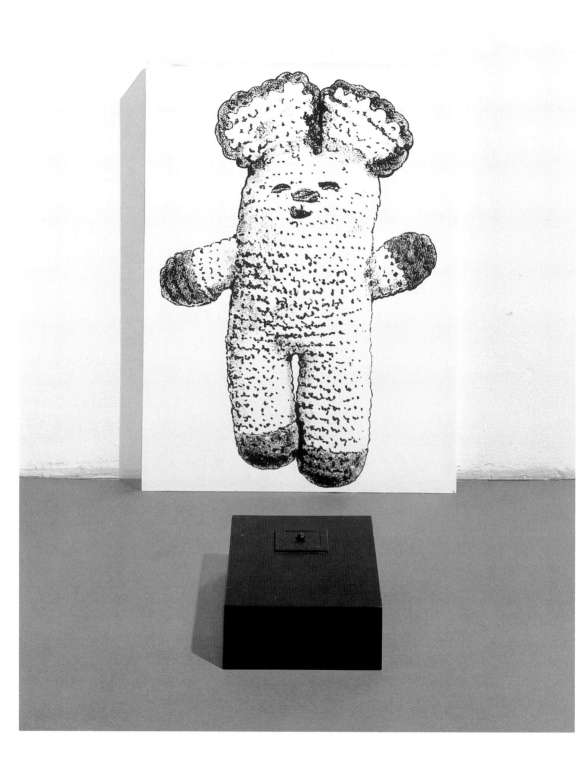

Mike Kelley, Empathy Displacement: Humanoid Morphology, 1990

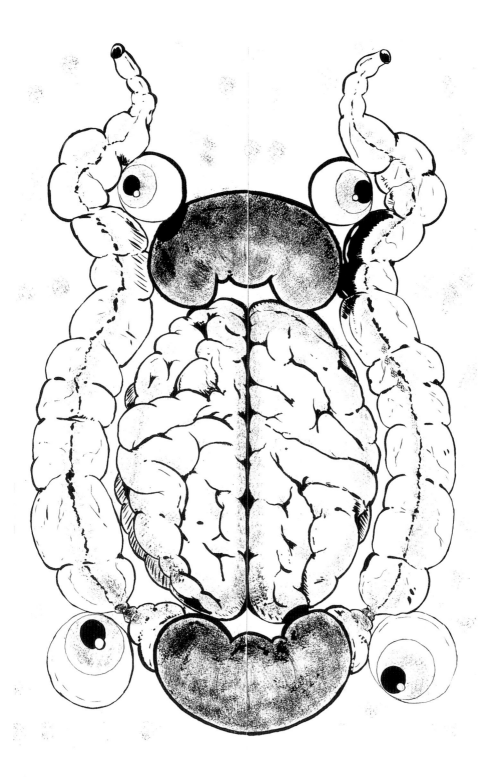

Mike Kelley, Incorrect Sexual Model: Utopia, 1987

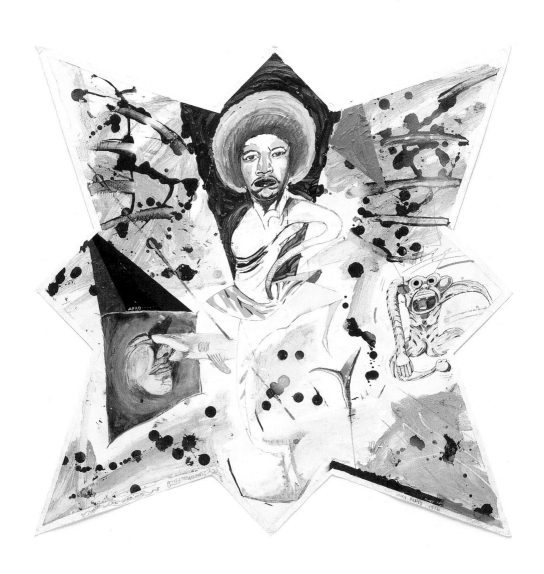

Mike Kelley, *Love to Love Your Baby (Jimi Hendrix)*, 1976

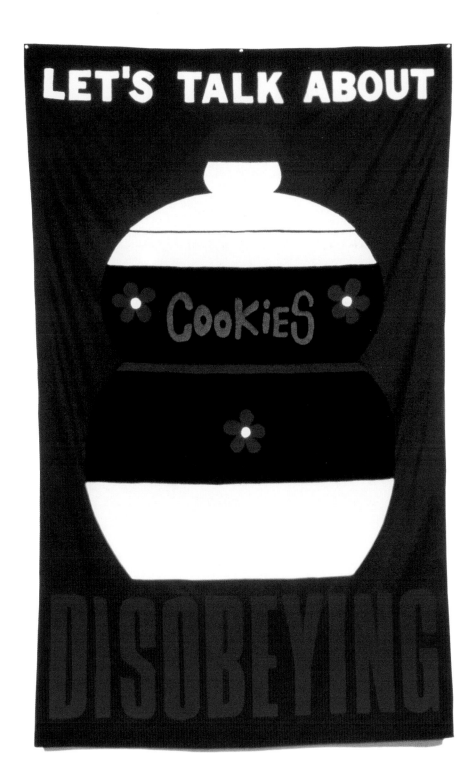

Mike Kelley, Let's Talk, 1987

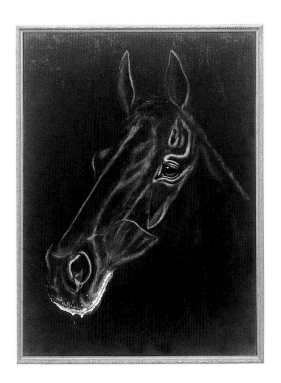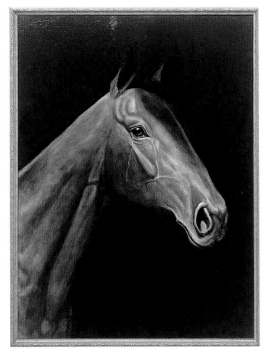

Mike Kelley, Alma Pater (Wolverine Den), 1990 (Detail)

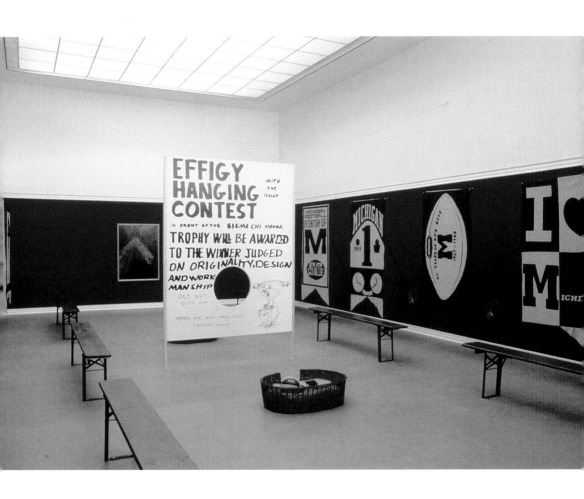

Mike Kelley, Alma Pater (Wolverine Den), 1990

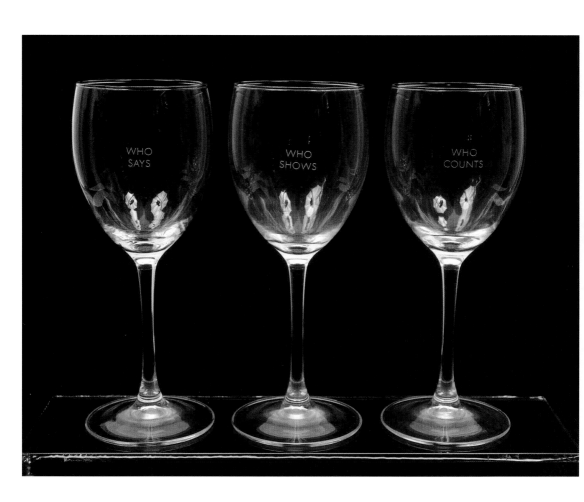

Louise Lawler, Who Says, Who Shows, Who Counts, 1990

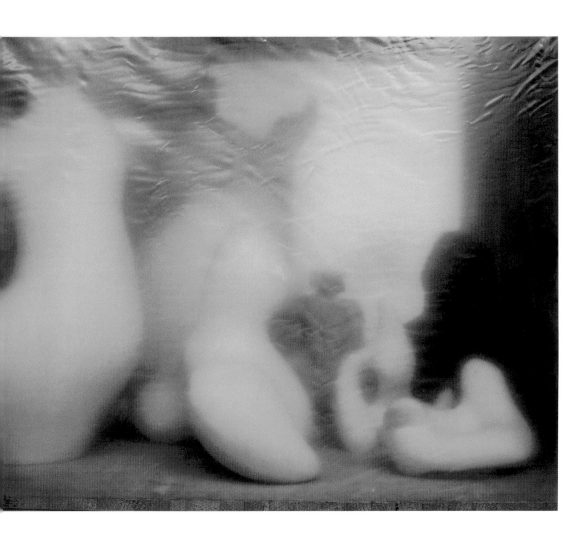

Louise Lawler, Original Models, 1993

Louise Lawler
Pollock and Tureen, arranged by Mr. and Mrs. Burton Tremaine, Connecticut, 1984

Louise Lawler, Untitled (Peter Halley), 1991

Louise Lawler, Glass and Local Storms, 1990

Louise Lawler, March 25, 1991, 1991

MORE THAN REAL
Varianten des Surrealismus &
Eine Theorie der Seele

Daniel Birnbaum

Jeder ist sich dessen bewußt, daß das Leben
parodistisch ist und keine Interpretation zuläßt.
Folglich ist Blei die Parodie von Gold.
Luft ist die Parodie von Wasser.
Das Gehirn ist die Parodie des Äquators.
Der Koitus ist die Parodie des Verbrechens.
Georges Bataille

Matthew Barney: »Houdini wußte wie man ein Schloß knackt, das noch nicht einmal erfunden war. Ich interessiere mich für die physische Transzendenz, die diese Form von Disziplin nahelegt.« [1]

Welche Vorstellung von Subjektivität liegt diesem Traum von der Transzendenz zugrunde? Sicherlich nicht der traditionelle Humanismus, der das menschliche Subjekt als ein beständiges Wesen betrachtet, das dauerhaft an eine verbindliche Identität gebunden ist. Vielmehr handelt es sich um eine Idee des Selbst als eine flexible, veränderliche Größe. Etwas Wandelbares: Tier, Maschine, mythologische Figur, Monster …

Wenn jetzt der historische Surrealismus in den Brennpunkt ehrgeiziger wissenschaftlicher Studien rückt, wie etwa bei Hal Fosters »Compulsive Beauty«, dürfte sich die Frage stellen, auf welche Weise dieses Vermächtnis weitergeführt worden ist. Welche Bedeutung könnte Surrealismus heute haben? »Ich glaube nicht, daß es in absehbarer Zeit ein surrealistisches Klischee gibt«, schrieb André Breton in seinem Ersten Manifest 1924. Seine Prognose hat sich allerdings nicht erfüllt: Spricht man heute von »Surrealismus«, denken die meisten sofort an eine Traumlandschaft von Salvador Dali – eine Uhr, die sich verflüssigt und über den Rand eines Abgrunds fließt. Dieses Klischee enthält jedoch unterschwellig eine facettenreiche visuelle Welt, die sich nicht so ohne weiteres auf einen simplen Nenner reduzieren läßt.

Die Kunst des Surrealismus erstreckt sich auf fotografische Experimente, ethnografische Studien, mechanische Phantasiegebilde und Traumkreaturen an der Grenze zwischen Tier, Mensch und Maschine. An den Rändern der Bewegung finden wir Figuren wie Georges Bataille, Hans Bellmer und, natürlich, Marcel Duchamp.

In der Kunst artikulieren sich unterdrückte Sexualkomplexe und vermitteln das unheimliche Gefühl, daß wir etwas zutiefst Fremdes in uns bergen, wie Freud in

1 Vergl. Thyrza Nichols Goodeve, »›The Logs He Carries AreToo Large‹: an Interview with Matthew Barney«, Matthew Barney, Tony Oursler, Jeff Wall (Ausst.-Kat.), Hrsg. von Ingvild Goetz / Sammlung Goetz, Hamburg 1996, S. 38.

128

seinem Essay »Das Unheimliche« (1919) ausgeführt hat. Auf der tiefsten Ebene unseres Wesens sind Kräfte am Werk, die wir weder akzeptieren noch wahrhaben wollen. Die Kunst setzt Energien frei, die der rationale Mensch nur als inhuman begreifen kann. Wir müssen aber diese Kräfte in uns zulassen, fordert Breton in seinem Manifest. Infantile Neigungen, Träume und Phantasien müssen ungehindert aus uns herausfließen, um beängstigende, wunderbare Formen des Lebens entstehen zu lassen: »Die Flora und Fauna des Surrealismus sind monströs.« Diese Flora und Fauna finden selbstverständlich auch in der heutigen Zeit reiche Nahrung. Sie gedeihen sogar besser denn je: in Matthew Barneys und Cindy Shermans Arbeiten beispielsweise. Und, auf weniger offensichtliche Weise, in den Arbeiten von Robert Gober und Tony Oursler, Charles Ray und Paul McCarthy. Der traditionelle Humanismus – der Glaube an eine Essenz, die »Menschheit« heißt – hat seine Macht verloren. Wir benötigen andere Modelle.

In seiner Abhandlung »Über die Genealogie der Moral« entwirft Nietzsche das Bild eines modernen Humanismus, der aus einer originären Gewalt entspringt, die sukzessive verfeinert, sublimiert und unsichtbar gemacht worden ist. Es geht darum, die Existenz eines »Menschentiers« zu definieren. Die erste Voraussetzung für das, was wir »Seelenleben« oder Subjektivität nennen, ist das Erinnerungsvermögen. Ein Gedächtnis, behauptet Nietzsche, kann nur durch Schmerz hergestellt werden: »Man brennt etwas ein, damit es im Gedächtnis bleibt: Nur was nicht aufhört, weh zu tun, bleibt im Gedächtnis.«[2] Die Geschichte von Brutalität und Gewalt reicht weit zurück: »Es ging niemals ohne Blut, Martern, Opfer ab, wenn der Mensch es nötig hielt, sich ein Gedächtnis zu machen.«[3] So ist das »Menschentier« durch die Erschaffung eines schmerzhaften, inneren Raums, der durch feine Dosierungen von Selbstquälerei (generell auch »Gewissen« genannt) erhalten bleibt, gleichsam »internalisiert« worden. Anstatt seine Aggressionen auszuleben, kehrt es sie nach innen und erhöht somit seine Leiden: »Alle Instinkte, welche sich nicht nach außen entladen, wenden sich nach innen – dies ist das, was ich die Verinnerlichung des Menschen nenne: Damit wächst erst das an den Menschen heran, was man später seine ›Seele‹ nennt. Die ganze innere Welt, ursprünglich dünn wie zwischen zwei Häute eingespannt, ist in dem Maße auseinander- und aufgegangen, hat Tiefe, Breite, Höhe bekommen, als die Entladung des Menschen nach außen gehemmt worden ist.«[4]

Diese Theorie über den inneren Raum des Subjekts als Produkt einer originären Gewalt und aggressiver Kräfte, die auf sich selbst zurückgeworfen werden, hat Michel Foucault weitergeführt. Seine Vorstellung des Subjekts als Resultat fundamentalerer Kräfte ist auf mehreren Ebenen formuliert worden und hat diverse essentielle Verschiebungen erfahren. Doch die Grundstruktur ist intakt geblieben: Das Innere ist das Produkt externer Energien. Foucault kommt in seinen Studien über institutionelle Macht, insbesondere in seiner Abhandlung »Überwachen und Strafen« (1976), Nietzsches Theorien am nächsten. Doch ging diesen Analysen der Macht eine sorgfältige Positionierung des

2 Vergl. Friedrich Nietzsche: Zur Genealogie der Moral (Werke, Bd. II), München 1966, S. 802.

3 Ibid.

4 Ibid., S. 825.

Subjekts auf der Ebene des Wissens voraus, und in seinen letzten Schriften finden wir noch eine weitere Ebene: Subjektivierung.

Der Mensch, wie er in den modernen Humanwissenschaften untersucht wird, ist Foucaults Schrift »Die Ordnung der Dinge« zufolge eine vorübergehende Bündelung der Kräfte, eine Art Knoten, der sich in der Zukunft lösen wird, um den Weg für alternative Lebensformen freizumachen: »Der Mensch ist eine Erfindung, deren junges Datum die Archäologie unseres Denkens ganz offen zeigt. Vielleicht auch das baldige Ende.«[5] Dementsprechend ist das Menschenbild des modernen Humanismus ein Entwurf, der bald »(…) verschwindet wie am Meeresufer ein Gesicht im Sand.«[6] Diese Vorstellung einer posthumanen Lebensform wird von Foucault nie zu Ende entwickelt und in nachfolgenden Texten durch Analysen der Macht ersetzt, wobei die Position des Subjekts im Sinne Nietzsches umrissen wird. Wissen und Macht sind untrennbar miteinander verbunden; die »Verinnerlichung« des Menschen ist hier eine Folge der unendlichen Modulation von Machtausübung innerhalb der Institutionen und der Wissenschaften.

Während sich Foucault in seinen Analysen meist auf »Prozesse der Subjektivierung« in vergangenen Epochen beschränkt, um Licht auf die Gegenwart zu werfen und unsere aktuellen Vorurteile zu hinterfragen, geht Gilles Deleuze einen Schritt weiter und stellt künftige Formen der Subjektivierung in Aussicht: posthumanistische Konstellationen des Lebens. Er erhebt die Frage, was geschieht, wenn die Energien des Lebens mit der dritten Generation von kybernetischen Maschinen in Kontakt geraten. Oder wenn die organische Chemie mit den siliziumgestützten Systemen künstlicher Intelligenz verbunden wird. Eine neue Lebensform betritt die Bühne – weder Mensch noch Maschine, weder Gottheit noch Tier. Warum sollte ein solches Wesen, daß »nicht länger an Kohlenstoff und die Erde gebunden ist, aber durch einen Siliziumchip Zugang zum Universum hat, noch ›Mensch‹ genannt werden«, fragt Deleuze und fügt hinzu, daß wir uns hier einem Territorium nähern, bei dem wir »aufpassen müssen, daß wir nicht auf der Ebene des Comic-strip landen.«[7]

An diese Prognosen mußte ich als erstes denken, als ich die Arbeiten von Matthew Barney bei der Documenta IX sah. Ich habe diese Arbeiten als Versuch einer Selbstinszenierung interpretiert, bei der Barney deutlich über das »Menschliche« hinausgeht. Seine Aktionen können zugleich aber auch als Befreiungsakt betrachtet werden: als Versuche, dem sozialen Raum zu entfliehen, der von Menschen – und *als* Menschheit – definiert wird. Ein halbnackter Körper wird mit allerlei Werkzeug und seltsamen Utensilien in Beziehung gesetzt und so in neue, bisher unbekannte Kraftfelder einer offensichtlich erogenen Qualität eingeschrieben. Doch ist dies noch ein Mensch?

Barney klettert mit seiner Bergsteigerausrüstung an der Decke entlang oder verschwindet in Aufzugschächten. Die Grenzen zwischen dem Körper, den Geräten

5 Vergl. Michel Foucault: Die Ordnung der Dinge, Frankfurt/Main 1974, S. 174.

6 Ibid.

7 Vergl. Gilles Deleuze: Pourparlers, Paris 1990, S. 125 (Übers. d. Orig.).

und Werkzeugen, die als vermittelndes Bindeglied zwischen Mensch und Raum dienen, und die architektonische Umgebung befinden sich in Auflösung. Barneys Räume sind mit »gymnastischem« Equipment angefüllt, das einen seltsam amorphen Charakter hat. Fast wirkt es, als wäre der gesamte Raum in einen Körper verwandelt worden, als wäre die Welt in ein Stadium infantiler, libidinöser Fixierung regrediert – eine globale anale Phase?

Barneys künstlerische Projekte können als Phantasien über posthumane Subjektivierungsprozesse gesehen werden: Eine bisher unbekannte Kreatur ist im Entstehen. Der menschliche Körper verbindet sich mit neuen physischen Regionen und neuen Formen des Begehrens. Sexualität ist in diesen Arbeiten und Aktionen explizit enthalten, während sie zugleich so radikal anders in Erscheinung tritt, daß sie nie ganz greifbar wird. Barney entfernt sich aus der ödipalen Struktur des Begehrens und entwickelt neue Fluchtwege.

Deleuze & Guattari haben vergleichbare Strategien in Kafkas Werk entdeckt: den Versuch, aus einer Subjektivität auszubrechen, die in den ödipalen Verhaltensmustern der Neurose verfangen ist. Das, was sie als »Tier-werden« bezeichnen, ist eine solche Fluchtstrategie. Dieses Motiv ist in Kafkas Kurzgeschichten in zahlreichen Varianten zu finden: Transformationen und Übergänge vom Mensch zum Tier. Das prägnanteste Beispiel ist vielleicht Gregor Samsas Metamorphose in einen Käfer, aber eine ebenso interessante Transformation wird in der Erzählung »Ein Bericht für eine Akademie«[8] beschrieben. Ein Affe wird an der afrikanischen Goldküste von der Firma Hagenbeck eingefangen, in einen Käfig gesteckt und nach Europa verschifft. Hinter Gittern eingesperrt, beginnt der Affe die Matrosen an Bord zu imitieren und kommt dann zu folgendem Entschluß: »(…) Affen gehören bei Hagenbeck unweigerlich an die Kistenwand –, so hörte ich auf, Affe zu sein.« Er lernt, kräftig auszuspucken, zu rauchen und eine Flasche Schnaps zu leeren und ist schon auf dem besten Wege, ein Mann zu werden. Doch reicht sein äußerliches Verhalten nicht aus: Ihm fehlt eine Seele. Wie aber kommt ein Affe zu einem Bewußtsein? Kafka hatte darauf die gleiche Antwort wie Nietzsche: durch Schmerz. Die Seele muß »eingebrannt« werden. Ein Matrose übernimmt die doppelte Aufgabe, den Affen zu trainieren und ihn auf subtile Weise zu peinigen. Durch strategisch dosierte Schmerzzufügung überwindet der Affe seine unreflektierte Tierexistenz. Er erlangt ein Gedächtnis, Sprache und eine Seele. Allmählich wird aus ihm ein kultiviertes Mitglied der Menschheit, und er stellt fest: »Durch eine Anstrengung, die sich bisher auf der Erde nicht wiederholt hat, habe ich die Durchschnittsbildung eines Europäers erreicht.«[9]

Hier findet die Subjektivierung in Richtung einer Humanisierung statt: Der Körper eines Tiers erhält eine Seele und wird menschlich. Diese Auffassung des Menschen als eine Art Konstrukt liegt auch jenen Fluchtwegen, die aus dem Humanismus herausführen, in den Untersuchungen von Deleuze & Guattari zugrunde. Bei Kafka zersetzt der Versuch, auszubrechen und die Gestalt eines Tiers anzunehmen, die Form

8 In: Franz Kafka: Sämtliche Erzählungen, Frankfurt/Main 1985, S. 147–155.

9 Ibid., S. 154.

131

»Mensch«. Matthew Barneys frühe Videos können meiner Ansicht nach von einer ähnlichen Perspektive aus betrachtet werden. Der Künstler steigt aus den Grenzen des »Menschseins« aus, um sich in neue Lebensformen hineinzubegeben. Uns fehlt es an geeigneten Begriffen für die Regionen, die sich hier auftun, und für die Wesen, die sie möglicherweise bevölkern.

In Barneys Arbeiten wird der Körper immer mit etwas, das außerhalb steht, in Beziehung gesetzt – eine Erweiterung des Raums, ein Gerät oder eine Grenze, die sich nicht überschreiten läßt und den Körper somit zu neuen Manövern zwingt. Der Körper selbst erscheint nie als etwas, das verbindlich definiert ist, sondern als Zone, in der Transformationen und Experimente stattfinden. Insbesondere die Körperöffnungen werden zum Gegenstand genauer Untersuchung. Es erscheint so, als würde Barney den Versuch unternehmen, den phänomenologischen Raum des Körpers durch radikale Rekodifizierung aller festen Koordinaten neu zu bestimmen. Das erinnert an Deleuze' Beschreibung von Francis Bacons Versuch, den Körper durch seine Öffnungen hindurch von innen nach außen zu stülpen.[10]

Barneys Dezentralisierung des humanistisch kodierten Körpers kann auch vor dem Hintergrund des Projekts, das in Michel Fehers Einleitung zu »Fragments for a History of the Human Body« beschrieben wird, betrachtet werden: »Die Geschichte des menschlichen Körpers ist weniger eine Geschichte seiner Repräsentationen als die der Modalitäten seiner Konstruktion. Denn die Geschichte seiner Repräsentationen bezieht sich stets auf einen Körper, der als ›geschichtslos‹ betrachtet wird – ob es sich um den Organismus handelt, der von den Naturwissenschaften untersucht wird, um den eigentlichen Körper, wie ihn die Phänomenologie begreift, oder um den instinktgesteuerten, verdrängten Körper, auf dem die Psychoanalyse basiert –, wobei die Geschichte der Modalitäten seiner Konstruktion den Körper, da sie die allzu massive Opposition von Wissenschaft und Ideologie oder von Authentizität und Entfremdung vermeidet, in einen gänzlich historisierten und vollständig problematischen Sachverhalt verwandelt.«[11]

Wenn sich Barney, an Metallhaken aufgehängt, langsam durch den Fahrstuhlschacht bewegt, ist er im Begriff, das Koordinatensystem zu verlassen, das den menschlichen Körper hinsichtlich seiner Menschlichkeit definiert. Dies ist nicht das erste Mal, daß jemand davon träumt, die körperlichen Energien vom »Gefängnis der Seele« zu befreien. Nietzsche folgend, wollte Bataille ein Wesen jenseits aller Vernunft schaffen – eine Kreatur ohne Kopf. Ein »Acephal«. Von seinem Kopf befreit, würde dieses Geschöpf Zugang zu völlig neuen Energien erhalten: »Der Mensch ist seinem Kopf entflohen, so wie der Verurteilte seinem Gefängnis entflieht. Außerhalb von sich hat er nicht Gott gefunden, der das Verbrechen verbietet, sondern das Wesen, das keine Verbote kennt. Außerhalb von mir entdecke ich ein Wesen, das mich zum Lachen bringt, weil es kopflos ist; das erfüllt mich mit Grauen, denn es ist von Unschuld und verbrecherischer Energie erfüllt. …

10 Vergl. Deleuze: Francis Bacon: Logique de la sensation, Paris 1981.

11 Michel Feher, »Introduction« in: Feher, Naddaff, Tazi (Hrsg.): Fragments for a History of the Human Body, New York 1989, S. 11.

Es ist kein Mensch. Es ist auch kein Gott. Es ist nicht ich, aber es ist mehr als ich selbst.«[12]

Fluchtwege aus dem Gefängnis des Menschseins? Formen der Subjektivierung, die den Menschen ablösen? Nietzsches Supermann, Batailles Acephal – in seinen frühen Arbeiten liefert uns Barney keine neuen Benennungen, statt dessen agiert er den Ausbruch als solchen tatsächlich aus.

Woran mag es liegen, daß der Surrealismus heute wieder an Relevanz zu gewinnen scheint? Bei einer wichtigen zeitgenössischen Figur wie Cindy Sherman hat ein ironisch-distanzierter Feminismus einer gewaltsameren Rebellion Platz gemacht: Ganze Kaskaden übelkeitserregender Substanzen quellen in ihren Bildern hervor. Ihr Interesse an menschlicher Identität als komplexes Artefakt kommt in menschlich-artifiziellen Zwitterwesen zum Ausdruck. Rosalind Krauss hat die Parallelen zwischen jenen Arbeiten von Sherman und den brutalen Puppengestalten, die Hans Bellmer in den dreißiger Jahren schuf, untersucht: Das gleiche schockierende Amalgam aus Gewalt und Sexualität bringt die Fundamente des »Normalen« ins Wanken. Im Vergleich zur kühlen, intellektuellen Dekonstruktion der achtziger Jahre, die in Sherrie Levines Kunst der Aneignung ihren Gipfel fand –, finden wir nunmehr Ausdrucksformen vor, die emotional aufgeladen sind. Was aber genau ist es, was in diesen Arbeiten an die Oberfläche drängt? Vielleicht vermittelt sich darin ein Gespür für die Unmöglichkeit intellektueller Kontrolle: Erst beginnt es nur aus kleinen Rissen herauszusickern, breitet sich dann aus, und plötzlich sind die Schleusen weit geöffnet. Etwas Formloses, Furchterregendes bricht hervor – aus dem Unterbewußtsein, der dunklen Nacht der Seele?

Dies ist jedoch kaum als Rückgriff auf eine vereinfachte freudianische Betrachtungsweise der Seele zu werten: Neo-Surrealismus ist kein Humanismus. Worin liegt der Unterschied? Das, was momentan entsteht, ist eine Art von Konkretisierung: Heutzutage erscheinen Bretons Phantasiegeschöpfe erschreckend real. Wir leben in einer Zeit, in der sich die ersten geklonten Schafe bereits vermehren. Dies sind Prozesse, die noch vor ein paar Jahrzehnten unvorstellbar gewesen wären, und die selbst heute nur wenige von uns begreifen können. Jan Avgikos hat kürzlich einen Vortrag über aktuelle Kunst am IASPIS in Stockholm gehalten. Sie stellte eine Liste der Dinge in unserer heutigen Welt auf, die ein Gefühl der Irrealität erzeugen: Genmanipulation, das Klonen von Lebewesen, komplexe Computersimulationen. Ist die Realität selbst surreal geworden?

Heute nimmt das Phantastische nicht nur in der Kunst, sondern auch in der sogenannten Realität Gestalt an. Offensichtlich kann unser Vorstellungsvermögen gelegentlich mit dem, was als Realität wahrgenommen wird, nicht Schritt halten. Die skandalösen Chapman-Brüder, die transsexuelle Monster, polymorph-perverse siamesische Drillinge und Achtlinge geschaffen haben, tun alles, um Aufmerksamkeit zu erregen. Aber können uns diese Puppen überhaupt noch schockieren? Surreale Kunst ist an die Grenzen des Erträg-

12 Georges Bataille: Œuvres complètes, Paris 1971, Bd. I, S. 232 (Übers. d. Orig.).

lichen gegangen und hat dabei eine unverkennbare Energie freigesetzt. Auf welche Weise wäre das heute möglich? Hat die Kunst in der Realität einen Konkurrenten gefunden, der einfach nicht zu schlagen ist?

Unter Matthew Barneys Filmen und Videos ist insbesondere der *Cremaster*-Zyklus meiner Ansicht nach eine der wenigen Arbeiten in der aktuellen Kunst, die gegen die Realität antreten kann. Worum geht es in diesen Filmen, wie lassen sie sich klassifizieren? Jerry Saltz hat eine ernsthafte Anstrengung unternommen: Theater, Science-fiction, Action-Abenteuer, Horror, biologischer Thriller, Pornografie. Sie sind dies alles und nichts davon. Neo-Surrealismus als zusätzliche Kategorie einzuführen, hilft da auch nicht weiter. Zu spät – das ist schon geschehen.

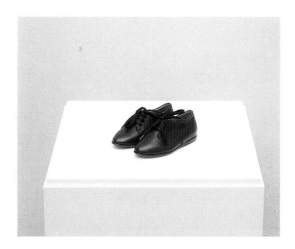

Sherrie Levine, 2 Shoes, 1992

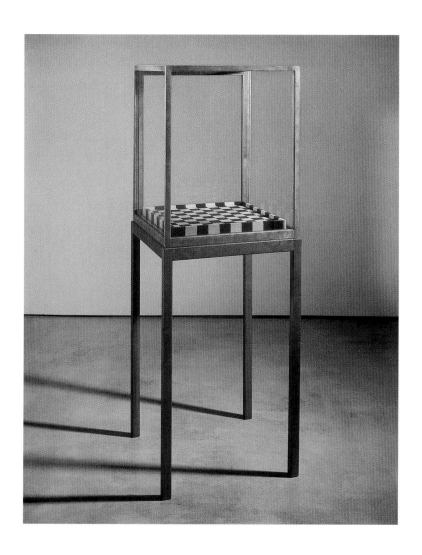

Sherrie Levine, Untitled (After Marcel Duchamp: Chessboards: 3), 1989

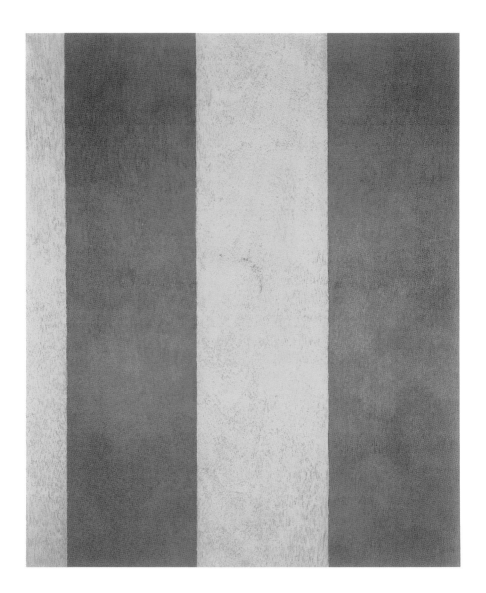

Sherrie Levine, Untitled (Broad Stripe: 1), 1985

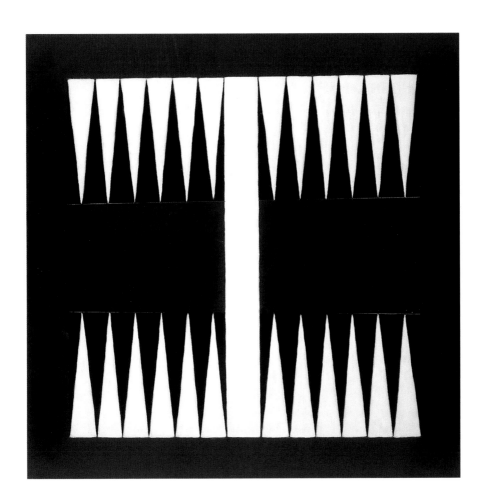

Sherrie Levine, Untitled (Lead Chevron: 9), 1988

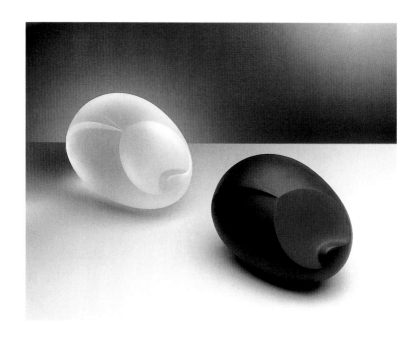

Sherrie Levine
Crystal Newborn, 1993
Black Newborn, 1994

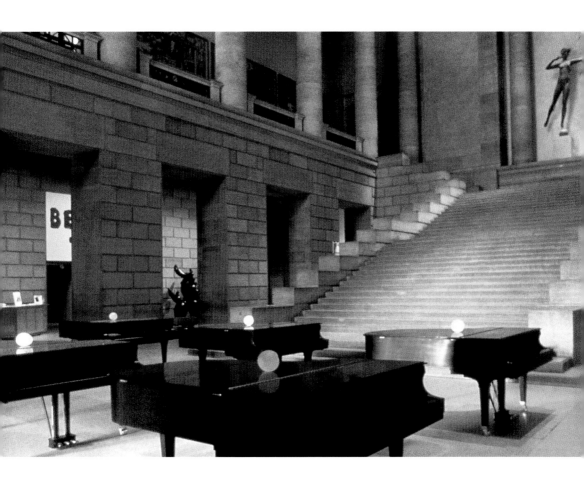

Installation von Sherrie Levines *Newborn* im Philadelphia Museum of Art, 1993
Sherrie Levine's *Newborn* installed at the Philadelphia Museum of Art, 1993

S./p. 140: Cady Noland, Rubberneck Communion, 1991
S./p. 141: Cady Noland, Tanya as a Bandit, 1989

161D NEW YORK, May 20-XXX A SUSPECT-The FBI charged Patricia Hearst p
ation of the federal firearms law Monday in Los Angeles. The charge
ies that Miss Hearst sprayed bullets at a sporting goods store in L
eles after a clerk attempted to stop William and Emily Harris, mem-
ted Symbionese Liberation Army members, from shoplifting a pair of
ks. This photo is a copy of one received in April in San Francisco
io station KSAN and purports to show Miss Hearst in front of a Sym-
nese Liberation Army insignia. (AP Wirephoto)(lee AP 51s 20sty
501/5/14)1974.

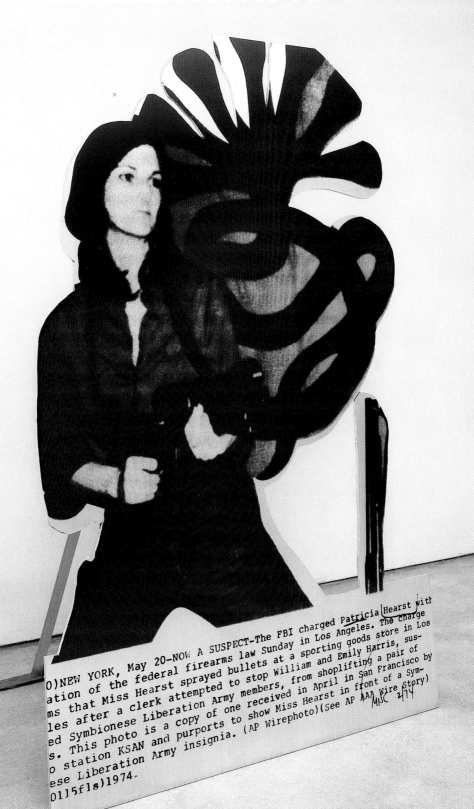

Cady Noland, California Offender, 1994

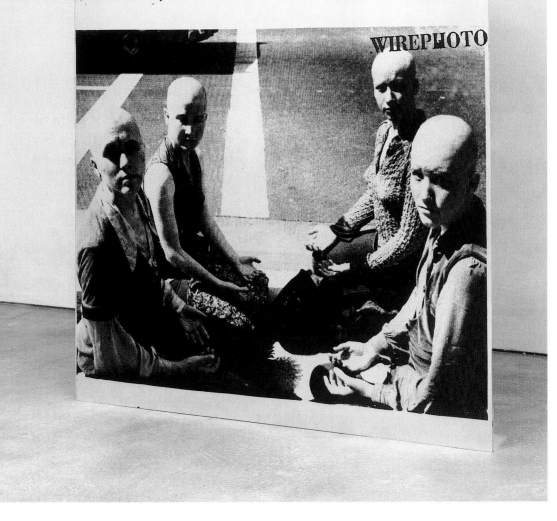

Cady Noland, Not Yet Titled (bald Manson girls sit-in demonstration), 1993–94 143

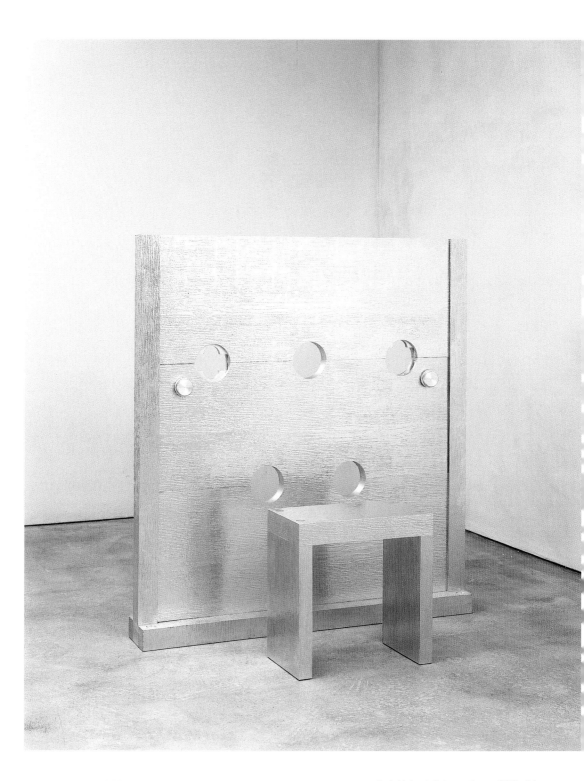

Cady Noland, Beltway Terror, 1993–94

MORE THAN REAL
Versions of Surrealism &
A Theory of the Soul

Daniel Birnbaum

Everyone is aware that life is parodic
and that it lacks an interpretation.
Thus lead is the parody of gold.
Air is the parody of water.
The brain is the parody of the equator.
Coitus is the parody of crime.
Georges Bataille

Matthew Barney: "Houdini knew how to pick a lock that hadn't even been invented yet. I'm interested in the physical transcendence that kind of discipline proposes."[1]

What is the conception of subjectivity inherent in this dream of transcendence? Clearly not a traditional humanism which views the human subject as a stable entity resting once and for all in permanent self-identity. Rather a sense of the self as something flexible and mutable. Something that is capable of transformations: animal, machine, mythological figure, monster…

At the present time, when historical surrealism is being brought into focus with ambitious studies such as Hal Foster's *Compulsive Beauty*, we may ask how this legacy has been carried on. What could surrealism mean today? "I do not believe any surrealist cliché will arise in the near future," André Breton wrote in his first manifesto in 1924. His prediction, however, did not prove true: use the term 'surrealism', and most people think of some dreamlike landscape by Salvador Dalí – a clock turning into fluid and flowing over the edge of a precipice. But underlying this cliché is a rich, multi-faceted visual world that is difficult to reduce to a common denominator. Surrealist art branches out into photographic experiments, ethnographic studies, mechanical fantasies and dreams of creatures on the fringe between animal, man and mechanical device. On the margins of the movement we find figures like Georges Bataille, Hans Bellmer and of course Marcel Duchamp.

In art, repressed sexual complexes become tangible, creating the uncanny feeling that there is something profoundly alien concealed within us, Freud contends in the essay "The Uncanny" (1919). On the deepest level of our selves forces that we do not wish to acknowledge, and do not want to know, are at work. Art sets energies free that the rational person can only conceive of as inhuman. We must admit these forces, Breton says in his manifesto. Infantile wishes, dreams and fantasies have to be let

1 cf. Thyrza Nichols Goodeve, "'The Logs He Carries Are Too Large': an Interview with Matthew Barney," *Matthew Barney, Tony Oursler, Jeff Wall* (exhib. cat.), Ingvild Goetz/ Sammlung Goetz, ed., (Hamburg 1996), p. 38.

145

loose in an automatic flow that enables frightening, marvellous forms of life to emerge: "The flora and fauna of surrealism are monstrous." These flora and fauna certainly exist to this day. Indeed, they are thriving: in Matthew Barney's work and in Cindy Sherman's. And – in a perhaps less obvious fashion – in the work of Robert Gober and Tony Oursler, Charles Ray and Paul McCarthy. Traditional humanism – the belief in an essence called "Man" – has lost its power. We need other models.

In *On the Genealogy of Morals*, Nietzsche delineates a picture of modern humanism as arising from an original violence which has subsequently been refined, sublimated and made invisible. The issue is to explain the existence of an "animal with soul". The first presupposition for what we call 'mental life' or 'subjectivity' is a capacity for memory. Memory, Nietzsche contends, can only be brought about by pain: "If something is to stay in the memory it must be burned in: only that which never ceases to hurt stays in the memory."[2] This reflects a long history of brutality: "Man could never do without blood, torture, and sacrifices when he felt the need to create a memory for himself." Thus, the 'animal man' has become 'internalized' by creating a painful inner space, nourished by subtle doses of self-torture (generally referred to as conscience). Instead of acting out its aggressions, it turns them inwards increasing its sufferings: "All instincts that do not discharge themselves outwardly turn inward – this is what I call the 'internalisation' of man: thus it was that man first developed what was later called his 'soul'. The entire inner world, originally as thin as if it were stretched between two membranes, expanded and extended itself, acquired breadth and height, in the same measure as outward discharge was inhibited."

This theory about the inner space of the subject as being a product of an original violence and of aggressive forces turned back onto themselves, has been further developed by Michel Foucault. His notion of the subject as a result of more fundamental forces has been expressed on different levels, and it has undergone various essential displacements. But the basic structure has remained intact: the interior is a product of external energies. Foucault is at his most Nietzschean in his studies of institutional power, above all in *Discipline and Punish.* But these analyses of power were preceded by a careful positioning of the subject on the level of knowledge; and in the very last writings we find even one more level: subjectivation.

'Man' as an object of study in the modern human sciences is, according to *The Order of Things*, a temporary crystallisation of forces, a kind of knot which in the future will be untied and give way to alternative forms of life: "As the archeology of our thought easily shows, man is an invention of recent date. And perhaps one approaching its end." The 'Man' of modern humanism is a formation that soon will be "erased, like a face drawn in the sand at the edge of the sea."[3] This prognosis for post-human life is never fully developed by Foucault, and in subsequent texts it is replaced by analyses of power,

2 Nietzsche, *On the Genealogy of Morals*, II: 3. All subsequent Nietzsche quotes are from this text.

3 Foucault, *The Order Of Things* (New York, 1973), p. 387.

circumscribing the position of the subject in a Nietzschean manner: knowledge and power are inextricably intertwined; the 'internalisation' of man is an effect of the infinite modulation stemming from the exercises of power within institutions and the sciences.

Whereas, most of the time, Foucault restricts his analyses to "processes of subjectivation" in past epochs, in order to shed light on the present and question our contemporary preconceptions, Gilles Deleuze goes one step further and predicts future forms of subjectivation: post-humanist constellations of life. He asks: What happens when the energies of life enter into contact with the third generation of cybernetic machines? What happens when organical chemistry is joined with the silicon based systems of artificial intelligence? A new life form enters the stage – neither man nor machine, neither god nor beast! Why should such a being, "no longer tied to carbon and the earth, but having access to silicon and the universe, still be called man?" Deleuze adds: here we are approaching a territory where we have to "look out so as not to end up on the level of the comic strip."[4]

These predictions were my very first associations upon seeing Matthew Barney's work at *Documenta IX*. I interpreted these works as an attempt at 'self-staging' that clearly transcends the "human." His actions can be seen as attempts at liberation: attempts to escape from the social space defined by – and as – Man. A half-naked body enters into a relation with tools and peculiar utensils, thus inscribing itself in new and previously unknown fields of force of an apparently erogenous nature. Is this still a man?

Barney climbs the ceiling with his mountaineering equipment; he disappears into an elevator shaft. The border between the body, the mediating tools and the surrounding architecture is about to dissolve; Barney's rooms are filled with 'gymnastic' equipment of a strangely anthropomorphic character. It is as if the entire room has been transformed into a body; as if the world has regressed to a state of infantile libido fixation; a global anal stage?

Barney's artistic projects can be read as fantasies about post-human subjectivation processes: a beast, hitherto unknown, is about to take shape. The human body becomes associated with new material regions and new desires. Sexuality is explicit in these works and actions, while simultaneously so radically different that it remains impossible to grasp. He moves out of the Oedipal structure of desire; he creates a route of escape.

Deleuze & Guattari have discovered comparable strategies in Kafka's works: attempts to overcome a subjectivity caught within the Oedipal pattern of neurosis. One such line of escape is what they call "becoming-animal." This may be found in many variations in Kafka's short stories: transformations and transitions between the human and the animal. The most evident example is perhaps Gregor Samsa's metamorphosis into a beetle, but an equally interesting transformation can be studied in *Statement Presented to an Academy*.[5] A monkey is caught at the African Gold Coast by the firm Hagenbeck; it is

4 Deleuze, *Pourparlers* (Paris, 1990), p. 125

5 In Kafka, *Sämtliche Erzählungen* (Frankfurt am Main, 1970).

147

put into a cage and brought to Europe. Trapped behind bars, the monkey begins to imitate the sailors on board. The monkey comes to a decision: "At Hagenbeck, the place for monkeys is inside a cage – well, so I had to stop being a monkey." He learns how to spit, smoke and empty a bottle of liquor; he his well on his way to becoming a man. But outward behaviour is not sufficient, a soul is lacking. How does a monkey acquire a consciousness? Kafka's answer runs just like Nietzsche's: through pain. The soul needs to be burnt in. A sailor performs the double service of trainer and subtle torturer. Through strategically applied doses of pain the monkey overcomes his unreflected animal life. He acquires a memory, language and a soul. Gradually he becomes a cultivated member of the nation of Man and reaches the following conclusion: "By an effort, as yet unprecedented on this earth, I have reached the culture of an average European."

Here the subjectivation takes place in a humanist direction: an animal body acquires a soul and becomes human. Such a view on 'Man' as a sort of construct is a precondition for those paths of escape out of humanism investigated by Deleuze & Guattari. In Kafka, the attempts to break out appear in the guise of 'becoming animal' which disrupts the form 'Man.' Matthew Barney's early videos may in my opinion be viewed from a similar perspective. He climbs out of the human shape and into a new life form. We lack adequate names for those regions opening up here, and for those beings that might possibly inhabit them.

In Barney's work the body is always related to something external – an extension, a tool or a limit that cannot be transcended, thus forcing the body to undertake new manœuvres. The body is never anything which can be defined once and for all, but instead a zone in which transformations and experiments take place. The orifices particularly become the object of close scrutiny. It is as if Barney attempted to redefine the phenomenological space of the body by a radical recoding of all fixed co-ordinates. One is reminded of Deleuze's description of Francis Bacon's attempt to turn the body inside out through its own orifices.[6]

Barney's decentralisation of the humanistically coded body can also be read in the light of the project delineated by Michel Feher in the introduction to *Fragments for a History of the Human Body:* "[T]he history of the human body is not so much the history of its representations as of its modes of construction. For the history of its representations always refers to a body considered to be 'without history' – whether this be the organism observed by the natural sciences, the body proper as perceived by phenomenology, or the instinctual, repressed body on which psychoanalysis is based – whereas the history of its modes of construction can, since it avoids the overly massive opposition of science and ideology or of authenticity and alienation, turn the body into a thoroughly historicised and completely problematic issue."[7]

When Barney, suspended in metal hooks, slowly travels through the eleva-

6 Deleuze, *Francis Bacon: Logique de la sensation* (Paris, 1981).

7 Feher, "Introduction" in Feher, Naddaff, Tazi (ed.), *Fragments for a History of the Human Body* (New York, 1989), p. 11.

tor shaft, he is in the process of leaving the system of co-ordinates defining the human body in terms of its humanity. It is not the first time somebody dreams of liberating the bodily energies from the "prison of the soul." Following Nietzsche, Bataille wanted to create a being beyond the rational – a creature without a head. An acephal. Liberated from his head, this creature would gain access to wholly different energies: "Man has escaped from his head just as the condemned man has escaped from his prison. He has found beyond himself not God, who is the prohibition against crime, but the being who is unaware of prohibition. Beyond what I am, I meet a being who makes me laugh because he is headless; this fills me with dread because he is filled with innocence and crime … He is not a man. He is not a god either. He is not me, but he is more than me."[8]

Escape routes from the human prison? Forms of subjectivation beyond man? Nietzsche's Superman, Bataille's Acephal … In his early works, Barney gives us no new definitions, but instead enacts the ultimate escape.

Why is it that surrealism seems to gain new relevance today? In the case of a major contemporary figure such as Cindy Sherman, a cool, ironic feminism has given way to a more violent form of rebellion: cascades of nauseating substances well up in her pictures. Her interest in human identity as a complex artefact has opened the gates to fantasies about human and artificial-human hybrids. Rosalind Krauss has analysed to what extent these particular works of the artist relate to the brutal dolls created by Hans Bellmer in the 1930s – the same shocking amalgam of violence and sexuality sets normality swaying on its foundations. In opposition to the intellectual and cool deconstruction of the 1980s – which reached an apogee in Sherrie Levine's appropriation art – we now have more emotionally charged forms of expression. What is it that is forcing its way to the surface in these works? Perhaps it is an awareness of the impossibility of intellectual control: it begins to ooze out of a small crack, expands and then suddenly the gates are flung wide open. Out pours something shapeless and terrifying. Out of the unconscious, out of the 'dark night of the soul'?

This is hardly to be seen as a return to some simplified Freudian view of the psyche: neo-surrealism is not a form of humanism. Where lies the difference? What is emerging here is a kind of material manifestation: today, Breton's fantasy creations seem menacingly real. We live in an age in which the first cloned sheep has already become a mother. These are processes that nobody could have envisioned a few decades ago, and only a few of us can grasp them even today. Jan Avgikos recently gave a talk on contemporary art at IASPIS in Stockholm. She made a list of phenomena in the contemporary world that evoke a sense of unreality: gene manipulation, cloning, complex computer simulations. Has reality itself become surreal?

Today, the fantastic is gaining shape, not just in art, but equally in so-called reality. Clearly our imagination can at times have difficulty to catch up with what is

8 Bataille, *Oeuvres complètes* (Paris, 1971), vol 1, p. 232.

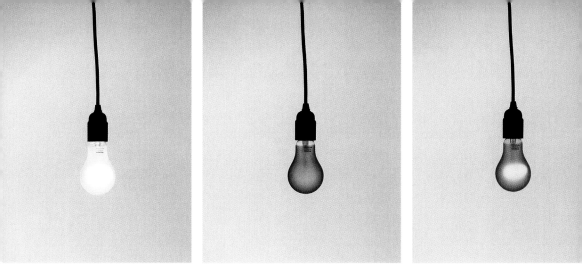

perceived as reality. The scandalous Chapman brothers – who have created transsexual monsters, polymorphous perverse Siamese triplets and octuplets – do what they can to attract attention. But are these dolls actually capable of shocking us? Surrealist art has gone to the edge of the acceptable and generated an unmistakable energy. How can this work today? Has art received a competitor – reality – that is just too tough to conquer?

Matthew Barney's films and videos – especially the *Cremaster cycle* – is, in my view, one of very few recent art works that could be a match for reality. What are these films about, how is one to classify them? Jerry Saltz has made a serious attempt: drama, science fiction, action adventure, horror, biological thriller, pornography. All of these and none. To add neo-surrealism as an additional category doesn't help. Too late, it's already been done.

Tony Oursler, Talking Light, 1996

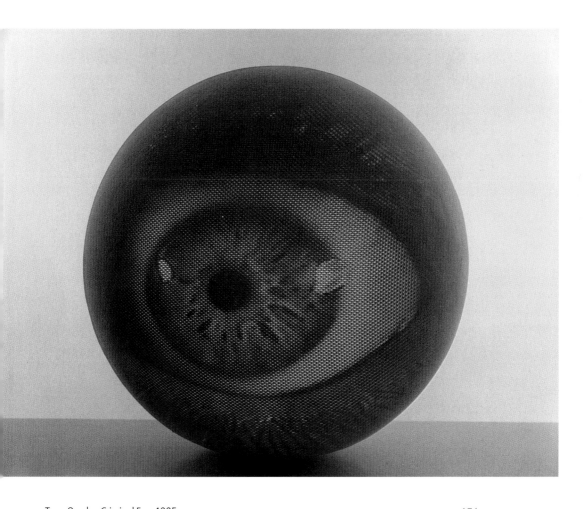

Tony Oursler, Criminal Eye, 1995

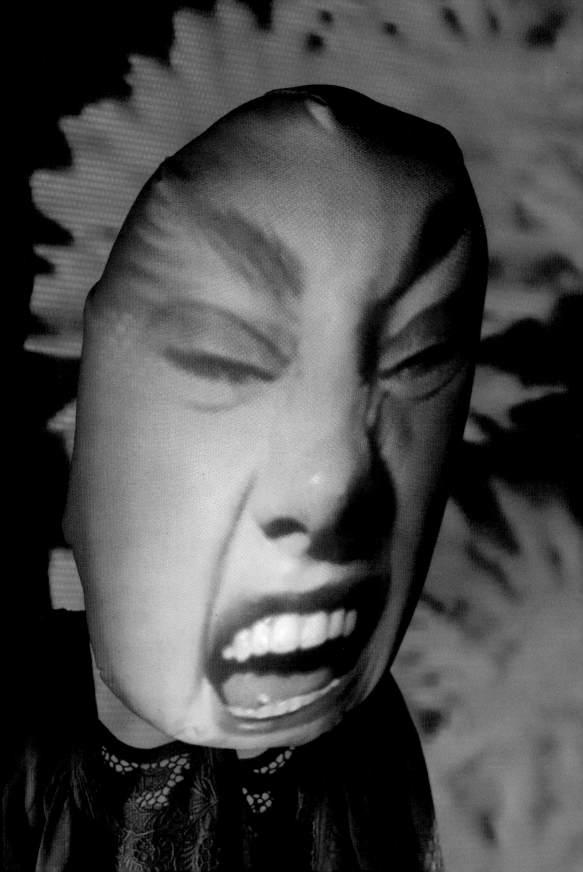

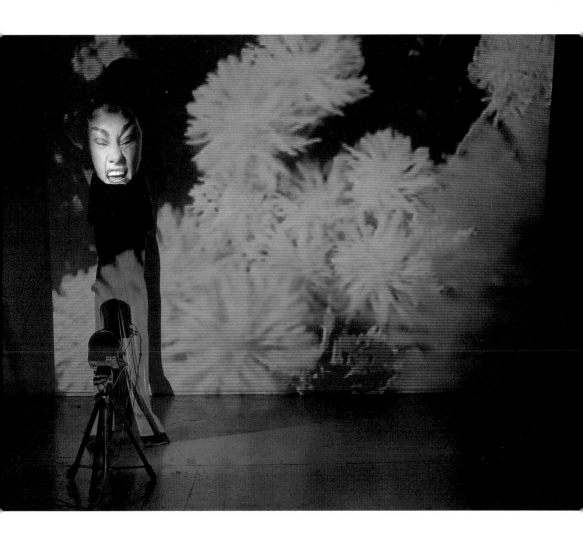

Tony Oursler, Sketchy Blue, 1996
◁ Detail

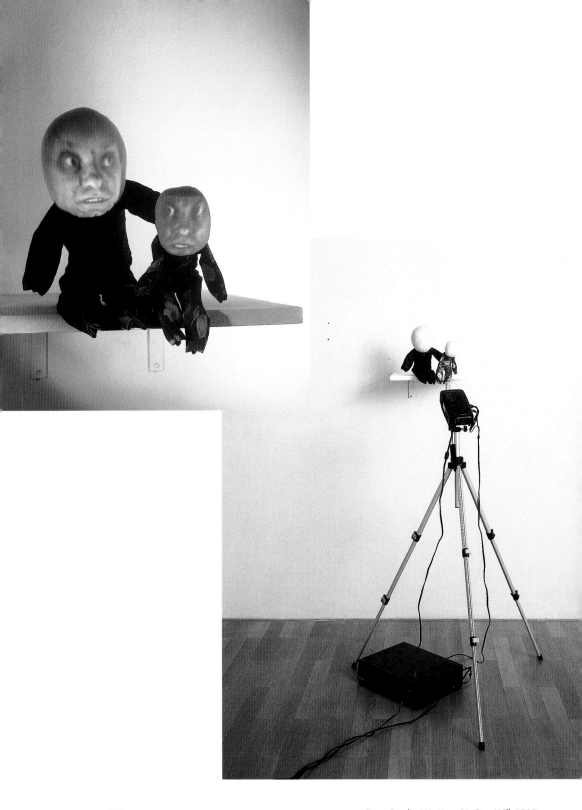

Tony Oursler, We Have No Free Will, 1995

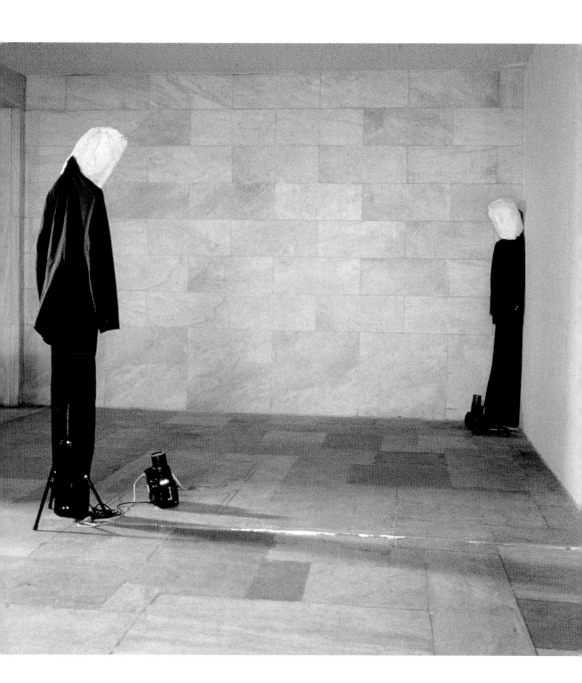

Tony Oursler, White Trash/Phobic, 1994

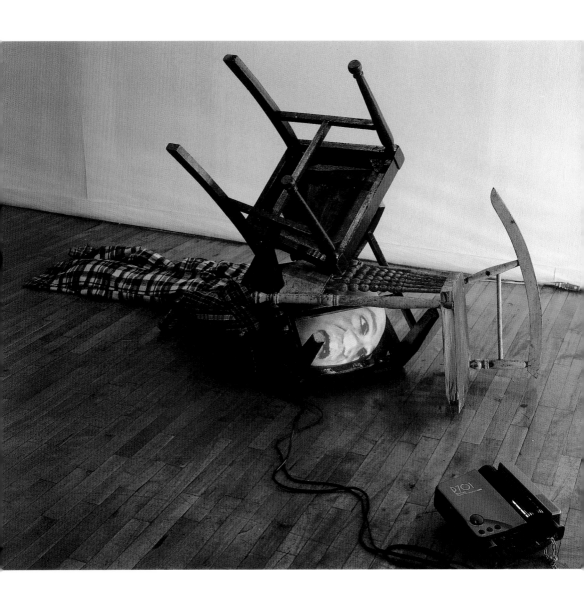

Tony Oursler, Broken, 1994

Two Lions Sitting Around After Supper: One lion says to the other, "Hey, Sid, remember last summer when we were all gathered around the kill and someone told a leopard joke, and you laughed so hard an antler came out of your nose?"

Two lions sitting around after supper: One lion says to the other, "Hey, Sid, remember last summer when we were all gathered around the kill and someone told a leopard joke, and you laughed so hard an antler came out of your nose?"

Richard Prince, Two Leopard Joke, 1989

A wife tells her husband he's the world's biggest schmuck.
"In fact," she says, "if they had a contest for schmucks,
you'd come in second." "Why second?" he asks. Says the wife,
"Because you're a schmuck!"

Richard Prince, Not Q Enough, 1992

I met my first girl, her name was Sally. Was that a girl, was that a girl. That's what people kept asking.

Richard Prince, Lady Doc/They Keep Asking, 1990–92

Richard Prince
△ Cowboy, 1984
◁ Creative Evolution, 1984–85

Richard Prince, Untitled (aus: October Portfolio), 1977/93

EMOTION UND SENSATION

Friedrich Meschede

Als 1987 unter der Regie der Royal Academy of Arts die Ausstellung »British Art in the 20th Century« konzipiert wurde – eine Ausstellung, die unter dem Titel »Englische Kunst im 20. Jahrhundert« im selben Jahr in der Staatsgalerie Stuttgart zu sehen war –, wurde die Bilanz über das Jahrhundert britischer Kunst offensichtlich zu früh gezogen. Das, was wir heute, zehn Jahre später, überhaupt als die britische Kunst verstehen, beginnt erst 1988 mit der inzwischen legendären, von Künstlern selbst organisierten Ausstellung »Freeze« – nicht in der Royal Academy selbstverständlich, sondern im Osten Londons in einer leerstehenden Spekulationsimmobilie. Die Tatsache, daß die seitdem anhaltende Euphorie über diese beispiellose Erfolgsstory junger britischer Kunst die eigentliche Sensation ist, mag die Verantwortlichen der Royal Academy bewogen haben, das Ereignis zum Titel zu erheben für die Ausstellung, mit der eine Privatsammlung 1997 in London vorgestellt wurde.

Als 1993 in der Fortsetzung dieser Serie von Übersichtsausstellungen zur Kunst des 20. Jahrhunderts unter nationalem Aspekt – ebenfalls in der Royal Academy in London und im Martin-Gropius-Bau in Berlin – die amerikanische Kunst des 20. Jahrhunderts beleuchtet wird, sind die Übergänge von den Anfängen bis heute weniger abrupt. Robert Gober, Mike Kelley und andere hatten schon ihren Platz in der Geschichte und in den Augen der Organisatoren gefunden, aber sie stellen auch keine Sensation mehr dar. Eine neue Generation folgt den vielen anderen des an Avantgarden reichen Amerika des 20. Jahrhunderts. Jedoch liegt das Defizit großer, vermeintlich historischer Übersichtsausstellungen, die zudem einem nationalen Aspekt im Zeitalter übernationaler Kommunikation folgen wollen, im Defizit eines theoretischen Instrumentariums, die Kunst des 20. Jahrhunderts und ihre Entwicklungslinien objektivieren zu wollen und zu können. Der Katalog ist als Standardwerk konzipiert und gibt den bekannten lexikalischen Standard wieder.

Was für die junge Kunst in den USA wie eine kontinuierliche Fortsetzung seit der amerikanischen Selbstbehauptung durch Pollock und Newman erscheint und immer wieder in jeder Dekade seit dem Zweiten Weltkrieg mit neuen Protagonisten hervorgebracht wird, ist für das Selbstverständnis der britischen Kunst neu. Zwei Aspekte müssen benannt werden, um den Erfolg von »Young British Art« verständlicher zu machen. Einerseits ist die Aufmerksamkeit für Künstler aus Großbritannien das Ergebnis einer langfristigen und weitsichtig angelegten Politik, die sich durch die Einrichtung des British Council vor 40 Jahren ein wirksames Instrument

auswärtiger Kulturpolitik geschaffen hat, das es vergleichbar in Amerika gar nicht, in anderen Staaten Europas nur bedingt gibt. Der Siegeszug junger britischer Kunst basiert weniger auf Ausstellungen im eigenen Land als vielmehr auf den Erfolgen der Gruppenausstellungen in der ganzen Welt von Minneapolis bis Wolfsburg.

Andererseits ist durch die junge britische Künstlergeneration ein nationales Selbstbewußtsein erwacht, das erst am Ende des 20. Jahrhunderts erkennt, daß britische Künstler zum ersten Mal im 20. Jahrhundert die Avantgarde stellen. Ein Mentor der jungen Generation, Michael Craig-Martin, sieht einen Grund für die Hochstimmung unter den Künstlern aller Generationen in Großbritannien darin, daß sie sich das Gefühl zu eigen gemacht haben und davon getragen werden, erstmals innerhalb der Kunstgeschichte der Moderne die Innovationen vorzugeben, zumindest einen wesentlichen Anteil daran zu haben. Bisher waren die künstlerisch-avantgardistischen Bewegungen in anderen Metropolen entstanden, in Paris natürlich zu Beginn des Jahrhunderts, dann in Berlin, lokalisierbar in Dessau, wieder in Paris und selbstverständlich in der zweiten Hälfte unseres Jahrhunderts in New York. Heute gehen Ideen von London aus und behaupten sich als Ausdruck innovativer, zeitgenössischer Kunst, auf die man stolz ist und mit der man sich identifiziert. Endlich kann auch bildende Kunst in Großbritannien eine Bewegung auslösen, wie sie zuvor und vergleichbar legendär in der Popmusik geschaffen worden war. An dieser Avantgarde können alle partizipieren, sie schließt alle sozialen Klassen ein, weil sie nicht elitär sein will, sondern öffentlich.

In dieser Verbindung von nationalem Selbstwertgefühl und avantgardistischem Selbstbewußtsein liegt ein aufschlußreicher Konflikt. Nikos Papastergiadis hat anläßlich der aktuellsten Ausstellung mit Kunst aus Großbritannien »Pictura Britannica« im Museum of Contemporary Art in Sydney im begleitenden Katalog darauf hingewiesen, daß Avantgarde in der Geschichte der Kunst der Moderne ihr Selbstverständnis darauf gründete, Grenzen zu überschreiten, nicht sie zu definieren. Die Wanderungen der Künstlerpersönlichkeiten des 20. Jahrhunderts, auch ihre erzwungenen Vertreibungen, haben Kunst zu internationaler Wirkung geführt, einen Dialog und Austausch über alle Einengungen hinaus geschaffen. Bei der englischen Avantgardegeneration vernimmt man häufig den Wunsch, nach Hause zu wollen, zurück nach London als der einzigen Stadt, in der man leben kann. Wenn man also die Präsenz von Kunst aus Großbritannien in Ausstellungen außerhalb Großbritanniens als Avantgarde begreift (»jung, frech, schräg und schrill, und vor allem sie ist aufregend«, titelte das Feuilleton der Frankfurter Allgemeinen Zeitung am 1. Januar 1997 anläßlich von »Full House« in Wolfsburg), dann liegt ein Widerspruch im Verständnis dieses Begriffs und seines Ursprungs. Auf der einen Seite herrscht die Vorstellung, der Künstler sei Avantgardist, wenn er sich den gesellschaftlichen Verpflichtungen und Normen verweigert, also Außenseiter und Bohèmien ist. Dieses Bild hat sich besonders am Ende des 19. Jahrhunderts manifestiert und wurde im Mythos der verkannten Künstler-

existenz kultiviert. Der Künstler ist immer im Konflikt mit den Verhaltensmustern der bürgerlichen Gesellschaft, deren Werte er in Frage stellt. Er schafft sich eigene Regeln, existiert in »Szenen«. Auf der anderen Seite hat Oskar Bätschmann in seinem Buch »Ausstellungskünstler – Kult und Karriere im modernen Kunstsystem« (Köln 1997) dargelegt, daß der Begriff der Avantgarde seinem Entstehen nach zu Beginn des 19. Jahrhunderts fest eingebunden war in die Ansprüche und Anforderungen einer neuen, nachrevolutionären Gesellschaftsordnung in Frankreich, und Künstlern mit dieser Auszeichnung ihren Platz im engen Verbund mit den anderen gesellschaftstragenden Kräften von Industrie und Wissenschaft zuwies. Die künstlerische Avantgarde ist der Idee der ursprünglichen Bedeutung folgend, die Gruppe jener, die Ideen für die Gesellschaft, nicht gegen sie zu entwickeln hat. Das ist die utopische Dimension des Begriffs, das immer visionäre Ideal von Kunst, für die Gesellschaft da zu sein, auf sie zu wirken.

Dieser Intention steht das Verhalten als »bad boy« oder »bad girl«, der englischen Variante des Bohèmien, entgegen. Oder man akzeptiert, daß dies das Exportimage britischer Kultur ist, Schrillheit und Provokation wird zum Ausdruck des institutionellen Rahmens staatlicher Kulturpolitik. In diesem Zusammenhang bleibt es ein Phänomen aller Ausstellungen mit britischer Kunst, daß sie diesen Erfolg als Gruppe fortschreiben, ungeachtet der einzelnen Namen, aus denen das Team zusammengestellt ist. Die einzelne künstlerische Leistung und das singuläre Werk tritt hinter die Bewegung junger britischer Kunst zurück. Das ermöglicht es, Positionen zu berücksichtigen, die nicht unmittelbar britischer Herkunft sind, aber in London existieren. Der Gruppencharakter verhindert es aber auch, Einzelpersönlichkeiten deutlicher wahrzunehmen. Junge britische Kunst basiert auf Mitgliedschaft, ein Befund, der im Vergleich zu Amerika nicht denkbar wäre. Schließlich nivelliert der Mannschaftsgeist kunsthistorische Betrachtung, denn »Young British Art« taugt wenig als Stilbegriff oder als Kategorie einer Werkanalyse. Dann wäre nämlich zu fragen, warum so manches Werk mit seiner Thematik avantgardistisch im ursprünglichen Sinn des Wortes sein soll. Der grenzüberschreitende Export lokalspezifischer Kunst mit dem Ziel, eine nationale Identität zu propagieren, hat dazu geführt, daß die Aktivitäten und die Gruppendynamik einer Generation von Künstlern aus Großbritannien wie ein Stilbegriff geführt wird, ohne aber damit in der Lage zu sein, zu beschreiben, was damit beschrieben werden könnte. Das Label »Young British Art«, das 1992 aufgrund einer Ausstellung in den Hallen der Saatchi Collection entstand, ist für ausländische Ausstellungsorganisatoren zu einem Synonym geworden für die Erwartungen an die Kunst, die immer das Neue zu erschaffen hat, wie es Boris Groys dargelegt hat. Kunst ist Austausch und Dialog, die »Umwertung der Werte« (Groys) als Ausdruck von Innovation, das »Neue um des Neuen willen ist ein Gesetz« (Groys), das damit die Arbeit der zahlreichen Ausstellungshallen und Museen vorschreibt.

Der Blick in die Statistik eines Jahres kann belegen, wie wirksam das British Council britische Kunst in Deutschland zu fördern versteht. In der Bilanz des Haushaltsjahres 1997/98,

das nicht dem Kalenderjahr folgt, sind 153 Künstlernamen aufgeführt, die mit ca. 70 Projekten und/oder in 12 Gruppen- bzw. Themenausstellungen bei Ausstellungen in Deutschland gefördert wurden. Eine Anfrage beim Institut für Auslandsbeziehungen in Stuttgart weist für den gleichen Zeitraum für 1997 nur fünf, 1998 bisher zehn Künstler und Ausstellungen aus, die mit deutschen Künstlern in Großbritannien gefördert wurden. Diese Gegenüberstellung spricht für sich. Die Namensliste der vom British Council geförderten Künstler ist nicht identisch mit den Namen, die in den Charts auftauchen. Die Mitgliedschaft im Club der »top ten« wird erst durch die Sammlungen garantiert, in denen die Künstler mit ihren Werken auch dann noch überleben, wenn das Werk die Turbulenzen des Neuen überlebt hat. Dies garantieren die wenigen exklusiven Handelsplätze in London, die die Ware in die Hausse befördern.

Wie mit jeder Kunst, die im 20. Jahrhundert entwickelt worden ist, führt der Weg in das Museum als Ort der Garantie für das, was der permanente Wechsel des Neuen nicht bieten kann, über die Zwischenlager der Privatsammlungen. Hier werden die Innovationen auf die Probe gestellt und durch regelmäßige Wechselausstellungen – die ihren Namen zu recht führen, ihre wahre Intention jedoch darin nicht zu erkennen geben – überprüft. Das Ziel ist die Reduktion im Sinne einer Konzentration, um mit Gewißheit im Besitz der Werke zu sein, die die Zeit überdauern, wobei dem Gedanken der Avantgarde des 20. Jahrhunderts folgend, eben diese Werke immer ihre Zeit überwinden wollten.

Für den Moment läßt sich feststellen, daß die Rede von der jungen britischen Kunst immer ein Kollektiv meint, das aus unterschiedlichen Teilnehmern besteht. Der vergleichende Blick auf die amerikanische Kunstszene unterscheidet dagegen mehr kulturgeographisch zwischen Ost- und Westküste und stellt das Amerikanische additiv zusammen als Reihung der einzelnen, die es gemäß des amerikanischen Traums geschafft haben, ohne staatliche Förderung ihre Ausdrucksformen zu behaupten. Und es wäre mehr als ein Traum, wenn es gelingen könnte, die identitätsstiftende Funktion, wie sie derzeit in Großbritannien zu erleben ist, in Amerika auf dem Feld der bildenden Kunst auszumachen. Deshalb ist es vielleicht ein zum fernen Ideal erklärter Begriff von Avantgarde – der in New York und Los Angeles vorherrscht –, nicht gesellschaftliche Anerkennung, aber gesellschaftliche Wirkung zu erzielen, wie es die jungen Briten vorleben. Vergleichbar ist immer nur der Austausch, der zum Erfolg führende Umweg über Europa, der den in Amerika mühsamen Weg in die musealen Weihestätten garantiert. Schon aufgrund der Tatsache, daß der gesamte angelsächsische Raum die bürgerliche Tradition von Kunstvereinen im deutschsprachigen Kulturkreis und deren Kunsthallen nicht kennt und somit das institutionelle Potential an Ausstellungsorten eingeschränkt ist, macht Europa für Ausstellungen attraktiv. Zwischen Galerie und Museum klafft eine Lücke sowohl in Amerika wie in Großbritannien, die durch Ausstellungen andernorts ausgefüllt wird.

Der Avantgarde-Begriff in seinen Anfängen wollte der Kunst eine Aufgabe zuweisen. Die Utopie war, daß die Gesellschaft Auftraggeber von Ideen ist, weil die alten Auftraggeber und deren Inhalte revolutioniert worden waren. Der Avantgardist des 20. Jahrhunderts akzeptiert nicht die Gesellschaft, er möchte sich abgrenzen und aus dieser Position außerhalb der Zuordnungen sagen, was Kunst ist oder sein könnte, aber im Kontext der Regeln, die Kunst macht. Somit haben die Ausstellungen in den Kunsthallen und Museen die Rolle des Auftraggebers von Kunst übernommen. Kunstgeschichte ist Ausstellungsgeschichte. Ausstellungen sind heute fester Bestandteil des gesellschaftlichen Lebens, sie waren es immer. Es gelingt vielleicht nur immer seltener, damit zu definieren, was Kunst ist. Aber diese Frage soll ja eben durch die Ausstellungen diskutiert werden.

OTTOMAN ARRANGEMENT FOR ROOM 11' X 16'

Andrea Zittel
Study for Ottomans, 1994
Study for Carpet/Furniture, 1993

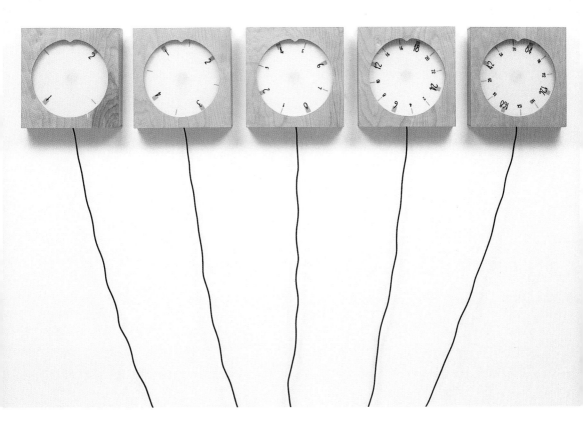

Andrea Zittel, A–Z Clocks, 1994

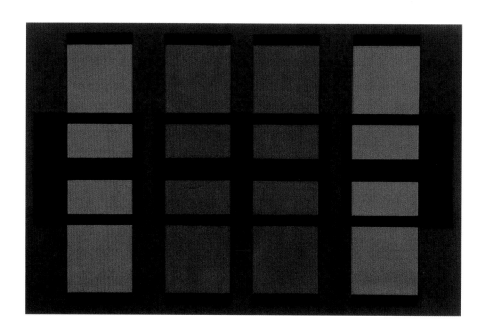

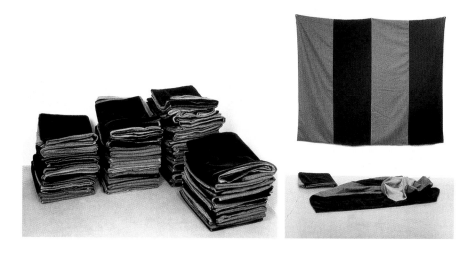

Andrea Zittel
Dining Room Carpet, 1997
Cover, 1993

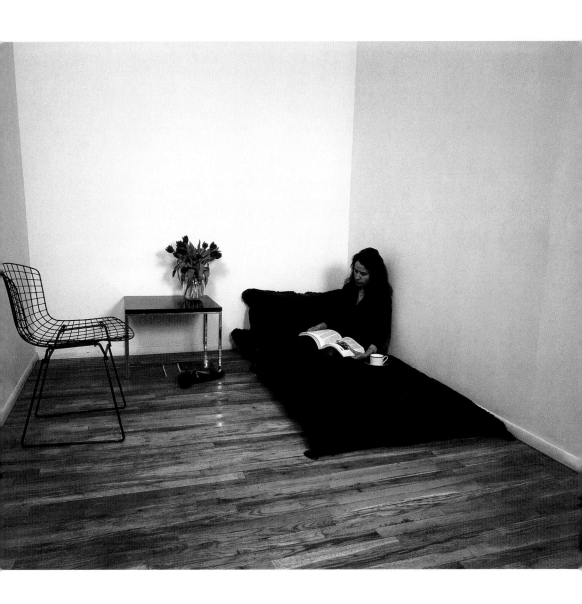

Andrea Zittel, Perfected Pillow, 1995

EMOTION AND SENSATION

Friedrich Meschede

When the exhibition *British Art in the 20th Century* planned at the Royal Academy of Arts in 1987 (it was shown the very same year under the title *Englische Kunst im 20. Jahrhundert* at the Staatsgalerie Stuttgart), the survey encompassing a century of British art was obviously concluded somewhat too early. The phenomenon we have come to perceive of today, that is, ten years later, as 'British art' only began to emerge in 1988, triggered by the meanwhile legendary exhibition *Freeze*, an event organised by the artists themselves, which did not take place, needless to say, at the Royal Academy but rather in London's East Side in a building that had been abandoned to property speculation. Enthusiasm about this unequalled success-story of young British art has been running high ever since, which could be the actual 'sensation' that motivated those responsible at the Royal Academy to promote an exhibition in London of this name, presenting works from a private collection, in 1997.

In 1993, when in continuation of the series of comprehensive exhibitions on art of the 20th century, seen from a national angle, American art of the 20th century was examined – again, at the Royal Academy in London and then at the Martin-Gropius-Bau in Berlin – the transitions within the overview of art from the modern age up to recent works appeared less abrupt. Robert Gober, Mike Kelley and others had already found a place in art history and in the eyes of exhibition-organisers, but they were no longer a sensation – just a new generation following its many predecessors in America, so rich in avant-garde movements in the 20th century. The deficiency, however, of supposedly historical surveys on art, which at the same time embrace a national posture in an era of global communication, lies in the very deficiency of adequate theoretical instruments capable of treating the art of the 20th century and its own particular lines of development objectively. Today, the exhibition catalogue is conceived of as a standard work and reflects the familiar lexical conventions.

While in regard to young art in the US there appears to have been a continuous development since the American self-assertion, given shape by Pollock and Newman and carried forth, with new protagonists, in every decade since the Second World War, this is a novel situation for the identity of British art. In order to make the success of 'Young British Art' more understandable, two aspects should be mentioned: For one, the awareness of British art is the result of long-term and far-sighted political planning, creating an effective instrument of foreign cultural policy by establishing the British Council 40 years ago, an institution that does not exist

in America in any comparable manner, and only to a certain extent in other European countries. The triumphant advance of young British art is based not so much on exhibitions in England but rather on the success of group shows presented throughout the world, from Minneapolis all the way to Wolfsburg.

On the other hand, the young generation of British artists has given rise to a new national self-confidence, which is only now, at the end of this century, acknowledging that British artists are providing for the first time an avant-garde movement within the 20th century. Michael Craig-Martin, a mentor for this young generation, believes that one reason for the general enthusiasm felt among all generations of artists in Great Britain lies in the fact that they have adopted and been buoyed up by the feeling that for the first time in modern art history they are passing on innovations or, at least, are involved in them in a major way. Previously, the artistic avant-garde movements had originated in other metropols – at the beginning of this century, of course, in Paris, then Berlin, more specifically in Dessau, then once again in Paris and in the second half of this century naturally in New York. Today, London is the pivotal city for new ideas asserting themselves as an expression of innovative contemporary art, which people can identify with and take pride in. Finally, at last, the fine arts have triggered off a movement in Britain comparable to those legendary successes in the field of pop music. Everyone can participate in this avant-garde, as it encompasses all social classes, being a public rather than an elitist movement.

An interesting conflict, however, is manifest in this bond between national self-esteem and avant-garde self-awareness. On the occasion of the latest exhibition of British art *Pictura Britannica* at the Museum of Contemporary Art in Sydney, Nikos Papastergiadis pointed out in the accompanying catalogue that in the history of modern art the identity of the avant-garde was based on transcending boundaries rather than defining them. The migration of major artists of the 20th century, as well as their forced expulsion, have given art an international impact and have created a dialogue and an exchange of ideas transcending all boundaries and restrictions. In regard to the British avant-garde generation, however, one is often confronted with a strong urge to return home to London as the only city in which it is allegedly worthwhile to live. Thus, if one perceives of the presence of British art in exhibitions taking place outside of England as avant-garde ('young, naughty, quirky and shrill – but above all exciting', as was written in the *Frankfurter Allgemeine Zeitung* upon the occurrence of the exhibition *Full House* in Wolfsburg), then an inherent contradiction lies in the definition of this term and its origins. On one hand, there exists a general notion that the artist is an avant-gardist if he refuses to comply with social obligations and conventions, that is, if he is an outsider and a Bohemian. This image became manifest particularly at the end of the 19th century and was cultivated in the myth of the unrecognised genius. The artist is always in conflict with the behaviour-

patterns of bourgeois society, whose values he questions. He creates his own rule-systems and exists in so-called 'scenes'. On the other hand, as Oskar Bätschmann has stated in his book *Ausstellungskünstler – Kult und Karriere im modernen Kunstsystem* (Cologne, 1997), the notion of the avant-garde established towards the beginning of the 19th century was immediately interwoven with the claims and demands of a new, post-revolutionary social order in France and assigned artists that carried this mark of distinction a place within the closely knit union of the other socially relevant forces – industry and economy. In relation to the original idea behind it or its meaning, the notion 'avant-garde' defines a certain group of people who are supposed to develop ideas *for* society, not *against* it. This utopian dimension of the avant-garde concept expresses itself in the forever visionary ideal that art should be there for society and affect it in some way.

This position stands in contrast to the contemporary British version of the Bohemian, namely the artist taking on the stance of either 'bad girl' or 'bad boy'. It is equally possible, however, to interpret this as an image of British culture designed for export – shrillness and provocation thus expressing the institutional framework of a national cultural policy. In this connection, concerning all exhibitions of British art, it is interesting to note that the artists' success is a group phenomenon, with no regard for the particular members constituting the team. Both the individual artistic achievement and the singular work disappear behind the movement of young British art as a whole. This makes it possible to take into account positions that are not directly of British origin, but which nevertheless actively exist in London. At the same time, this particular group phenomenon also makes it difficult to become more closely aware of individual personalities. Young British art is based on a sort of club-membership status which in comparison would be unthinkable in America. In the final analysis, this team spirit neutralises art-historical considerations, as the term 'Young British Art' is neither particularly suitable as a stylistic definition, nor for that matter, as a category for describing the works of art. In such case, one might be urged to question why, indeed, considering their subject matter, a number of works should be defined as avant-garde in the original sense of the word at all. Exporting internationally a specifically endemic art phenomenon with the goal of promoting a national identity has resulted in the situation that the activities and group dynamics of a generation of artists from Great Britain are employed as an instrument for defining a particular style, without, though, being capable of describing with this 'instrument' what might actually be worth describing. The label 'Young British Art', coined in connection with an exhibition shown in the private museum space of the Saatchi Collection in 1992, has become synonymous for international exhibition organisers with the expectations placed in an art that must continuously generate the 'new', as Boris Groys has pointed out. Art is a form of exchange and dialogue, the 're-evaluation of values' (Groys), an expression of innovation, while to be 'new for the sake of

being new is a law' (Groys) that accordingly dictates the work of numerous exhibition halls and museums.

A brief look at the annual statistics provides evidence for how effectively the British Council is promoting British art in Germany. In the balance of the fiscal year 1997/98, which is not identical to the calendar year, 153 artists are listed, who received support for around 70 projects and/or who were featured in a total of 12 group shows or thematic exhibitions throughout Germany. An inquiry at the Institute of Foreign Cultural Relations in Stuttgart yielded the information that within the same time span only five artists and exhibitions (in 1997) and ten (in 1998), respectively, involving German artists were supported in Great Britain. This comparison speaks for itself. The list of artists supported by the British Council, by the way, is not identical with that of the artists who appear in the charts. A membership in the club of the 'top ten', though, is guaranteed only through art collections, in which the artists' works survive even when they have outlived the turbulences of being 'new'. This is guaranteed by those few exclusive market places in London that cause the art products to rise on the Stock Exchange.

As is the case with all art created in the 20th century, the path to the museum, as a haven as well as a guarantee for those assets that the continuous succession of the 'new' cannot provide, leads via the intermediate storage spaces of private collections. Here the innovations are put to the test and scrutinised in temporary exhibitions – an appropriate term, even if it does not reveal the actual intent behind these events, namely to achieve a permanent place in the world of art. The goal is to concentrate on those works that will outlast the moment – on the other hand, however, the works following the avant-garde concept of the 20th century have always been created in the hope of conquering time.

For the time being, one might conclude that when young British art is addressed in a general way, this is always in reference to a collective that consists of various individual participants. In comparison, the American art scene distinguishes in a more cultural-geographical sense between east-coast and west-coast art, for example, and views the national artistic output as a series of individual approaches that add together to form a composite whole, carried out by artists who, in correspondence to the American dream, have managed to assert their own forms of expression without government support. And, thus, it would appear that finding the identity-boosting aspect currently being experienced in Great Britain in American art must remain a dream. Possibly, this is the reason why an avant-garde concept that has been elevated to a distant ideal remains prevailant in New York and Los Angeles: not to achieve social recognition, but rather to have an effect on society, a strategy the young British artists are a living example of. The only common aspect is cultural exchange, the road to success, leading indirectly via Europe, that helps artists, who in America face a number of obstacles, into the sacred shrine of the museum. Already the simple fact that the Anglo-Saxon world is not familiar with

the bourgeois tradition of the 'Kunstvereine' (the local arts societies that provide exhibition space) and the specific type of public art galleries found in German-speaking countries, which means the institutional potential in regard to exhibition possibilities is somewhat more limited, makes Europe attractive for the staging of exhibitions. The wide gap that exists between private galleries and museums in America and in Britain is filled, in a sense, by exhibitions abroad.

The avant-garde in its beginning stages sought to confer responsibility upon the arts. Part of their utopia was that society was to take on the responsibility of commissioning ideas after the former patrons and their concerns had been revolutionised. The avant-gardist of the 20th century does not accept society – in fact, he explicitly wants to distance himself from society and to state from a position beyond all classifications what art is or could be, but to do so in compliance with the rules that art itself generates and prescribes. As a result, the exhibitions in the public galleries and museums have taken on the role of 'patron' to the arts. Art history is exhibition history. Today, as in former eras, exhibitions are an integral part of social life. It may be increasingly difficult to define by means of exhibitions what art, in fact, is. But then again, this is a point of discussion that these exhibitions may illuminate.

Ausgestellte Werke der britischen Künstlerinnen und Künstler
Exhibited Works by British Artists

ANGELA BULLOCH

Jade Four, 1990
4 Warnleuchten, Kabel, Halterungen, Fassungen,
Glühbirnen, elektronisches Schaltgerät
4 Belisha beacons, cable, brackets, bulbs, bulbholders,
electronic switching mechanism
180 x 220 x 30,5 cm
Photo: Philipp Schönborn, München
Abb./illus. 14

Bungy Adventures (from "Rules Series"), 1993
Text auf Wand, Maße variabel
Text on wall, dimensions variable
Photo: Raimund Koch, Berlin
Abb./illus. 13

Beach Synth, 1996
Sisalteppich, Sensormatte, lackierte Lautsprecher,
Synthesizer, Elektrik
Coconut fibre mat, pressure sensitive mats, two painted
speaker cases, synthesizer, electric equipment
circa 60 x 442 x 202 cm
Photo: Raimund Koch, Berlin
Abb./illus. 12

WILLIE DOHERTY

Fixed Parameter, 1989
Schwarzweißphotographie mit Text
Black-and-white photograph with text
122 x 183 cm
Photo: Raimund Koch, Berlin
Abb./illus. 27

They're all the same, 1991
Ton-Dia-Projektion, Maße variabel
Sound-slide projection, dimensions variable
Photo: Raimund Koch, Berlin
Abb./illus 26

Disclosure II (Invisible Traces), 1996
Cibachrome auf Aluminium
Cibachrome on aluminium
122 x 183 cm
Photo: Courtesy Alexander and Bonin, New York
Abb./illus. 29

TRACEY EMIN

Happy as an Adolescent Girl – I wish!, 1995
Monoprint auf Papier
Monoprint on paper
58,2 x 74,6 cm

I Need a Fucking Cuddle, 1995
Monoprint auf Papier
Monoprint on paper
42 x 59 cm

Monument Valley (Grand Scale), 1995
Farbphotographie auf Vinyl
Colour photograph on vinyl
121,5 x 182,5 cm
Photo: Raimund Koch, Berlin
Abb./illus. 32

Why I Never Became a Dancer, 1995
Video, 6 Minuten 40 Sekunden
Video, 6 minutes 40 seconds
Photo: Raimund Koch, Berlin
Abb./illus. 33–35

Growing Pains, 1995
Monoprint auf Papier
Monoprint on paper
58,2 x 74,6 cm

All the Loving (Underwear Box), 1982–1997
Ottoman-Schachtel mit aufgehefteten Buchstaben,
Unterwäsche von 1982–1997, Accessoires, Draht, Sockel
Ottoman box with appliqued letters, underwear from
1982–1997, accessories, wire, pedestal
71 x 80 x 60,3 cm
Photo: Courtesy White Cube, London
Abb./illus 31

Mad Tracey from Margate, Everyone's there, 1997
Applikationen auf Wolldecke aus von Freunden zur
Verfügung gestellten Kleidern
Appliques on blanket fabric from clothing provided
by friends
215 x 267 cm
Photo: Raimund Koch, Berlin
Abb./illus. 30

See You Later Baby, 1997
Monoprint auf Papier
Monoprint on paper
58 x 81 cm

Prince is the Name of the Dog, 1997
Monoprint auf Papier
Monoprint on paper
58,2 x 81 cm

DOUGLAS GORDON

Letter (Number 9) Blue "I remember more than you know", 1992
Wandtext
Text on wall
Maße variabel
Dimensions variable

Trigger Finger, 1994
Videoinstallation, Maße variabel
Video installation, dimensions variable
Photo: Raimund Koch, Berlin
Abb./illus. 46/47

B-Movie, 1995
Videoinstallation, Maße variabel
Video installation, dimensions variable
Photo: Raimund Koch, Berlin
Abb./illus. 45

30 Seconds Text, 1996
Vinyltext, Glühbirne, Zeitschaltuhr, Maße variabel
Vinyl text, light bulb, timer, dimensions variable
Photo: Courtesy Bloom Gallery, Amsterdam
Abb./illus. 44

Three Inches (Black) # 11, 1997
Farbphotographie
C-print
80,5 x 105 cm

Three Inches (Black) # 4, 1997
Farbphotographie
C-print
105 x 80,5 cm

Dead Right, 1998
Video, Maße variabel
Video, dimensions variable
Photo: Dave Morgan, London
Abb./illus. 48

Left Dead, 1998
Video, Maße variabel
Video, dimensions variable
Photo: Dave Morgan, London
Abb./illus. 48

MONA HATOUM

Measures of Distance, 1988
Video, 15 Minuten
Video, 15 minutes
Photo: Raimund Koch, Berlin
Abb./illus. 54

Short Space, 1992
9 Bettfederngestelle, 3 Motoren, 1 Flaschenzugsystem
9 bed spring meshes, 3 motors, pulley system
295,5 x 353 x 500 cm

Performance Still, 1985–95
Schwarzweißphotographie auf Aluminium
Black-and-white photograph on aluminium
76,5 x 100 cm
Photo: Steven White, London
Abb./illus. 50

Van Gogh's Back, 1995
Farbphotographie
C-print
50 x 38,8 cm
Photo: Courtesy White Cube, London
Abb./illus. 49

Divan Bed, 1996
Tränenstahl
Steel tread plate
60 x 192 x 77 cm
Photo: Courtesy White Cube, London
Abb./illus. 55

Deep Throat, 1996
Tisch, Stuhl, Fernseher, Wasserglas, Teller, Messer und Gabel, Laserdisk, Laserdisk-Rekorder
Table, chair, television set, plate, fork and knife, waterglass, laser disc, laser disc player
89 x 85 x 130 cm
Photo: Philipp Schönborn, München
Abb./illus. 52/53

No Way, 1996
Rostfreier Stahl
Stainless steel
7 X 40,5 X 12,8 cm

No Way II, 1996
Emaillierter Stahl, rostfreier Stahl
Enameled steel, stainless steel
13 x 27 x 23 cm

Flat Colander, 1996
Reiberdruck auf Wachspapier
Rubbing on waxpaper
40 x 54,5 cm

Grater, 1996
Reiberdruck auf Wachspapier
Rubbing on waxpaper
27,5 x 38 cm

Milk Strainer, 1996
Reiberdruck auf Wachspapier
Rubbing on waxpaper
27,5 x 38 cm

Shaker Colander, 1996
Reiberdruck auf Wachspapier
Rubbing on waxpaper
40 x 54,5 cm

Moutons, 1996
145 Kügelchen aus Menschenhaar, Maße variabel
145 balls made from human hair, dimensions variable
Photo: Courtesy Galerie Crousel, Paris
Abb./illus. 51

ABIGAIL LANE

Conspiracy, 1992
Karton, Papier, Stempelkissen, Stempel, Vitrine
Card, paper, ink pad, rubber stamps, vitrine
2teilig, 2 parts
je 34 x 23,5 x 4 cm / 34 x 23,5 x 4 cm each
Vitrine/vitrine: 93,5 x 152 x 52 cm
Photo: Courtesy Victoria Miro Gallery, London
Abb./illus. 66

Bottom Wallpaper, 1994
Stempelfarbe auf Tapete, Maße variabel
Stamp pad ink, dimensions variable
Photo: Richard K. Lösch, Ohio
Abb./illus. 70

Ink Pad (Blue), 1994
Aluminium, MDF, Baumwolle, Filz, blaue Stempelfarbe
Aluminium, MDF, cotton, felt, blue stamp pad ink
244 x 305 x 2,5 cm (offen / open)
244 x 152,5 x 2,5 cm (geschlossen / closed)
Photo: Raimund Koch, Berlin
Abb./illus. 69

Absent Friends, 1994–95
Portfolio mit 6 Schwarzweißphotographien
Portfolio with 6 black-and-white photographs
25,3 x 30,5 cm (4x), 30,5 x 25,3 cm (2 x)
Photo: Raimund Koch, Berlin
Abb./illus. 67

Blue Inked Chair, 1996
Stuhl mit Stempelkissen
Chair with ink pad
80 x 40 x 47 cm
Photo: Richard K. Lösch, Ohio
Abb./illus. 70

Untitled (Ingvild Goetz), 1997
Holz, Gummi, Metallklammern
Wood, rubber, metal tacks
2teilig, 2 parts
je 15 x 24 x 10 cm / 15 x 24 x 10 cm each
Photo: Raimund Koch, Berlin
Abb./illus. 65

She Imagined She Knew the Future, 1997
Tintenstrahldrucker auf Papier
Ink jet on paper
119 x 88 cm
Photo: Courtesy Victoria Miro Gallery, London
Abb./illus. 68

Another Time, Another Place, 1997
Tintenstrahldrucker auf Papier
Ink jet on paper
89 x 116 cm

His Values Were Personal, 1997
Tintenstrahldrucker auf Papier
Ink jet on paper
89 x 116 cm
Courtesy the artist and Victoria Miro Gallery, London

Her Life Became Nocturnal, 1997
Tintenstrahldrucker auf Papier
Ink jet on paper
89 x 116 cm
Courtesy the artist and Victoria Miro Gallery, London

She Didn't Need Her Eyes Open in Order to See, 1997
Tintenstrahldrucker auf Papier
Ink jet on paper
119 x 88 cm
Courtesy the artist and Victoria Miro Gallery, London

It Was on the Tip of Her Tongue, 1997
Tintenstrahldrucker auf Papier
Ink jet on paper
80 x 110 cm
Courtesy the artist and Victoria Miro Gallery, London

SARAH LUCAS

Self-Portrait with Fried Eggs, 1996
Cibachrome
167 x 118,5 x 2,5 cm
Photo: Raimund Koch, Berlin
Abb./illus. 80

Sexmachine, 1996
Holz, Draht, Porzellan, Spiegeleier, Banane, Fisch
Wood, wire, porcelain, fried eggs, banana, fish
180 x 110 x 91 cm

Untitled (Chair), 1996
PVC, Sessel, Tageszeitung, Firnis
PVC, armchair, newspaper, varnish
65 x 337 x 302 cm
Photo: Courtesy Contemporary Fine Arts, Berlin
Abb./illus. 80

The Smoking Room, 1997
Spanplatten, Tageszeitungen, Firnis, Maße variabel
Chipboards, newspaper, varnish, dimensions variable
Photo: Raimund Koch, Berlin
Abb./illus. 81

Bunny Gets Snookered # 2, 1997
Strumpfhosen, weiße Strümpfe, Bürosessel,
Schraubzwinge, Kapok-Fasern, Draht
Tan tights, white stockings, office chair, clamp, kapok, wire
circa 102 x 102 x 94 cm
Photo: Raimund Koch, Berlin
Abb./illus. 79

SAM TAYLOR-WOOD

16 mm, 1993
16-mm-Film, CD, Endlosfilm
16 mm film, CD, loop film

Five Revolutionary Seconds V, 1996
Farbphotographie auf Vinyl mit Videokassette,
Kassettenrekorder, Boxen
Colour photograph on vinyl with cassette tape,
tape recorder, speakers
72 x 757 cm
Photo: Courtesy White Cube, London
Abb./illus. 82/83

Knackered, 1996
Videoprojektion mit Ton, 3 Minuten 5 Sekunden
Video projection with sound, 3 minutes 5 seconds
Photo: Raimund Koch, Berlin
Abb./illus. 84

16 mm, 1996
Portfolio mit 10 Schwarzweiß-Photolithographien,
CD mit Soundtrack des Films 16 mm
Portfolio of 10 photolithographs and a CD soundtrack
from the film 16 mm
11teilig, Lithographien je 25 x 31,5 cm
11 parts, lithographs 25 x 31,5 cm each

Atlantic, 1997
Laserdiskprojektion auf drei Leinwände (gefilmt auf
16 mm), 10 Minuten, 3teilig, Maße variabel
Laserdisc projection on three screens, 10 minutes, 3 parts,
dimensions variable
Photo: Courtesy White Cube, London
Abb./illus. 82/83

RACHEL WHITEREAD

Study for "Bed", 1992
Tusche und Korrekturflüssigkeit auf Pergamentpapier
Chinese ink and correction fluid on parchment paper
29,8 x 41,5 cm

Untitled (Bed), 1992
Acryl und Wasserfarbe auf Millimeterpapier
Acrylic and watercolour on graph paper
41,8 x 29,8 cm

Untitled (Building), 1992
Korrekturflüssigkeit auf Millimeterpapier
Correction fluid on graph paper
45,7 x 60,8 cm

Untitled (Concave and Convex Beds), 1992
Gummi und Neopren, 2teilig
Rubber and neoprene, 2 parts
34 x 100 x 196 cm; 40 x 100 x 196 cm
Photo: Courtesy Karsten Schubert Gallery, London
Abb./illus. 86/87

Untitled (Mattress), 1992
Mischtechnik auf Papier
Mixed media on paper
41,9 x 29,6 cm

Untitled (Kitchen Floor), 1993
Tusche und Korrekturflüssigkeit auf Papier
Chinese ink and correction fluid on paper
38 x 28 cm
Photo: Raimund Koch, Berlin
Abb./ illus. 89

Untitled (Kitchen Floor), 1993
Mischtechnik auf Papier
Mixed media on paper
41,7 x 29,5 cm
Photo: Raimund Koch, Berlin
Abb./illus. 89

Untitled (Torso), 1994/1995
Gips / Plaster
circa 10,5 x 18 x 23,5 cm
Photo: Raimund Koch, Berlin
Abb./illus. 88

Untitled (Torso), 1994/1995
Kunstharz / Resin
circa 9,5 x 17 x 25 cm
Photo: Raimund Koch, Berlin
Abb./illus. 88

Demolished, 1996
Portfolio mit 12 Duotondrucken
Portfolio of 12 duotone screenprints
je 48,5 x 74 cm / 48,5 x 74 cm each
Photo: Courtesy Karsten Schubert Gallery, London
Abb./illus. 85

Ausgestellte Werke der amerikanischen Künstlerinnen und Künstler
Exhibited Works by American Artists

MATTHEW BARNEY

Soweit nicht anders vermerkt, unterliegen die Repro-Photos von Matthew Barney der Courtesy von Barbara Gladstone. Unless otherwise stated the repro-photos of Matthew Barney are subject to the courtesy of Barbara Gladstone.

CREMASTER 4: The Isle of Man, 1994
© 1994 Matthew Barney, Photo: Michael James O'Brien
Farbphotographien, selbstschmierende Kunststoffrahmen
C-prints, self-lubricating and prosthetic frames
5teilig/5 parts
42 x 38 x 3,5 cm (2x); 70 x 84,5 x 3,5 cm (2x);
84,5 x 70 x 3,5 cm (1x)
Repro-Photo: Joshua White, Los Angeles
Abb./illus. 4, 100

TI: ascending HACK descending HACK, 1994
© 1994 Matthew Barney, Photo: Michael James O'Brien
Farbphotographie, selbstschmierender Kunststoffrahmen
C-print, self-lubricating plastic frame
100,5 x 70 x 3,5 cm

CREMASTER 4: Three Legs of Man, 1994
© 1994 Matthew Barney, Photo: Michael James O'Brien
Farbphotographie, selbstschmierender Kunststoffrahmen
C-print, self-lubricating plastic frame
70 x 100,5 x 3,5 cm
Abb./illus. 101

CR 4: LOUGHTON RAM, 1994
© 1994 Matthew Barney, Photo: Michael James O'Brien
Farbphotographie, selbstschmierender Kunststoffrahmen
C-print, self-lubricating plastic frame
85,5 x 59,5 x 3,5 cm
Repro-Photo: Joshua White, Los Angeles
Abb./illus. 95

CREMASTER 4, 1994/95
Videographie: Peter Strietmann
Video, Prothesenkunststoff, Hochzeitssatin, Manx (Bewohner der Insel Man) Schottentuch, Siebdruck auf Laserdisk in Florpostpapier-Schutzhülle, Polyäthylenvitrine
Video, prosthetic plastic, bridal satin banner, Manx tartan, silkscreen laser disk in onionskin sleeve and polyethylene vitrine, Video 42 Minuten/video 42 minutes
Vitrine/vitrine: 120 x 122 x 92 cm
Objekt/object: 71 x 74 x 15 cm
Abb./illus. 99

CREMASTER 4: (PIT) Field of the Descending Faerie, 1995
Silikon, Prothesenkunststoff, Wagenheber, Polyester und Satinbänder
Silicone, prosthetic plastic, hydraulic jack, polyester and satin ribbon
25,5 x 150 x 200 cm

CREMASTER 1: The Goodyear Waltz, 1995
© 1995 Matthew Barney, Photo: Michael James O'Brien
Farbphotographie, 8 Schwarzweißphotographien (Barytvergrößerung), selbstschmierende Kunststoffrahmen
C-print, 8 gelatin silver prints, self-lubricating plastic frames
9teilig/9 parts
64 x 54,5 x 3,5 cm (8x); 85,5 x 70 x 3,5 cm (1x)

GOODYEAR: CREMASTER 1, 1995
© 1995 Matthew Barney, Photo: Michael James O'Brien
Schwarzweißphotographie (Barytvergrößerung), selbstschmierender Kunststoffrahmen
Gelatin silver print, self-lubricating plastic frame
84 x 110 cm
Repro-Photo: Zindman/Fremont, New York
Abb./illus. 96

CR 1: Goodyear Lounge, 1995
© 1995 Matthew Barney, Photo: Michael James O'Brien
Farbphotographien, selbstschmierende Kunststoffrahmen
C-prints, self-lubricating plastic frames
2teilig/2 parts
je 65,5 x 65,5 cm/65,5 x 65,5 cm each
Repro-Photo: Zindman/Fremont, New York
Abb./illus. 97

CREMASTER 1, 1995/96
Videographie: Peter Strietmann
Video, Siebdruck auf Laserdruck, Prothesenkunststoff, selbstschmierender Kunststoff, Polyäthylen-Vitrine
Silkscreened video disc, cast polyester, prosthetic plastic, self-lubricating plastic, patent vinyl vitrine
Video 45 Minuten/video 45 minutes
Objekt/object: 40,6 x 61 x 54,6 cm
Vitrine/vitrine: 136,5 x 122,3 x 91,7 cm
Repro-Photo: Zindman/Fremont, New York
Abb./illus. 98

CREMASTER 5, 1997
Acryl-Vitrine, 35-mm-Film, Laserdisk, Polyester, Acryl, Samt, Nylon, Silber
Acrylic vitrine, 35 mm film, print, laserdisc, polyester, acrylic, velvet, nylon, sterling silver
94 x 91,4 x 121,9 cm

CREMASTER 5: Elválás, 1997
© 1997 Matthew Barney, Photo: Michael James O'Brien
2 Farbphotographien, 1 Schwarzweißphotographie
(Barytvergrößerung), Acrylrahmen
2 C-prints, gelatin silverprint, acrylic frames
3teilig/3 parts
89,4 x 74,8 cm (2x); 104,6 x 87,2 cm (1x)
Repro-Photo: Larry Lame, New York
Abb./illus. 102

C5: Ereszkedés, 1998
Graphit, Vaseline auf geprägtem Papier, Acrylrahmen
Graphite, petroleum jelly on embossed paper in acrylic
and vivak frames
3teilig/3 parts
je 45,5 x 40,4 x 3,2 cm / 45,5 x 40,4 x 3,2 cm each

R O B E R T G O B E R

The Sink Inside of Me, 1985
Gips, Holz, Drahtplatte, Stahl, halbglänzende Emailfarbe
Plaster, wood, wire lath, steel, semi-gloss enamel paint
135,3 x 212,5 x 75,9 cm
Photo: Courtesy F. Petzel Gallery, New York
Abb./illus. 108

Untitled, 1988
Emaillelack auf Holz
Enamel paint on wood
79,2 x 82,4 x 34,6 cm
Photo: Raimund Koch, Berlin
Abb./illus. 109

Untitled, 1988
Gips, Leinen, Drahtplatte, Kleiderfarbe
Plaster, linen, wire lath, fabric paint
41,7 x 49,3 x 58,1 cm
Photo: Courtesy F. Petzel Gallery, New York
Abb./illus. 111

Bag of Donuts, 1989
Papier, Teig, Rhoplex
Paper, dough, rhoplex
27,9 x 15,8 x 15,2 cm
Photo: Geoffrey Clements, New York
Abb./illus. 110

Untitled, 1991
6 Photographien (Offsetdruck), Tintenroller, collagiert
6 photographs (offset print), ball point pen, collaged
36 x 36,7 cm

Untitled (Red Shoe), 1992
Wachs
Wax
8 x 20 x 8 cm
Photo: Raimund Koch, Berlin
Abb./illus. 114

Untitled, 1994
Tinte auf Papier
Ink on paper
20 x 12,5 cm
Photo: Courtesy Paula Cooper Gallery, New York
Abb./illus. 112

Lard Box, 1994 – 95
Holz, Stahl, Bronze, Farbe
Wood, steel, bronze, paint
69,9 x 180,3 x 180,3 cm
Gewicht/weight: 453 kg
Photo: Russell Kaye, New York
Abb./illus. 113

Untitled, 1996
Karton, Klebestreifen, Farbe, Modellpappe
Cardboard, foamcore, tape, paint
5,5 x 8,5 x 10,5 cm

M I K E K E L L E Y

Love to Love Your Baby (Jimi Hendrix), 1976
Bleistift, Acryl, Buntstift auf Papier
Pencil, acrylic, colour pencil on paper
61 x 61 cm
Photo: Raimund Koch, Berlin
Abb./illus. 118

Incorrect Sexual Model: Utopia, 1987
Synthetik-Polymer, Holz
Synthetic polymer, wood
2teilig/2 parts
je 183 x 61 cm / 183 x 61 cm each
Gesamt/total: 183 x 122 cm
Photo: Courtesy Jablonka Galerie, Köln
Abb./illus. 117

Let's Talk, 1987
Filz, Kleber
Felt, glue
239 x 149,3 cm
Photo: Courtesy Metro Pictures, New York
Abb./illus. 119

Alma Pater (Wolverine Den), 1990
13 Filzbanner mit Stangen, 2 gerahmte Bilder, 1 zweiseitig
bemalte Holztafel, 2 Hundekörbchen, 1 Basketball,
Maße variabel
13 felt banners with poles, 2 framed paintings, 1 two sided
wood panel painting, 2 dog beds, 1 basketball,
dimensions variable
Photo: Katrin Schilling, Frankfurt
Abb./illus. 120/121

**Empathy Displacement: Humanoid
Morphology, 1990**
Acryl auf Holz, handgemachte Puppe, Holzbox
Acrylic on wood, handmade doll, wooden box
Box/box: 9,5 x 22,5 x 28,6 cm
Bild/image: 73,6 x 56,5 cm
Photo: Courtesy ART Advisory Service, INC., New York
Abb./illus. 116

Citrus and White, 1991
Plüschtiere, 2 Deodorizer – weiß: Verkehrsweiß
(RAL 9016); schwarz: Tiefschwarz (RAL 9005), Stahl,
Reepschnur
Stuffed animals, 2 deodorizers: white acryl (RAL 9016),
black acryl (RAL 9005), steel, rope
Deodorizer/deodorizer:
je 215 x 60 x 43 cm / 215 x 60 x 43 cm each
Maße variabel / Dimensions variable

Strawberry Scientist, 1976/93
Mischtechnik auf Papier
Mixed media on paper
60,6 x 60,6 cm

Untitled (Biomorphic), 1976/93
Mischtechnik auf Papier
Mixed media on paper
58,5 x 60,6 cm

A Big Wind From New York, 1976/93
Bleistift, Wachs, Schmutz, Acryl auf Papier
Pencil, wax, dirt, acrylic on paper
61 x 61 cm

**Dialogue # 1 (An excerpt from "Theory,
Garbage, Stuffed Animals, Christ"),
German Version, 1991–96**
Bettuch, Stofftiere, CD-Spieler, CD
Sheet, stuffed animals, CD player, CD
122 x 82,5 x 17,8 cm
Photo: Courtesy Metro Pictures, New York
Abb./illus. 115

Male Bonding, 1997
Acryl, Buntstift, Bleistift auf Papier
Acrylic, colour pencil, pencil on paper
65,5 x 50,5 cm

Written on the Lump, 1991/98
Teppich, Stofftier, Acryl auf Holz
Rug, stuffed animal, painted wood panel
Bild/image:
182,1 x 204,9 x 5 cm
Teppich/rug:
20,2 x 245,4 x 182,1 cm

MIKE KELLEY & TONY OURSLER

Singing Stop Sign, 1998
Siebdruck, Reflektorband auf Metall, Einschußlöcher,
Hifi-Kompaktanlage
Reflektive tape and silkscreen on metall, bullet holes,
speaker, CD boom box
60 x 60 cm

LOUISE LAWLER

(Allan McCollum and other artists) Lemon, 1981
Cibachrome
40,4 x 50,6 cm

**Pollock and Tureen, arranged by Mr. and
Mrs. Burton Tremaine, Connecticut, 1984**
Schwarzweißphotographie, Text auf Passepartout
Black-and-white photograph, text on mat
71,2 x 99 cm
Photo: Courtesy Metro Pictures, New York
Abb./illus. 124

**Bought in Paris, New York, Switzerland or Tokyo.
Stella/Brass (detail) Les Indes Galantes IV …
purchased from a banker, now located on the
Blvd. Victor Hugo, 1966/86, 1986**
Cibachrome
58,1 x 39,2 cm

Bought and Installed by Didier Guichard, 1988
Cibachrome
126 x 91 cm

Glass and Local Storms, 1990
Cibachrome
104,5 x 131 cm
Photo: Raimund Koch, Berlin
Abb./illus. 126

Who Says, Who Shows, Who Counts, 1990
3 Chablis-Gläser auf Glasregal, Gravur
3 Chablis glasses on a glass shelf, gravure
21,5 x 35,4 x 11,4 cm
Photo: Bill Orcutt, New York
Abb./illus. 122

Untitled (Peter Halley), 1991
Cibachrome
61 x 51 cm
Photo: Raimund Koch, Berlin
Abb./illus. 125

March 25, 1991, 1991
Schwarzweißphotographie, Text auf Passepartout
Black-and-white photograph, text on mat
68,9 x 83,4 cm
Photo: Courtesy Metro Pictures, New York
Abb./illus. 127

Untitled (Salon Hodler), 1992
Cibachrome, Kristall, Filz
Cibachrome, crystal, felt
Höhe/heigth: 5 cm
Durchmesser/diameter: 8,8 cm

Untitled (Piero Manzoni and other artists) White (aus: October Portfolio), 1981/93
Farbphotographie
C-print
15 x 18,3 cm

Original Models, 1993
Cibachrome
98,7 x 118,7 cm
Photo: Raimund Koch, Berlin
Abb./illus. 123

Untitled (Rose Stem), 1993
Cibachrome, Kristall, Filz
Cibachrome, crystal, felt
Höhe/height: 5 cm
Durchmesser/diameter: 9 cm

Produced in 1988, Purchased in 1989. Produced in 1989, Purchased in 1993, 1995
Cibachrome
113,8 x 148 cm

SHERRIE LEVINE

Untitled (President), 1978/79
Gouache auf rückseitig liniertem Papier
Gouache on paper
28 x 20,5 cm

President Collage: 3, 1979
Photocollage auf Papier
Photo collage on paper
61 x 45,5 cm

Untitled (Broad Stripe: 1), 1985
Kasein, Wachs auf Mahagoni
Casein, wax on mahagony
61,3 x 50,8 x 2,3 cm
Photo: Barbara Deller-Leppert, München
Abb./illus. 136

Untitled (Thin Stripe: 12), 1986
Kasein, Wachs auf Mahagoni
Casein, wax on mahagony
61,6 x 50,8 x 2,3 cm

Untitled (Lead Chevron: 8), 1988
Kasein auf Blei
Casein on lead
51,2 x 51,2 x 2 cm

Untitled (Lead Chevron: 9), 1988
Kasein auf Blei
Casein on lead
51,2 x 51,2 x 2 cm
Photo: Courtesy Galerie nächst St. Stephan, Wien
Abb./illus. 137

Untitled (Copper Knots: 2), 1988
Metallanstrich auf Sperrholz
Metallic paint on plywood
120 x 97 x 7,5 cm

Untitled (Copper Knots: 3), 1989
Metallanstrich auf Sperrholz
Metallic paint on plywood
120 x 97 x 7,5 cm

Untitled (Copper Knots: 4), 1989
Metallanstrich auf Sperrholz
Metallic paint on plywood
120 x 97 x 7,5 cm

Untitled (Copper Knots: 5), 1989
Metallanstrich auf Sperrholz
Metallic paint on plywood
118,5 x 95,7 x 6,5 cm

Untitled (After Marcel Duchamp: Chessboards: 3), 1989
Tempera auf Holz, Vitrine
Tempera on wood, vitrine
173,3 x 61,6 x 61,6 cm
Photo: Raimund Koch, Berlin
Abb./illus. 135

2 Shoes, 1992
1 Paar Kinderschuhe, braunes Leder
Pair of shoes, brown leather
je circa 16 x 6 x 6 cm / circa 16 x 6 x 6 cm each
Photo: Raimund Koch, Berlin
Abb./illus. 134

President Profile: I (aus: October Portfolio), 1980/93
Schwarzweißphotographie
Black-and-white photograph
14 x 10,5 cm

Crystal Newborn, 1993
Glasguß
Cast glass
circa 12,7 x 12,7 x 20,3 cm
Photo: Douglas M. Parker Studio, USA
Abb./illus. 138

Black Newborn, 1994
Glasguß
Cast glass
circa 12,7 x 12,7 x 20,3 cm
Photo: Douglas M. Parker Studio, USA
Abb./illus. 138

CADY NOLAND

Untitled, 1989
2 Bürostühle, Metallrohre, Plastik, Drahtgeflecht,
Schlüsselringe, Flagge, Auspuffrohr, Handschellen
2 office chairs, metall tubes, plastic, wire grating, key rings,
flag, exhaust pipe, handcuffs
90 x 380 x 205 cm

Tanya as a Bandit, 1989
Siebdruck auf Aluminium
Silkscreen on aluminium
180 x 120 x 0,9 cm
Photo: Raimund Koch, Berlin
Abb./illus. 141

Rubberneck Communion, 1991
Siebdruck auf Aluminium
Silkscreen on aluminium
180 x 76,5 x 1 cm
Photo: Geoffrey Clements, New York
Abb./illus. 140

SLA Group Shot With Floating Head, 1991
Siebdruck auf Aluminium
Silkscreen on aluminium
151 x 151,2 x 1 cm

California Offender, 1994
Siebdruck auf Aluminium
Silkscreen on aluminium
213,4 x 152,4 x 14,6 cm
Photo: Raimund Koch, Berlin
Abb./illus. 142

Beltway Terror, 1993–94
Aluminium über Holz
Aluminium over wood
2teilig/2 parts:
152,5 x 142,8 x 20,3 cm;
53,3 x 52,7 x 29,8 cm
Photo: Raimund Koch, Berlin
Abb./illus. 144

Not Yet Titled (bald Manson girls sit-in demonstration), 1993–94
Siebdruck auf Aluminium
Silkscreen on aluminium
152,4 x 183,5 x 14,6 cm
Photo: Raimund Koch, Berlin
Abb./illus. 143

TONY OURSLER

White Trash/Phobic, 1994
2 lebensgroße Figuren, Stoff, Videoprojektion
2 Figures, human scale, cloth, video projection
190 x 50 x 30 cm
Courtesy the artist and Metro Pictures, New York
Abb./illus. 155

Broken, 1994
(Performance von/by Tony Oursler)
Videoprojektor, VCR, Videoband, Holz, Stoff
Video projector, VCR, videotape, wood, fabric
Maße variabel/dimensions variable
Photo: Courtesy Metro Pictures, New York
Abb./illus. 156

Criminal Eye, 1995
(Performance von/by Tony Oursler)
Sony-CPJ100-Projektor, VCR, Videoband, Stativ V 5000,
Holz, Farbe
Sony CPJ 100 projector, VCR, video tape, tripod V 5000,
wood, paint
Durchmesser/diameter: 45,5 cm
Photo: Courtesy Metro Pictures, New York
Abb./illus. 151

We Have No Free Will, 1995
(Performance von/by Warren Niesluchowski)
2 kleine Stoffpuppen, Videoband, Videoprojektor, VCR,
Holzregal
2 small cloth dolls, video tape, video projector, VCR,
wood shelf
Maße variabel/dimensions variable
Photo: Raimund Koch, Berlin
Abb./illus. 154

Sketchy Blue, 1996
(Performance von/by Tracy Leipold)
1 Sony-CPJ100-Projektor, Sharp-LCD XV-P15U-Projektor
2 Videoprojektoren VP 2504 (2 VCRs), 2 Videobänder,
große Stoffigur, Gestell, Stativ
Sony CPJ100 projector, sharp LCD projector, 2VCRs,
2 videotapes, large cloth figure, light stand, tripod
244 x 275 x 152,5 cm (variabel/variable)
Photo: Courtesy Metro Pictures, New York
Abb./illus. 152/153

Talking Light, 1996
CD mit der Stimme des Künstlers, 40 Watt Glühbirne,
Tonverstärker mit Zubehör (die Glühbirne reagiert auf die
Frequenz der Stimme auf CD), circa 15 Minuten
Compact disk with artist's voice, light bulb, sound organ
kit (the light bulb reacts to the frequency of the voice on
the CD), circa 15 minutes
Maße variabel/dimensions variable
Photo: Raimund Koch, Berlin
Abb./illus. 150

Poetic (Coda) # 25, 1997
Mischtechnik auf Papier
Mixed media on paper
50,8 x 66 cm

Poetic (Coda) # 27, 1997
Mischtechnik auf Papier
Mixed media on paper
50,8 x 66 cm

Poetic (Coda) # 28, 1997
Mischtechnik auf Papier
Mixed media on paper
50,8 x 66 cm

Poetic (Coda) # 38, 1997
Mischtechnik auf Papier
Mixed media on paper
50,8 x 66 cm

Poetic (Coda) # 47, 1997
Mischtechnik auf Papier
Mixed media on paper
50,8 x 66 cm

Poetic (Coda) # 48, 1997
Mischtechnik auf Papier
Mixed media on paper
50,8 x 66 cm

Light and Skulls, 1998
Acryl, Mischtechnik auf Papier
Acrylic and mixed media on paper
75,9 x 55,6 cm

Spectacle Code, 1998
Acryl, Mischtechnik auf Papier
Acrylic and mixed media on paper
75,9 x 55,6 cm

Fellini's Funeral, 1998
Acryl, Mischtechnik auf Papier
Acrylic and mixed media on paper
75,9 x 55,6 cm

RICHARD PRINCE

Untitled (Jewelry Against Nature), 1978–79
Farbphotographie
C-print
50,5 x 60,6 cm

Cowboy, 1984
Farbphotographie
C-print
58,4 x 40 cm
Photo: Raimund Koch, Berlin
Abb./illus. 161

Creative Evolution, 1984–85
Farbphotographie
C-print
167,5 x 122 cm
Photo: Courtesy Sotheby's, New York
Abb./illus. 160

Criminals and Celebrities, 1986
Farbphotographie
C-print
218,4 x 121,9 cm

Untitled (Joke) # 6, 1987
Graphit, Kreidegrund auf Leinwand
Powdered graphite on gessoed canvas
61 x 45,7 cm

Why Are You Crying, 1988
Siebdruck, Bleistift, Acryl, Filzstift auf Papier
Silkscreen, pencil, acrylic, felt tip pen on paper
60,7 x 45,5 cm

Why Are You Crying, 1988
Acryl, Siebdruck auf Leinwand
Acrylic, silkscreen on canvas
167,5 x 137 cm

Two Leopard Joke, 1989
Acryl, Siebdruck auf Leinwand
Acrylic, silkscreen on canvas
244 x 190,5 cm
Photo: Barbara Deller-Leppert, München
Abb./illus. 157

Untitled (SB Hood # 1), 1989
Acryl, Fiberglasguß, Holz
Acrylic, fiberglass cast, wood
81 x 124,5 x 134,5 cm
Sockel/pedestal: 61 x 124 x 134 cm

Untitled (Protest Painting), 1989–92
Acryl, Siebdruck, Graphit, Papier auf Leinwand
Acrylic, silkscreen, graphite, paper on canvas
95,8 x 50,5 cm

Lady Doc / They Keep Asking, 1990–92
Acryl, Siebdruck auf Leinwand
Acrylic, silkscreen on canvas
208 x 295 cm
Photo: Courtesy Galerie Jablonka, Köln
Abb./illus. 159

Not Q Enough, 1992
Acryl, Siebdruck auf Leinwand
Acrylic, silkscreen on canvas
170 x 120 cm
Photo: Barbara Deller-Leppert, München
Abb./illus. 158

Cowboys and Girlfriends, 1992
Farbphotographien
C-prints
14teilig/14 parts
je 50,8 x 61 cm / 50,8 x 61 cm each

Untitled (Cowboys), 1992
Farbphotographie
C-print
101,6 x 71,75 cm

Untitled (aus: October Portfolio), 1977/93
Farbphotographie
C-print
22 x 33 cm
Photo: Barbara Deller-Leppert, München
Abb./illus. 162

Untitled (Girlfriend), 1993
Farbphotographie
C-print
162,6 x 111,8 cm

Untitled (Girlfriend), 1993
Farbphotographie
C-print
62,6 x 111,8 cm

Untitled (Protest Painting), 1994–95
Acryl, Siebdruck auf Leinwand
Acrylic, silkscreen on canvas
76,2 x 55,9 cm

Shakespeare in the Alley, 1995
Acryl, Siebdruck auf Leinwand
Acrylic, silkscreen on canvas
190,5 x 147,5 cm

Untitled (Jack in the Box), 1995
Kugelschreiber, Buntstift, Bleistift, Filzstift, Kohle, Papier
collagiert auf Papier
Biro, colour pencil, pencil, felt tip pen, charcoal, paper
collage on paper
76,2 x 55,9 cm

Untitled (New painting), 1997
Acryl, Siebdruck, Graphit, Ölkreide auf Siebdruckrahmen
Acrylic, silkscreen, graphite, oil crayon on silkscreen frame
129,5 x 110,8 cm

Untitled, 1997
Acryl, Tintenroller, Kreide, Siebdruck collagiert auf
Siebdruckrahmen
Acrylic, crayon, silkscreen collaged on silkscreen frame
150,5 x 121,9 cm

ANDREA ZITTEL

Study for Carpet / Furniture, 1992
Gouache auf Papier
Gouache on paper
38 x 50,6 cm

Study for Carpet / Furniture, 1993
Gouache, Bleistift auf Papier
Gouache, pencil on paper
38 x 50,6 cm
Photo: Raimund Koch, Berlin
Abb./illus. 168

Cover, 1993
Wolle, Samt, Leinen
Wool, velvet, linen
3teilig/3 parts:
je 182,8 x 152,4 cm / 182,8 x 152,4 cm each
Photo: Courtesy Andrea Rosen Gallery, New York
Abb./illus. 170

Study for Ottomans, 1994
Gouache, Bleistift auf Papier
Gouache, pencil on paper
38 x 50,6 cm
Photo: Raimund Koch, Berlin
Abb./illus. 168

A–Z Clocks, 1994
Holz, Glas, Plastik, Farbe, Motor
Wood, glass, plastic, paint, motor
5teilig/5 parts:
35,5 x 35,5 x 8,6 cm
Photo: Raimund Koch, Berlin
Abb./illus. 169

Perfected Pillow, 1995
Samtbett (schwarz/grün), Kissen, Fransen
Black green velvet single bed, pillow, bith fringed
202,4 x 101,2 cm
Photo: Courtesy Artists Space, New York
Abb./illus 171

Dining Room Carpet, 1997
Nylon-Teppich (blau/hellgrün/grün)
Nylon carpet (blue/deep brigth green/bright green)
304 x 198 cm
Photo: Courtesy Lehmann Maupin, New York
Abb./illus. 170

Biografien der britischen Künstlerinnen und Künstler

Biographies of British Artists

ANGELA BULLOCH

1966 geboren / born in Fort Francis, Canada
Lebt und arbeitet / Lives and works in London

Ausbildung / Education
1985–88 Goldsmiths College, London,
 B.A. (Hons.) Fine Art.

Preise / Awards
1989 Whitechapel Artist Award
1994 Artist residency Arcus-project, Moriya, Japan

Einzelausstellungen / Solo Exhibitions
1990 Esther Schipper, Köln
 Galerie Claire Burrus, Paris
 APAC Centre d'Art Contemporain, Nevers
 Interim Art, London
1991 Le Case d'Arte, Milano
1992 Galeria Locus Solus, Genova
 Esther Schipper, Köln
1993 1301, Santa Monica, CA
 Rules Series, Esther Schipper und Friesenwall 116a,
 Köln
 Centre pour Creation Contemporaine, Tours
1994 F.R.A.C. Languedoc-Roussillon: Aldebaran,
 Baillargues
 Kunstverein in Hamburg, Hamburg
1995 Marc Foxx Gallery with 1301/Brian Butler,
 Santa Monica
 »From the Chink to Panorama Island«, PADT, London
 »Mudslinger«, Schipper & Krome, Köln
1996 Robert Prime, London
 Galerie Walcheturm, Zürich
1997 »Soundbank«, Kunstverein Ludwigsburg
 »Vehicles«, Le Consortium, Dijon
1998 »Superstructure«, Museum für Gegenwartskunst
 Zürich

Ausgewählte Gruppenausstellungen
Selected Group Exhibitions
1988 »Freeze«, Surrey Docks, London
1993 La Biennale di Venezia
1994 »temporary translation(s)«, Sammlung Schürmann,
 Deichtorhallen, Hamburg
1996 »Full House – Junge Britische Kunst«, Kunstmuseum
 Wolfsburg
 »Nach Weimar«, Kunstsammlungen zu Weimar,
 Weimar
 »Kunst in der neuen Messe Leipzig«, Leipziger Messe
1997 »The Turner Prize 1997«, Tate Gallery, London
1998 »Fast Forward/trademark«, »Fast Forward/body
 check«, Kunstverein Hamburg

WILLIE DOHERTY

1966 geboren / born in Derry, Northern Ireland
Lebt und arbeitet / Lives and works in Derry

Ausbildung / Education
1978–81 Ulster Polytechnik, Belfast

Preise / Awards
1995 Irish Museum of Modern Art Glen Dimplex Artists
Award
1998 Berliner Künstlerprogramm 1999 / DAAD, Berlin

Ausgewählte Einzelausstellungen
Selected Solo Exhibitions
1980 Installation, Orchard Gallery, Derry
1986 »Photoworks«, Oliver Dowling Gallery, Dublin
1990 »Unknown Depths«, Photogallery Cardiff; The Third
Eye Centre
»Same Difference«, Matt's Gallery, London
1991 »Unknown Depths«, ICA Gallery London;
John Hansard Gallery, Southampton;
Angel Row Gallery, Nottingham
»Kunst Europa – Großbritannien: Willie Doherty«,
Kunstverein Schwetzingen
1992 Oliver Dowling Gallery, New York
Peter Klichmann Galerie, Zürich
1993 Galerei Jennifer Flay, Paris
»They're All the Same«, Centre for Contemporary Art,
Ujazdowski Castle, Warschau
»30 Januar 1972«, Douglas Hyde Gallery, Dublin
1994 »The Only Good One is a Dead One«, Amolfini,
Bristol; Grey Art Gallery, New York
1995 The Kerlin Gallery, Dublin
Galerie Peter Kilchmann, Zürich
1996 »The Only Good One is a Dead One«, The Edmonton
Art Gallery, Galleria Emi Fontana, Mailand
»Willie Doherty«, Musée d'art Moderne de la Ville de
Paris, Paris
»In the Dark. Projected Works/Im Dunkeln
Projizierte Arbeiten«, Kunsthalle Bern
1997 »Willie Doherty«, Galerie Peter Kilchmann, Zürich
1998 Tate Gallery, Liverpool
Angles Gallery, Los Angeles

Ausgewählte Gruppenausstellungen
Selected Group Exhibitions
1985 »Points of View«, Heritage Library, Derry
1989 »1.Internationale Foto-Triennale«, Esslingen
1991 »A Place for Art?«, The Showroom, London
1993 »An Irish Presence«, La Biennale di Venezia
»Critical Landscape«, Tokyo Metropolitan Museum
of Photography, Tokyo
1994 »The Turner Prize«, Tate Gallery, London
1995 »Willie Doherty, Andreas Gursky«, Moderna Museet
Stockholm
1996 10th Biennale of Sydney
1997 »no Place (like Home)«, Walker Art Center,
Minneapolis

TRACEY EMIN

1963 geboren / born in London
Lebt und arbeitet / Lives and works in London

Ausbildung / Education
1986 Maidstone College of Art (Bachelor of Fine Art)
1989 Royal College of Art

Preise / Awards
1997 Video Art Prize, Südwest Bank, Stuttgart
1997 Internationaler Preis für Videokunst, Baden-Baden

Einzelausstellungen / Solo Exhibitions
1994 Art Cologne, sponsored artist (White Cube, London)
Mattress Factory, Pittsburgh; Sandra Gering Gallery,
New York;
White Columns, New York
Museum of Contemporary Art, San Diego;
David Klein Gallery, Detroit
»Exploration of the Soul – Journey Across America«,
Readings at the following locations: Rena Bransten,
San Francisco; Regen Projects, Los Angeles
»My Major Retrospective«, White Cube/Jay Jopling,
London
1995 »Tracey Emin Museum«, 221 Waterloo Road, London
SE1 (permanent site)
1996 »Solo Exhibition«, Habitat, London
»Exorcism of the Last Painting I Ever Made«,
Galleri Andreas Brändström, Stockholm
»It's not me that's crying, it's my soul«, Galerie Mot &
Van den Boogaard, Bruxelles
1997 »I Need Art Like I Need God«, South London Gallery,
London
»Solo Exhibition«, Moo Gallery, Helsinki
1998 »Tracey Emin«, Galerie Philippe Rizzo, Paris
»I Need Art Like I Need God«, Gesellschaft für
Aktuelle Kunst, Bremen
»Tracey Emin«, Galerie Gebauer, Berlin

Ausgewählte Gruppenausstellungen
Selected Group Exhibitions
1994 »Karaoke & Football«, Portikus Frankfurt
1995 »Brilliant! New Art from London«, Walker Art Center,
Minneapolis
1996 »Full House«, Kunstmuseum Wolfsburg
»The Aggression of Beauty«, Galerie Arndt & Partner,
Berlin
»Faustrecht der Freiheit«, Sammlung Volkmann,
Kunstsammlung Gera;
1997 »Sensation«, Royal Academie of Arts, London
»Istanbul Biennial«, Pera Palace Hotel, Türkei
(Performance)
»Time Out«, Kunsthalle Nürnberg
1998 »La Biennale de Montreal«, Centre International
D'Art Contemporain de Montreal, Montreal, Quebec
»Fast Forward/body check«, Kunstverein Hamburg

DOUGLAS GORDON

1966 geboren / born in Glasgow
Lebt und arbeitet / Lives and works in Glasgow und /
and Berlin

Ausbildung / Education
1984–88 Glasgow School of Art
1988–90 The Slade School of Art, London

Preise / Awards
1996 Turner Prize, London
1997 »Premio 2000« at Venezia Biennale
1998 Hugo Boss Prize, Guggenheim Museum, New York

Ausgewählte Einzelausstellungen
Selected Solo Exhibitions
1993 »24 Hour Psycho«, Tramway, Glasgow und Kunst-
 Werke, Berlin
 »Migrateur«, L'ARC Musée d'Art Moderne de la Ville
 de Paris
1994–95 Lisson Gallery, London
1995 »Bad Faith«, Künstlerhaus Stuttgart
 »The End«, Jack Tilton Gallery, New York
 »Entr'Acte 3«, Van Abbe Museum, Eindhoven
1995–96 Centre Georges Pompidou, Paris
1996 »Douglas Gordon & Rikrit Tiravanija«, FRAC
 Languedoc-Rousillion, Montpellier
 »24 hour Psycho«, Akademie der bildenden Künste,
 Wien
 »…head«, Uppsala Konstmuseum
 Museum für Gegenwartskunst, Zürich
 Galerie Walcheturm, Zürich
 »The Turner Prize 1996«, Tate Gallery, London
1997 Galleri Nicolai Wallner, Kopenhagen
 »Douglas Gordon«, Biennale de Lyon
 »5 Year Drive-By«, Kunstverein Hannover
 »Leben nach dem Leben nach dem Leben…«,
 Deutsches Museum Bonn
1998 »Douglas Gordon«, Dvir Gallery, Tel Aviv
 »Douglas Gordon: Videoinstallation, Retrospektive«,
 Kunstverein Hannover

Ausgewählte Gruppenausstellungen
Selected Group Exhibitions
1995 »Take me (I'm yours)«, Serpentine Gallery, London;
 Kunsthalle Nürnberg
 »Wild Walls«, Stedelijk Museum, Amsterdam
1995–96 »Biennale de Lyon«, Lyon
1996 »Manifesta 1«, Rotterdam
 »Nach Weimar«, Kunstsammlungen zu Weimar
 10th Biennale of Sydney
1997 »Past, Present, Future«, Venezia Biennale
 »Skulptur Projekte«, Münster
 »Pictura Britannia«, Museum of Contemporary Art
 Sydney; Gallery of South Australia, Adelaide;
 City Gallery, Wellington, New Zealand
1998 »Tuning up No.5«, Kunstmuseum Wolfsburg

MONA HATOUM

1952 geboren / born in Beirut
Lebt und arbeitet / Lives and works in London

Ausbildung / Education
1970–72 Beirut University College, Beirut
1975–79 The Byam Shaw School of Art, London
1979–81 The Slade School of Art, London

Ausgewählte Einzelausstellungen
Selected Solo Exhibitions
1984 »The Negotiating Table«, The Franklin Furnace,
 New York
1985 »Between the Lines«, The Orchard Gallery, Derry
 (Performance)
1989 »The Light at the End«, The Showroom, London und
 Oboro Gallery, Montréal
1992 »Dissected Space«, Chapter, Cardiff
 »Mona Hatoum«, Mario Flecha Gallery, London
1993 »Positionings« (und Barbara Seinman), Art Gallery of
 Ontario, Toronto
 »Le Socle du Monde«, Galerie Crousel-Robelin Bama,
 Paris
1994 »Mona Hatoum«, C.R.G. Art Incorporated, New York
 »Mona Hatoum«, Musée national d'art moderne,
 Centre Georges Pompidou, Paris
 »Mona Hatoum«, Galerie René Blouin, Montréal
1995 »Short Space«, Galerie Chantal Crousel, Paris
 »Socle du Monde«, White Cube/Jay Jopling, London
1996 »Quarters«, Via Farini, Milano
 »Current Disturbance«, Capp Street Project,
 San Francisco
 »Mona Hatoum«, The Fabric Workshop and
 Museum, Philadelphia
1997 »Mona Hatoum«, Chicago Museum of
 Contemporary Art, Chicago;
 New Museum, New York
1998 »Mona Hatoum«, Museum of Modern Art, Oxford

Ausgewählte Gruppenausstellungen
Selected Group Exhibitions
1991 »The Interrupted Life«, The Museum of
 Contemporary Art, New York
1994 »Sense and Sensibility: Women and Minimalism in
 the Nineties«, Museum of Modern Art, New York
1995 »FeminMasculin: Le Sexe de l'Art«, Centre Georges
 Pompidou, Paris
 »The Turner Prize Exhibition«, Tate Gallery, London
 »Identity and Alterity«, La Biennale di Venezia
1996 »Life/Live La Scene artistique au Royaume-Uni en
 1996«, Museé d'art moderne de la Ville de Paris
 »NowHere«, Louisiana Museum of Modern Art,
 Humlebæk
1997 »De-Genderism: Detruire Dit-Elle/II«, Setagaya Art
 Museum, Tokyo
 »Angel, Angel«, Kunsthalle Wien

ABIGAIL LANE

1967 geboren / born in Penzance, England
Lebt und arbeitet / Lives and works in London

Ausbildung / Education
1985 Bristol Polytechnic
1986–89 Goldsmiths College, London,
 BA (Hons) Fine Art

Einzelausstellungen / Solo Exhibitions
1992 »Abigail Lane: Making History«, Karsten Schubert,
 London, England (in Zusammenarbeit mit / in
 cooperation with Interim Art)
1994 »Abigail Lane«, Emi Fontana, Milano
1996 »Abigail Lane«, Bonnefanten Museum, Maastricht
 »25 Watt Moon«, Ridinghouse Editions, London
1997 »Abigail Lane«, Andréhn-Schiptjenko, Stockholm
 »Another Time, Another Place«, Galerie Chantal
 Crousel, Paris
1998 »Never, never mind«, Victoria Miro Gallery, London
 »Wether the roast burns, the train leaves or the
 heavens fall«, MCA, Chicago

Ausgewählte Gruppenausstellungen
Selected Group Exhibitions
1988 »Freeze«, Surrey Docks, London
1989 »The New Contemporaries«, ICA, London
1992 »Group show«, Kunsthalle Luzern
1994–95 »Some Went Mad, Some Run Away…«,
 Nordic Art Centre, Helsinki;
 Kunstverein Hannover; MCA, Chicago
1995 4th International Istanbul Biennial, Istanbul
 »Here and Now«, Serpentine Gallery, London
1995–96 »Brilliant! New Art from London«, Walker Art
 Center, Minneapolis
1996 »Full House«, Kunstmuseum Wolfsburg
1996–97 »Painting – The Extended Field«, Magasin 3
 Stockholm Konsthall
1997 »L'Autre«, kuratiert von Harald Szeeman, 4e Biennale
 de Lyon, Halle Tony Garnier, Lyon
 »Sensation. Young British Artists from the Saatchi
 Collection«, Royal Academy of Arts, London
1998 »Fotografie als Handlung«, 4. Internationale Foto-
 Triennale Esslingen, Galerien der Stadt Esslingen

SARAH LUCAS

1962 geboren / born in London
Lebt und arbeitet / Lives and works in London

Ausbildung / Education
1982–83 Working Men's College, London
1983–84 London College of Printing
1984–87 Goldsmiths College, London

Einzelausstellungen / Solo Exhibitions
1992 »Penis Nailed to a Board«, City Racing Gallery,
 London
 »The Whole Joke«, 8 Kingly Street, London
1993 »The Shop« (with Tracey Emin), 103 Bethnal
 Green Road, London
1994 »Got a Salmon On (Prawn)«, Anthony d'Offay
 Gallery, London
 »Where's My Moss«, White Cube, London
1995 »Supersensible«, Barbara Gladstone Gallery,
 New York
1996 »Sarah Lucas«, Museum Boijmans Van Beuningen,
 Rotterdam
 »Sarah Lucas«, Portikus, Frankfurt / Main
 »Is Suicide Genetic?«, Contemporary Fine Arts, Berlin
1997 »The Law«, organized by Sadie Coles, St. Johns Lofts,
 London
 »Bunny gets Snookered«, Sadie Coles HQ, London
 »Car Park«, Museum Ludwig Köln
1998 »The Old In Out«, Barbara Gladstone Gallery,
 New York

Ausgewählte Gruppenausstellungen
Selected Group Exhibitions
1988 »Freeze«, Surrey Docks, London
1993 »Young Britsh Artists II«, Saatchi Collection, London
 »Sarah Lucas and Steven Pippin«, Project Room,
 Museum of Modern Art, New York
1994 »Group Show«, Portikus, Frankfurt
1995 ARS '95, Museum of Contemporary Art, Helsinki
 »Brilliant! New Art from London«, Walker Art Center,
 Minneapolis
1996 »Full House«, Kunstmuseum Wolfsburg
1997 »Sensation. Young British Artists from the Saatchi
 Collection«, Royal Academy of Arts, London
1998 »Die Rache der Veronika, Aktuelle Perspektiven der
 zeitgenössischen Fotografie«, Deichtorhallen,
 Hamburg

SAM TAYLOR-WOOD

1967 geboren / born in London
Lebt und arbeitet / Lives and works in London

Ausbildung / Education
1990 Goldsmiths College, London

Preise / Awards
1997 Illy Cafe Prize for Most Promising Young Artist,
Biennale di Venezia

Einzelausstellungen / Solo Exhibitions
1994 »Killing Time«, The Showroom, London
1995 »Sam Taylor-Wood«, Gallerie Andreas Brändström,
Stockholm
1995/96 »Travesty of a Mockery«, White Cube/Jay Jopling,
London
The Showroom, London
1996 »16 mm«, Ridinghouse Editions, London
1996/97 »Pent-Up«, Chisenhale Gallery, London;
Sunderland City Art Gallery
1997 »Sam Taylor-Wood: Five Revolutionary Seconds«,
Sala Montcada de la Fundacio »la Caixa«, Barcelona
»Sustaining the Crisis«, Regen Projects, Los Angeles
1997–98 »Solo exhibition«, Kunsthalle Zürich; Lousiana
Museum of Modern Art, Humblebæk

Ausgewählte Gruppenausstellungen
Selected Group Exhibitions
1995 »British Art Show 4«, Manchester, Edingburgh,
Cardiff, London
»FemininMasculin: Le Sexe de l'Art«, Centre Georges
Pompidou, Paris
»Brilliant! New Art from London«, Walker Art Centre,
Minneapolis; Contemporary Art Museum, Houston
1996 »Life Live«, Musée d'Art Moderne de la Ville de Paris,
Paris
»Full House«, Kunstmuseum Wolfsburg
Manifesta 1, Museum Boymans Van Beuningen;
Witte de With, Rotterdam
1997 »Sensation. Young British Artists from the Saatchi
Collection«, Royal Academy of Arts, London
La Biennale di Venezia
»Home Sweet Home«, Deichtorhallen, Hamburg
1998 »New British Video Programme«, Museum of
Modern Art, New York

RACHEL WHITEREAD

1967 geboren / born in London
Lebt und arbeitet / Lives and works in London

Ausbildung / Education
1982–85 Brighton Polytechnic – Painting
1985–87 Slade School of Fine Art – Sculpture

Preise / Awards
1993 Turner Prize, London
1997 Honorary Degree of Doctor of Letters, Staffordshire
University

Ausgewählte Einzelausstellungen
Selected Solo Exhibitions
1992 »Rachel Whiteread: Recent Sculpture«, Luhring
Augustin Gallery, New York
»Rachel Whiteread: Sculptures«, Stedelijk Van
Abbemuseum, Eindhoven
1993 »Rachel Whiteread: Sculptures«, MCA, Chicago
»House« commissioned by Artangel Trust and Beck's
(corner of Grove Road and Roman Road, E3), London
»Rachel Whiteread: Zeichnungen«, DAAD Galerie,
Berlin
1994 »Rachel Whiteread: Skulpturen/Sculptures«,
Kunsthalle Basel
ICA Philadelphia, ICA Boston
»Rachel Whiteread: Drawings«, Luhring Augustine
Gallery, New York
1995 »Rachel Whiteread: Untitled (Floor)«, Karsten
Schubert, London
1996 »Rachel Whiteread«, Karsten Schubert, London
(in Zusammenarbeit mit Charles Booth-Clibborn)
»Rachel Whiteread: Sculptures«, Luhring Augustine
Gallery, New York
»Rachel Whiteread: Shedding Life«, Tate Gallery,
Liverpool
1997 Reina Sofia, Madrid
1997 British Pavillion, La Biennale di Venezia
1998 »Water Tower Project«, Public Art Fund, New York

Ausgewählte Gruppenausstellungen
Selected Group Exhibitions
1989 »Einleuchten«, Deichtorhallen, Hamburg
1991 »Metropolis«, Martin-Gropius-Bau, Berlin
»The Turner Prize«, Tate Gallery, London
1992 »documenta IX«, Kassel
Sydney Biennale, Sydney
1993 »The Turner Prize«, Tate Gallery, London
1994 »Sense and Sensibility: Woman Artists and
Minimalism in the Nineties«
The Museum of Modern Art, New York
1995 »ARS '95«, Museum of Contemporary Art and
Finnish National Gallery, Helsinki
1997 »Skulptur. Projekte«, Münster
»Sensation. Young British Artists from the Saatchi
Collection«, Royal Academy of Arts, London

Biografien der amerikanischen Künstlerinnen und Künstler

Biographies of American Artists

MATTHEW BARNEY

1967 geboren / born in San Francisco
Lebt und arbeitet / Lives and works in New York

Ausbildung / Education
1989 B.A. Yale University, New Haven, Connecticut

Preise / Awards
1993 »Europa 2000« Prize, Aperto '93
1996 Hugo Boss Prize, Guggenheim Museum, New York

Einzelausstellungen / Solo Exhibitions
1988 »Rainforest Alliance«, Open Center, New York
　　　»Scab Action« – Video exhibition for the
　　　New York City
1989 »Field Dressing« – Payne Whitney Athletic Complex,
　　　Yale University, New Haven
1991 »Matthew Barney: New Work«, Artist's Book,
　　　San Francisco Museum of Modern Art, Regen
　　　Projects Los Angeles
　　　Barbara Gladstone Gallery, New York
1994 »Portraits from CREMASTER 4«, Regen Projects,
　　　Los Angeles
1995 »PACE CAR for the HUBRIS PILL«, Museum Boijmans
　　　Van Beuningen, Rotterdam;
　　　Musée d'art Contemporain, Bordeaux und Kunst-
　　　halle Bern
　　　Fondation Cartier, Paris
　　　The Tate Gallery, London
1996 »Transexualis and REPRESSIA«, »CREMASTER 1 and
　　　CREMASTER 4«, San Francisco MOMA, San Francisco
1997 »CREMASTER 1«, Kunsthalle Wien, Wien
　　　»CREMASTER 5«, Barbara Gladstone Gallery,
　　　New York
　　　»CREMASTER 5«, Portikus, Frankfurt a.M.
1998 »CREMASTER 1«, Öffentliche Kunstsammlung Basel,
　　　Kunstmuseum
　　　»CREMASTER 5«, Regen Projects, Los Angeles

Ausgewählte Gruppenausstellungen
Selected Group Exhibitions
1992 »documenta IX«
　　　»Post Human«, FAE Museé d'Art Contemporain,
　　　Pully/Lausanne;
　　　Castello di Rivoli; Deste Foundation for Contempor-
　　　ary Art, Athen; Deichtorhallen, Hamburg
1993 Whitney Biennial, Whitney Museum of American Art,
　　　New York
　　　»Aperto '93«, La Biennale di Venezia
1995 »ARS '95«, Museum of Contemporary Art, Helsinki
　　　Biennial Exhibition, Whitney Museum of American
　　　Art, New York
1996 10th Biennale of Sydney
　　　»Hugo Boss Prize Exhibition«, Guggenheim Museum,
　　　New York
1998 »Wounds Between Democracy and Redemption in
　　　Contemporary Art«
　　　Moderna Museet Stockholm

ROBERT GOBER

1954 geboren in / born in Wallingford, Connecticut
Lebt und arbeitet / Lives and works in New York

Ausbildung / Education
1973–74 Tyler School of Art, Roma
1976 Middlebury College, Vermont, B.A.

Einzelausstellungen / Solo Exhibitions
1984 »Slides of a Changing Painting«, Paula Cooper
 Gallery, New York
1985 Daniel Weinberg Gallery, Los Angeles
 Paula Cooper Gallery, New York
1986 Daniel Weinberg Gallery, Los Angeles
1987 Galerie Jean Bernier, Athen
 Paula Cooper Gallery, New York
1988 Tyler Gallery, Tyler School of Art, Temple University,
 Philadelphia
 »Robert Gober«, The Art Institute of Chicago
 Galerie Max Hetzler, Köln
 Galerie Gisela Capitain, Köln
1989 Paula Cooper Gallery, New York
1990 Galleria Marga Paz, Madrid
 Museum Boijmans Van Beuningen, Rotterdam;
 Kunsthalle Bern
1991 Galerie Nationale du Jeu de Paume, Paris;
 Museo Nacional Centro de Arte Reina Sofia, Madrid
1992 DIA Center for the Arts, New York City
1993 Serpentine Gallery, London; Tate Gallery, Liverpool
1994 Paula Cooper Gallery, New York
 »Robert Gober Dessins« Galerie Samia Saouma, Paris
1995 Galerija Dante Marino Cettina, Umag
 »Robert Gober«, Museum für Gegenwartskunst,
 Basel
1996 Galerie Max Hetzler, Berlin
 The Geffen Contemporary, Museum of Contem-
 porary Art, Los Angeles
1998 The Aldrich Museum Contemporary Art, Ridgefield
1999 »Robert Gober: Sculpture and Drawing«, Walker Art
 Center, Minneapolis

Ausgewählte Gruppenausstellungen
Selected Group Exhibitions
1989 »Horn of Plenty«, Stedelijk Museum, Amsterdam
 »Metropolis«, Martin Gropius Bau, Berlin
1990 »The Readymade Boomerang, Certain in Relations in
 20th Century Art«, Biennale of Sydney
1991 »Whitney Biennial«, Whitney Museum of American
 Art, New York
1992 »documenta IX«, Kassel
1993 »Whitney Biennial«, Whitney Museum of American
 Art, New York
1994 »Change of Scene V«, Museum für Moderne Kunst,
 Frankfurt a. M.
1997 »Objects of Desire: The Modern Still of Live«,
 Museum of Modern Art, New York
1997–98 »Check in!«, Museum für Gegenwartskunst, Basel
1998 »Wounds«, Moderna Museet, Stockholm

MIKE KELLEY

1954 geboren in / born in Detroit, Michigan
Lebt und arbeitet / Lives and works in Los Angeles

Ausbildung / Education
1976–78 University of Michigan, Ann Arbor
 California Institute of the Arts, Valencia

Ausgewählte Einzelausstellungen
Selected Solo Exhibitions
1981 »Meditation on a Can of Vernors«, Riko Mizuno
 Gallery, Los Angeles
1982 »Monkey Island und Confusion«, Metro Pictures,
 New York
1984 »The Sublime«, Rosamund Felsen Gallery, Los Angeles
1985 »Plato's Cave, Rothko's Chapel, Lincolns's Profile«,
 Metro Pictures, New York
1989 »Why I got into Art – Vaseline Muses«, Jablonka
 Galerie, Köln
 »Pansy Metal, Clovered Hoof«, Metro Pictures,
 New York
1991 »Lumpenprole«, Galerie Peter Pakesch, Wien
1992 Kunsthalle Basel (Wanderausstellung: ICA, London;
 Musée d'Art contemporain, Bordeaux)
 »Alma Pater (Wolverine Den)«, Portikus,
 Frankfurt / Main
1993 »Catholic Tastes«, The Whitney Museum of
 American Art, N.Y.
1995 Jablonka Galerie, Köln
 »Missing Time«, Kestner Gesellschaft Hannover
1996 »Land-O-Lakes«, Wako Works of Art, Tokio
1997 Museum of Contemporary Art, Barcelona
1998 Jablonka Galerie, Köln

Ausgewählte Gruppenausstellungen
Selected Group Exhibitions
1988 »The BiNational: American Art of the Late 80s,
 German Art of the late 80s«, Museum of Fine
 Arts/ICA, Boston;
 Kunsthalle Düsseldorf, Kunstsammlung NRW und
 Kunstverein für die Rheinlande und Westfalen
 »Aperto«, La Biennale di Venezia
1989 »A Forest of Signs: Art in the Crisis of Represen-
 tation«, Los Angeles Museum of Contemporary Art
1991 »Metropolis«, Martin Gropius Bau, Berlin
1992 »documenta IX«, Kassel
 »Post Human«, FAE Museé d'Art Contemporain,
 Pully/Lausanne; Castello di Rivoli;
 Deste Foundation for Contemporary Art, Athen;
 Deichtorhallen, Hamburg
1993 »Sonsbeek 93«, Arnhem
1995 »FemininMasculin: Le Sexe de l'Art?«, Musée
 National d'Art Moderne, Centre Georges Pompidou,
 Paris
1997 »Sunshine and Noir. Art in L. A. 1960–1997«,
 Louisiana Museum of Art, Humlebæk
 »Home Sweet Home«, Deichtorhallen, Hamburg
 »documenta X«, Kassel

LOUISE LAWLER

1947 geboren / born in Bronxville, New York
Lebt und arbeitet / Lives and works in New York

Ausbildung / Education
Cornell University (BFA 1969)

Ausgewählte Einzelausstellungen
Selected Solo Exhibitions
1982 »An Arrangement of Pictures«, Metro Pictures,
New York
1985 »Interesting«, Nature Morte Gallery, New York
1986 »What is the same«, Maison de la Culture et de la
Communication de Saint-Etienne
1987 »It remains to be seen«, Metro Pictures, New York
»Enough«, Projects: Louise Lawler, The Museum of
Modern Art, N.Y.
»As serious as a circus«, Isabella Kacprzak, Stuttgart
1988 »Vous avez déjà vu ça«, Galerie Yvon Lambert, Paris
1989 »How many Pictures«, Metro Pictures, New York
1990 »A vendre«, Galerie Yvon Lambert, Paris
1991 »For Sale«, Metro Pictures, New York
1992 Galerie Isabella Kacprzak, Köln
1993 Sprengel Museum, Hannover
1994 Centre d'Art Contemporain, Genf
Monika Sprüth Galerie, Köln
Studio Guenzani, Milano
1995 »A spot on the wall«, Kunstverein München
1996 »It could be Elvis and other pictures«, Galerie Six
Friedrich, München
S. L. Simpson Gallery, Toronto
1997 »Paint, Wall, Picture: Something always follows
something else. She wasn't always a statue«,
Metro Pictures, New York
»Wände, Farbe, Bilder«, Monika Sprüth Galerie, Köln
1998 »Without Moving / Without Stopping«,
www.stadiumweb.com (online exhibition)
»Birdcalles«, www.stadiumweb.com
(online exhibition)

Ausgewählte Gruppenausstellungen
Selected Group Exhibitions
1989 »A Forest of Signs: Art in the Crisis of Represen-
tation«, Museum of Contemporay Art, Los Angeles
»Wittgenstein – Das Spiel des Unsagbaren«, Wiener
Secession, Wien; Palais des Beaux-Arts, Bruxelles
1993 »KontextKunst«, Neue Galerie am Landesmuseum
Johanneum, Graz
1994 »The Century of the Multiple: From Duchamp to the
Present«, Deichtorhallen Hamburg
»temporary translation(s): Sammlung Schürmann«,
Deichtorhallen Hamburg
1997 »Deep Storage: Arsenal der Erinnerungen«,
Haus der Kunst, München; Nationalgalerie, Berlin;
Kunstmuseum Düsseldorf im Ehrenhof;
P. S. 1 Center for Contemporary Art, New York;
Henry Art Gallery, Seattle

SHERRIE LEVINE

1947 geboren in / born in Hazelton, Pennsylvania
Lebt und arbeitet / Lives and works in New York

Ausbildung / Education
1965–73 University of Wisconsin;
Madison (B.F.A. 1969; M.F.A. 1973)

Ausgewählte Einzelausstellungen
Selected Solo Exhibitions
1974 De Saisset Art Museum, Santa Clara, CA
1977 3 Mercer Street, New York
1979 The Kitchen, New York
1981 Metro Pictures, New York
1983 Richard Kuhlenschmidt Gallery, Los Angeles
1984 Nature Morte Gallery, New York
1986 Daniel Weinberg Gallery, Los Angeies
1987 Donald Young Gallery, Chicago
Mary Boone Gallery, New York
1988 Hirshhorn Museum, Washington, D.C.
Galerie nächst St. Stephan, Wien
1991 San Francisco Museum of Modern Art, San Francisco
Galerie Ghislaine Hussenot, Paris
Kunsthalle Zürich, Zürich
1992 Westfälisches Landesmuseum, Münster
Rooseum, Malmö
1993 Jablonka Galerie, Köln
Philadelphia Museum of Art, Philadelphia
1994 Portikus, Frankfurt
Marian Goodman Gallery, New York
1995 Museum of Contemporary Art, Los Angeles
Margo Leavin Gallery, Los Angeles, California
1996 Jablonka Galerie, Köln
Margo Leavin Gallery, Los Angeles
1997 Edition Schellmann, München

Ausgewählte Gruppenausstellungen
Selected Group Exhibitions
1982 »documenta VII«, Kassel
1984 »Difference: On Sexuality and Representation«;
The New Museum of New York;
Renaissance Society, Chicago; ICA, London
1987 »Avant-Garde in the Eighties«, Los Angeles County
Museum of Art, Los Angeles
1989 »Bilderstreit«, Rheinhalle, Köln
»A Forest of Signs: Art in the Crisis of Represen-
tation«, Museum of Contemporay Art, Los Angeles
»Wittgenstein – Das Spiel des Unsagbaren«, Wiener
Secession, Wien; Palais des Beaux-Arts, Bruxelles
1992 »Allegories of Modernism: Contemporary Drawing«;
Museum of Modern Art, New York
1994 »Duchamp's Leg«, Walker Art Center Minneapolis
1995 »Pittura Immedia«, Neue Galerie am Landesmuseum,
Graz
1996 »Abstraction. Pure and Impure«, Museum of Modern
Art, New York

CADY NOLAND

1956 geboren in / born in Washington, D.C.
Lebt und arbeitet in / Lives and works in New York

Einzelausstellungen / Solo Exhibitions

1988 Wester Singel, Rotterdam
1989 The White Room, White Columns, New York
1989 American Fine Arts, New York
 Anthony Reynolds Gallery, London
1990 Luhring Augustine Hetzler Gallery, Santa Monica
1994 Paula Cooper Gallery, New York
1995 Museum Boijmans Van Beuningen, Rotterdam

Ausgewählte Gruppenausstellungen
Selected Group Exhibitions

1989 »Einleuchten«, Deichtorhallen, Hamburg
1990 »Aperto«, La Biennale di Venezia, Venezia
1991 »Whitney Biennial«, Whitney Museum of American
 Art, New York
 »Metropolis«, Martin Gropius Bau, Berlin
1992 »documenta IX«, Kassel
 »Post Human«, FAE Musee d'Art Contemporain,
 Lausanne; Castello de Rivoli, Turin; Deste Foundation
 for Contemporary Art, Athen;
 Deichtorhallen, Hamburg
1993 »New World Images«, Louisiana Museum,
 Humlebæk
1994 »Radical Scavenger(s): The Conceptual Vernacular in
 Recent American Art«, Museum of Contemporary
 Art, Chicago
1995 »Public Information: Desire, Disaster, Document«,
 San Francisco, Museum of Modern Art

TONY OURSLER

1957 geboren / born in New York
Lebt und arbeitet / Lives and works in New York

Ausbildung / Education

1979 California Institute of Arts, B.F.A.

Ausgewählte Einzelausstellungen
Selected Solo Exhibitions

1987 The Kitchen, New York
1988 »Tony Oursler's Works«, Le Lieu, Quebec City
1989 »Drawings, Objects, Videotapes«, Delta Gallery;
 Kunstmuseum Düsseldorf;
 Museum Folkwang Essen
 Museum fur Gegenwartskunst, Basel
 »On Our Own«, Segue Gallery, New York
1991 Diana Brown Gallery, New York
 »Dummies, Hex Signs, Watercolors«, The Living
 Room, San Francisco
1993 »White Trash Phobic«, Centre d'Art Contemporain,
 Genève; Kunstwerke Berlin
 Andrea Rosen Gallery, New York
 »Dummies, Dolls, an Poison Candy«, IKON Gallery,
1994 Lisson Gallery, London
 »System for Dramatic Feedback«, Portikus Frankfurt
 »Dummies, Flowers, Alters, Clouds, and Organs«,
 Metro Pictures, N.Y.
 Centre d'Art Contemporain, Genève
 Stedelijk van Abbe Museum, Eindhoven
 Wiener Secession, Wien
1996 Metro Pictures, New York
 Museum of Contemporary Art, San Diego, CA
 Kasseler Kunstverein, Kassel
1997 »Judy«, Institute of Contemporary Art, Philadelphia
 Margo Leavin Gallery, Los Angeles

Ausgewählte Gruppenausstellungen
Selected Group Exhibitions

1984 »The Luminous Image«, Stedelijk Museum,
 Amsterdam
1987 »documenta IIX«, Kassel
1988 »The BiNational: American Art of the Late 80s,
 German Art of the Late 80s«
 Contemporary Art Museum of Fine Arts, Boston;
 Kunsthalle, Düsseldorf
1990 »Tendances Multiples, Vidéo des années 80«,
 Musée National d'Art Moderne, Centre Georges
 Pompidou, Paris
1992 »documenta IX«, Kassel
1994 »Home Video Redefined: Media, Sculpture and
 Domesticity«, Center of Contemporary Art, Miami
1995 »Video Spaces: Eight Installations«, The Museum of
 Modern Art, New York
1996 »Young Americans: New American Art in the Saatchi
 Collection«, Saatchi Gallery, London
1997 »Skulptur. Projekte«, Münster

RICHARD PRINCE

1949 geboren in der / born in Panama Canal Zone
Lebt und arbeitet / Lives and works in New York

Ausgewählte Einzelausstellungen
Selcted Solo Exhibitions
1976 Ellen Sragow Gallery, New York
1981 Metro Pictures, New York
Richard Kuhlenschmidt Gallery, Los Angeles
1983 Le Nouveau Musée, Lyon
Institute of Contemporary Art, London
1984 Feature Gallery, Chicago
Baskerville + Watson, New York
1988 Barbara Gladstone Gallery, New York
Centre National d'Art Contemporain de Grenoble,
Grenoble
Kunsthalle Zürich, Zürich (mit Allan McCollum)
Galerie Ghislaine Hussenot, Paris
Jablonka Galerie, Köln
1989 Jay Gorney Modern Art, New York
IVAM, Centre del Carme, Valencia
1991 Galerie Ghislaine Hussenot, Paris
Stuart Regean Gallery, Los Angeles
1992 Whitney Museum of American Art, New York
1993 Kunstverein und Kunsthalle, Düsseldorf
San Francisco Museum of Modern Art, San Francisco
1994 Kestner Gesellschaft, Hannover
1995 Theoretical Events, Napoli
1996 Jablonka Galerie, Köln
1997 Jürgen Becker, Hamburg

Ausgewählte Gruppenausstellungen
Selected Group Exhibitions
1987 »The Viewer as Voyer«, New York, Whitney Museum
of American Art
»Whitney Biennial«, Whitney Museum of American
Art, New York
1988 »BiNationale-Deutsche und Amerikanische Kunst der
späten 80er Jahre« Kunsthalle, Düsseldorf; Kunst-
sammlung NRW und Kunstverein;
Institute of Contemporary Art, Boston
1989 »Bilderstreit«, Rheinhalle, Köln
»A Forest of Signs: Art in the Crisis of Represen-
tation«, Museum of Contemporay Art, Los Angeles
»Wittgenstein – Das Spiel des Unsagbaren«, Wiener
Secession, Wien; Palais des Beaux-Arts, Bruxelles
1990 »Art et Publicité«, Centre George Pompidou, Paris
1992 »Allegories of Modernism«, MOMA, New York
1994 »Tuning Up«, Kunstmuseum Wolfsburg
1995 »Pittura / Immedia«, Neue Galerie am Landes-
museum, Graz
1996 »Young Americans: New American Art in the Saatchi
Collection«, Saatchi Gallery, London
1997 »Birth of the Cool: American painting from Georgia
O'Keeffe to Christiopher Wool«, Deichtorhallen,
Hamburg
»Kunst…Arbeit«, Südwest LB, Stuttgart

ANDREA ZITTEL

1966 geboren / born in Ascondeao, California
Lebt und arbeitet / Lives and works in New York

Ausbildung / Education
1988 BFA Painting / Sculpture (Honors), San Diego State
University
1990 MFA Sculpture, Rhode Island School of Design

Einzelausstellungen / Solo Exhibitions
1988 »Drawings and Constructions«, Flor Y Cant Gallery,
San Diego, CA,
1989 »Landscape«, Sol Koffler Gallery, Providence,
Rhode Island
1993 Jack Hanley Gallery, San Francisco, CA
Christopher Grimes Gallery, Santa Monica
»Purity«, Andrea Rosen Gallery, New York
1994 »Comfort«, Anthony d'Offay Gallery, London
»Andrea Zittel: Three Living Systems«, The Carnegie
Museum of Art, Pittsburgh
»A series of rotating installations«, Andrea Rosen
Gallery, New York
1995 Andrea Rosen Gallery
»New Work: Andrea Zittel«, San Francisco Museum
of Modern Art
1996 School of the Museum of Fine Arts, Museum of Fine
Arts Boston
»New Art 6: Andrea Zittel«, Cincinnati Art Museum
»The A–Z Travel Trailer Units«, Louisiana Museum of
Modern Art, Humbebæk
»Andrea Zittel – Living Units«, Museum für
Gegenwartskunst, Basel
Andrea Rosen Gallery, New York
1997 »Andrea Zittel – Living Units«, Neue Galerie am
Landes Museum Johanneum, Graz
1998 »A–Z For You – A–Z For Me«, University Art Gallery,
San Diego State University, San Diego
»RAUGH«, Andrea Rosen Gallery, New York
Sadie Coles HQ, London

Ausgewählte Gruppenausstellungen
Selected Group Exhibitions
1993 »Aperto«, La Biennale di Venezia
1994 »Sense and Sensibility«, Museum of Contemporary
Art, New York
1995 »Whitney Biennial Exhibition«, Whitney Museum of
American Art, New York
1996 »Nach Weimar«, Kunstsammlung zu Weimar,
Weimar
1997 »documenta X«, Kassel
»Skulptur Projekte in Münster«

IMPRESSUM/COLOPHON

Publikation zur Ausstellung
Publication on the occasion of the exhibition

Emotion – Junge britische und amerikanische
Kunst aus der Sammlung Goetz
Emotion – Young British and American Art
from the Goetz Collection

Deichtorhallen Hamburg
30. Oktober 1998 – 17. Januar 1999

Ausstellungsleitung / Curator of the exhibition:
Zdenek Felix

Ausstellungsassistenz / Curatorial assistant:
Annette Sievert, Agnes Wegner

Redaktion des Kataloges / Catalogue editing:
Zdenek Felix, Annette Sievert

Redaktionelle Mitarbeit / Editorial assistants:
Agnes Wegner, Gerlinde Eckardt-Salaemae

Übersetzungen / Translations:
Belinda Grace Gardner

Grafische Gestaltung, Satz / Design, typesetting:
Eduard Keller-Mack

Verlagslektorat / Copy editing:
Cornelia Plaas

Gesamtherstellung / Printed by:
Dr. Cantz'sche Druckerei, Ostfildern

© 1998 Deichtorhallen Hamburg, Cantz Verlag
und Autoren / and authors

Erschienen im / Published by Cantz Verlag
Senefelderstraße 12
73760 Ostfildern-Ruit
Tel. 0711-4405-0
Fax 0711-4402-220

ISBN 3-89322-439-4

Umschlagabbildung / Cover illustration:
Tracey Emin, *Monument Valley (Grand Scale)*, 1995
Photo: Raimund Koch, Berlin

Distribution in the US:
Distributed Art Publishers, Inc.
155 Avenue of the Americas
Second Floor
USA-New York, N.Y. 10013-1507
T. 212 / 627 1999
F. 212 / 627 9484

Printed in Germany

die Ausstellung wurde gefördert durch:

Stephan Schlüter, Hamburg

STEINWAY & SONS.

Deichtorhallen Hamburg

Direktor:
Zdenek Felix

Kaufmännischer Geschäftsführer:
Helmut Sander

Direktionsassistenz:
Annette Sievert

Sekretariat:
Gerlinde Eckardt-Salaemae

Technische Leitung:
Rainer Wollenschläger

Technische Assistenz:
Thomas Heldt-Schwarten
Nils Handschuh

Buchhaltung/Finanzwesen:
Christine Fichtner

Konservatorische Betreuung:
Christian Scheidemann

weitere Mitarbeiter:
Agnes Wegner
Sabine Poerschke

Deichtorhallen Hamburg
Deichtorstraße 1–2
20095 Hamburg
Tel. 040–32 10 30
Fax 040–32 10 32 30